THE PRACTICAL ILLUSTRATED ENCYCLOPEDIA OF
DIGITAL
PHOTO

A STEP-BY-STEP GUIDE

STEVE LUCK

HERMES
HOUSE

This edition is published by Hermes House,
an imprint of Anness Publishing Ltd,
108 Great Russell Street,
London WC1B 3NA;
info@anness.com

www.hermeshouse.com; www.annesspublishing.com;
twitter: @Anness_Books

Anness Publishing has a new picture agency outlet for images
for publishing, promotions or advertising. Please visit our
website www.practicalpictures.com for more information.

© Anness Publishing Ltd 2015

A CIP catalogue record for this book
is available from the British Library.

Publisher: Joanna Lorenz
Senior Editor: Felicity Forster
Designed and produced for Anness Publishing by
 THE BRIDGEWATER BOOK COMPANY LIMITED
Art Director: Lisa McCormick
Project Editor: Polita Caaveiro
Designer: Kevin Knight
Production Controller: Rosanna Anness

PUBLISHER'S NOTE
Although the advice and information in this book are believed
to be accurate and true at the time of going to press, neither
the authors nor the publisher can accept any legal responsibility
or liability for any errors or omissions that may have been made
nor for any inaccuracies nor for any loss, harm or injury that
comes about from following instructions or advice in this book.

CONTENTS

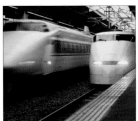

Introduction

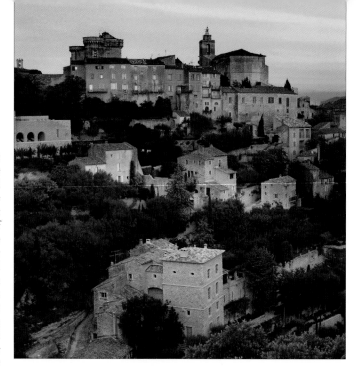

Digital photography has come a long way in a short amount of time. The digital camera, which was heralded by many in the industry as little more than an overpriced gimmick that had no real value in the world of photography, has been through some staggering changes. Today, hardly anyone thinking of buying a general 'all-purpose' camera would even consider buying a conventional film camera, while the film versus digital image-quality debate seems a thing of the distant past – the general consensus seems to be that neither one is 'better' than the other, they simply have a different 'look'.

A digital world

To keep sales of their cameras ticking over, camera manufacturers – many of whom are running scared at the inexorable rise of the camera-phone – are developing cameras that make it increasingly easy for us to take well-exposed, sharply focused images. Sophisticated metering and auto-

▼ Learning to take great photographs involves seeing in a different way. We are surrounded by a world of picture possibilities, but some are far better than others.

focusing systems, together with face detection and anti-shake technologies, mean that technically incompetent shots are becoming a thing of the past. But we need to be wary of an over-reliance on such technology – as innovative and exciting as it is – if we're to improve as photographers and to really enjoy what can be an extremely satisfying and rewarding pastime.

Being able to take as many photographs as we like, pretty much with financial impunity, can be seen as a double-edged sword. On the one hand, it encourages experimentation – and you only have to look at a website such as Flickr (www.flickr.com) to see some of the hugely creative things people achieve with their digital cameras, which are unlikely to have come about without the digital revolution. On the other hand, it also encourages an almost 'scatter-gun' approach to photography – keep firing and sooner or later you're bound to come up with some interesting images. Although there's nothing inherently wrong with such an approach, it does in many ways negate the need or desire to learn. We need to slow down and look at our images in a more considered way – why does one shot 'work'

when another from the same sequence fails? Why doesn't the image appear so full of movement? Why are the vibrant colours less intense? If we do this, we're going to increase our success rate, and by analysing what exactly it is about certain images that makes them stand out from the rest, we can mix the visual components a little to see what else works, and in that way our experimentation has some reason and method to it.

Capture

In this book the technical has been deliberately mixed with the creative. To be a good digital photographer it helps if you have a basic knowledge of how a digital image is created – learning the 'vocabulary' of digital imaging will make your learning curve smoother and quicker; more important, however, is to have a thorough understanding of your equipment, particularly if you're either new to digital cameras or have 'upgraded' from a simple point-and-shoot to a more complex model. To the uninitiated, the often mind-boggling settings and options might seem surplus to requirements, but most are there for a very good reason and it pays to spend some time learning how they work and what they do. But this technical knowledge would come to nothing without having some idea about what to point the lens at. If you're reading this, then it's safe to assume that you have an appreciation for images and sights that you've seen and a desire to capture them in a way that most accurately reflects both how they appeared to you and what they meant to you.

The intention of the first three chapters is to provide you with a good technical knowledge of what your equipment is capable of producing. They offer hints on how best to creatively translate the scene in front of you into a distilled, two-dimensional replica that elicits the sense of time and place. Interspersed along the way are exercises that help you to put the theory into practice.

Post production

As you gain proficiency and confidence with your photography it's very likely that you'll want to assume greater control over your images once you've captured them. Even basic editing techniques such as cropping can make an image. The next two chapters provide a range of the most popular image-editing techniques and explain the basic concepts of how image-editing software works. They are by no means exhaustive, but should provide you with enough information to start experimenting and to see what these powerful applications can do.

The final chapter is brief rundown of how to go about showing and sharing your photographs – whether in print or online. New products and services are springing up regularly, and here we show you just a few of the many ways in which you can share the images you've worked at and enjoyed creating.

The Digital Environment

 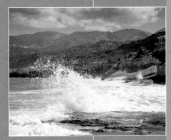

The 'language' of digital photography can sometimes seem at best baffling and, at worst, impenetrable. Is it really necessary to know all the technical jargon? While not essential, a grasp of the language of digital imaging will help you to navigate around the digital environment more smoothly, and to understand the technical requirements for a good-looking image. In this chapter, we'll look at the physical make-up of a digital image, and how it is captured and stored, and finish with a rundown of the most popular digital cameras and various lenses available to today's photographers.

Pixels and Resolution

All digital images are composed of minute blocks known as 'pixels', which is short for 'picture elements'. An individual pixel carries information that governs its colour, the strength of that colour, and how light the pixel is displayed or printed – three aspects that are usually referred to as the pixel's Hue, Saturation and Brightness (HSB) values. Because most digital images are made up of millions of pixels they are not usually visible to the naked eye, so when we look at a digital image we see the gradual and subtle changes in light and shade, and tone and colour as smooth transitions, or 'continuous tones'.

The number of pixels that an image has dictates the image's resolution (how much detail it contains) and the more pixels, the higher the resolution. The number of pixels also relates to the maximum print size, as more pixels mean you can achieve a larger print size. It is for this reason that resolution is one of the key factors governing the quality of digital images, but as we shall see later, the number of pixels in the image is by no means the only factor.

Print resolution

The resolution of a digital image is measured in pixels per inch (ppi), and the standard resolution to achieve photo-quality prints is 300ppi. So, if you know how many megapixels (millions of pixels) a digital camera has, it's simple to work out the optimum print size the camera is capable of producing. For example, let's assume a 12 megapixel (12MP) camera has a sensor with 4,288 pixels across by 2,848 pixels down (12 million pixels in total). To work out the optimum print size the camera is capable of, simply divide 4,288 and 2,848 pixels by 300ppi. This gives you 14½ and 9½. Therefore, a 12MP camera is capable of producing a print measuring 14½ × 9½in (37 × 24cm).

It's important to remember, however, that 300ppi is considered to be the optimum industry-standard resolution. Depending on the image, the camera, the printer and the intended size of the print (larger prints tend to be viewed from farther away), you may find that a resolution of 200ppi (or lower) can produce perfectly acceptable results.

Screen resolution

Because a computer's monitor has a standard resolution of either 72ppi (Windows) or 96ppi (Macintosh), images from a digital camera that are to be viewed on screen can be set to the same 72ppi or 96ppi resolution (which are extremely low in terms of print) and will still appear as continuous-tone images when viewed on screen.

In terms of image size, it follows that with a monitor resolution that is set to 1024 × 768 pixels, the image from the camera only needs to be 1024 × 768 pixels for the image to fill the screen completely.

Digital colour

Almost all the colours in a digital image are made by combining the three additive primary colours – red, green and blue – often referred to as the RGB colour model. For the vast majority of digital images, each of these three colours has 256 different shades ranging from 0 to 255.

Digitally, each of these colours is known as a channel, and a typical digital image that can display up to 16.7 million colours is often described

RIGHT The more pixels that are used to make up an image, the more detail is visible and the smoother the image appears. In this sequence of images, the number of pixels in the image has been halved each time, but the image's physical size has remained the same. As the number of pixels decreases so detail is lost and the pixels become increasingly visible – so that by the final image, it's possible to see the individual pixels that make up the image.

320 x 320 pixels 160 x 160 pixels

PPI versus DPI

You might occasionally see pixels per inch (ppi) incorrectly expressed as dots per inch (dpi) in some manuals, magazines or books when referring to resolution. The former specifically refers to the pixel dimensions of the image, whereas the latter is a measure of how many dots of ink a printer can render in one inch.

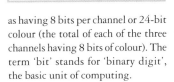

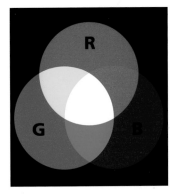

as having 8 bits per channel or 24-bit colour (the total of each of the three channels having 8 bits of colour). The term 'bit' stands for 'binary digit', the basic unit of computing.

Bits utilize the binary counting system in which '0' equals 'off' and '1' represents 'on'. A true 1-bit image would only be made of either '0' (off or black) or '1' (on or white), while a 2-bit image would be made up of '00' (black), '11' (white) and '01' (grey) or '10' (a different grey). By the time we get up to 8 bits, there are 254 additional greys in between black and white. Substitute the white, black and greys for one of the red, green and blue channels and you have a combination of different colours made up of 256 (red) multiplied by 256 (green) multiplied by 256 (blue), or 16.7 million colours in total.

ABOVE This screen shot taken from an image-editing program shows the image used in the sequence below broken into its three red, green and blue channels. All colour digital images use the 'RGB colour model' to show more or less all the colours the human eye can see.

ABOVE The additive primary colours – red, green and blue – are the colours of natural light, and can be used to make up just about all the colours our eyes are able to differentiate. This is why the RGB model is used in digital imaging to represent most of the colours of the visible spectrum.

MEGAPIXELS VERSUS PRINT SIZE

Camera	Pixels	Approximate print size at 300ppi	Approximate print size at 200ppi
7MP	3,072 x 2,304	10 x 7½in (25 x 19cm)	15½ x 11½in (39 x 29cm)
8MP	3,264 x 2,448	11 x 8in (28 x 20cm)	16½ x 12in (42x 30cm)
10MP	3,888 x 2,592	13 x 8½in (33 x 22cm)	19½ x 13in (49 x 33cm)
12MP	4,288 x 2,848	14½ x 9½in (37 x 24cm)	21½ x 14in (55 x 36cm)
13MP	4,160 x 3,120	13½ x 10½in (35 x 26cm)	20½ x 15½in (52 x 39cm)
16MP	4,608 x 3,072	15½ x 10½in (39 x 26cm)	23 x 15½in (58 x 39cm)
24MP	5,472 x 3,648	18 x 12in (40 x 40cm)	27½ x 18in (70 x 46cm)
51MP	8,688 x 5,792	29 x 19½in (74 x 50cm)	43 x 29in (109 x 74cm)

80 x 80 pixels

40 x 40 pixels

20 x 20 pixels

Camera Sensors

A digital camera's sensor takes on the same function as film does in a conventional camera. The sensor is where the camera's lens focuses the subject or scene and it is where the image is initially 'captured' before being converted to digital data and relayed to the camera's memory card for longer-term storage.

Anatomy of the sensor

The surface of the sensor is covered with a grid of millions of microscopic, light-recording devices called 'photosites'. Each photosite represents one pixel of the captured image. When manufacturers refer to a 16MP camera, the camera's sensor has approximately 16 million photosites.

One of the key components of a photosite is the photodiode, which converts light into an electrical charge – the stronger the light, the greater the charge. The array of photosites records the various light levels and converts them to cor--responding, electrical charges. These electrical charges are then amplified and sent to an analogue to digital (A/D) converter, where the charge is converted into digital data.

Seeing red, green and blue

Photosites record light intensity, but cannot differentiate between light of different wavelengths, and cannot, therefore, record colour. To generate a colour image, a thin filter is placed over the layer of photodiodes. Known as a colour filter array (CFA), the filter is a mosaic of red, green and blue squares, with each square sitting directly above a photodiode. With a CFA in place, each photosite is able to record varying intensities of red, green or blue light. To make up an almost full spectrum of colours, the camera's

processor analyses the colour and intensity of each photosite, then compares it with the colour and intensity of its direct neighbours. In this way, the processor interpolates, or 'estimates', a much more accurate colour for each pixel. This complex and sophisticated interpolation

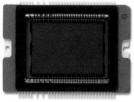

ABOVE A CCD sensor from a digital SLR. The image area measures 1 x ⅔in (2.54 x 1.67cm) but contains 16 million individual photosites, or pixels.

process is known as 'demosaicing' and is how each pixel in the image can display one of millions of colours.

Processing and formatting

Once the demosaicing interpolation process is complete, the image undergoes further processing, which may, for example, enhance colours, adjust brightness and contrast, or even sharpen the image depending on the camera's settings. Once these adjustments have been applied, the data is then formatted and fed to the camera's memory card for storage.

BELOW Millions of photodiodes cover a digital sensor. A coloured filter enables it to record colour, while the microlens optimizes the light from the camera lens.

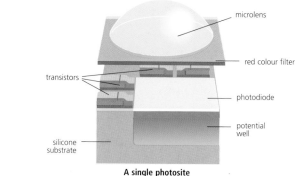

microlens
red colour filter
photodiode
potential well
transistors
silicone substrate

A single photosite

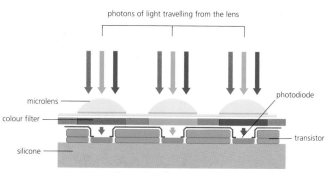

photons of light travelling from the lens

microlens
colour filter
silicone
photodiode
transistor

Three colour-filtered photosites

SENSOR TYPES

Almost all digital cameras use one of two types of sensor – a complementary metal oxide semiconductor (CMOS), or a charge-coupled device (CCD). Both sensors are made in a similar way and both capture an image as described on these pages. The principal difference between the two is how the information from each photosite is processed.

In a CCD, each row of photosites is connected or 'coupled'. After an image is taken, the accumulated charge value from each photosite is passed down row-by-row and read at one corner of the array before being deleted. The values are then fed to another chip for the analogue to digital (A/D) conversion to take place.

In a CMOS chip, each photosite is equipped with its own amplifiers and circuitry so that the charge value can be read directly from each individual photosite before passing directly to the A/D converter. Each type of sensor has its own benefits and drawbacks. Historically, CCDs, which are the more common of the two types, were more efficient at gathering light and tended to produce higher-quality images, while CMOS sensors were cheaper to manufacture and were more energy efficient.

In recent years, manufacturers of both systems have worked hard to improve their systems and it is now very difficult to say that one works significantly better than the other.

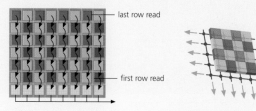

A 'coupled' CCD sensor array

A CMOS has individual amplifiers

last row read

first row read

THE COLOUR FILTER ARRAY (CFA)

As an image sensor's photodiodes can only recognize shades of grey, a colour filter array (CFA) is placed over the sensor so the photodiodes record red, green or blue light. There are twice as many green squares as either of the other colours, because the human eye is much more sensitive to green light. The most commonly used pattern in today's CFAs is called the Bayer pattern, after the Kodak technician who invented it.

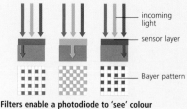

incoming light

sensor layer

Bayer pattern

Filters enable a photodiode to 'see' colour

Bayer pattern filter array

SENSOR SIZE

It's important to know that sensor sizes vary enormously from camera to camera and this can impact on the quality of digital images. For example, there are a number of digital cameras on the market featuring 12MP sensors, but this doesn't mean that the sensors are the same size. This is quite significant because the physical size of the sensor determines the size of its individual photosites. To fit 12 million photosites on a smaller sensor they have to be much smaller. Smaller photosites are less sensitive to light, less able to capture very dark or very light areas of a scene accurately, and can result in increased levels of 'noise' (see pages 14–15). The images show the relative size of the common sensors used in today's digital cameras. Some advanced dSLRs have 'full-frame' sensors, which are the same size as a frame of 35mm film.

Designated sensor type	Sensor's dimensions

1/2.5in sensor = 5.8 x 4.3mm

1/1.8in sensor = 7.2 x 5.3mm

2/3in sensor = 8.8 x 6.6mm

Typical dSLR sensor = 23.5 x 15.7mm

Full-frame dSLR = 36 x 24mm

ISO, Sensitivity and Noise

Those who are familiar with film photography will know that different films have different ISO (or ASA) ratings. The ISO (International Standards Organization) rating determines how sensitive the film is to light – the higher the rating, the more sensitive the film. Similarly, the sensor in a digital camera can also be adjusted to be more or less sensitive to light, and helpfully this is given as an equivalent ISO rating or setting. A compact camera, for example, may have ISO settings of 125, 200, 400, 800 and 1600, while a digital SLR will often feature incremental settings of 100, 200, 400, 800, 1600, 3200, 6400, 12800 and 25600. As with ISO ratings for film, the higher the digital camera's ISO setting, the more sensitive the sensor is to light, but in reality this means the signal created by light striking the sensor is amplified to a greater degree.

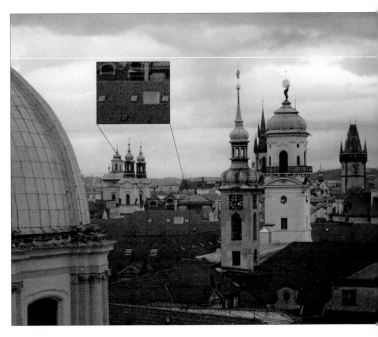

dSLR at ISO 100

dSLR at ISO 200

dSLR at ISO 400

dSLR at ISO 800

dSLR at ISO 1600

dSLR at ISO 3200

ABOVE This shot of rooftops over Prague was taken in late afternoon, low-light conditions. A high ISO setting of 800 was used to ensure a shutter speed of ¹⁄₆₀ sec could be used to avoid camera shake. The result, however, is a 'noisy' image, characterized by an unpleasant speckled effect that is more noticeable in the darker areas of the red roof tiles, clearly shown in the inset image.

LEFT This series of images shows how 'noise' increases with higher ISO settings. These images were taken from a dSLR. Those on the opposite page were shot with a high-specification compact camera. At a low ISO and small print size there's little difference between the two.

Low light

The benefit of being able to increase a camera's ISO setting is apparent in low-light situations, such as indoors or outdoors in dark or very overcast conditions. In such circumstances (and where using flash or a tripod is not an option), if the camera is set with a low ISO setting of 50 or 100, the camera would have to have a slow shutter speed of, for example, $1/8$ or $1/15$ of a second (sec), or an increased lens aperture size (see pages 76–77). At these slow shutter speeds you run the real risk of the camera moving slightly as you take the picture, which results in a blurry image. This usually undesirable effect is commonly referred to as 'camera shake'. Alternatively, your subject may move during the exposure, again resulting in a blurred image.

High ISO

There is a direct correlation between shutter speed and ISO setting. By increasing the ISO setting, the shutter speed increases proportionately, so that, for example, from $1/15$ sec at ISO 50, the shutter speed increases to $1/30$ sec at ISO 100, $1/60$ sec at ISO 200, $1/125$ sec at ISO 400 and $1/250$ sec at ISO 800. At these later speeds, you'll avoid camera shake and 'freeze' most human movement. You can adjust the ISO between shots to suit the shooting conditions.

Noise

Unfortunately, there is a drawback to using high ISO settings and comparisons can be drawn with

conventional film photography. Photographers who use 'fast' film (film with a high ISO rating), will end up with speckled or 'grainy' prints. Likewise, in digital photography, increasing the ISO setting amplifies the electronic signal from the sensor, but will also amplify the background electronic 'noise' that is present in the camera's circuitry and result in interference – think of it as 'visible hissing'. This distorts the image signal and creates a speckled or 'noisy' image, which, unlike certain film 'graininess', is rarely pleasant to look at.

Low ISO

It's sensible to use the lowest ISO setting that will still allow a fast enough shutter speed to avoid camera shake and resulting blurred images. Alternatively, use a tripod, as you'll be able to use a lower ISO setting and slower shutter speed than is possible when holding the camera. If you're using slow shutter speeds use the camera's 'Noise Reduction' facility if it has one.

Noise and sensor size

Larger sensors, such as those found on digital SLRs (dSLRs), are less prone to 'noise'. This is because the larger photosites found on such sensors collect light more effectively and thus don't need as much amplification (high ISO) to capture a poorly lit scene as a small sensor. In addition, because photosites are set farther apart on larger sensors, increasing the ISO setting will cause less overall interference, and so create less noise. Therefore, you can obtain acceptable results from a dSLR when the ISO is set at 800 or 1600 – settings that are unavailable on many compacts.

Auto ISO

Most cameras will have an automatic ISO option. When selected, the camera will monitor the shutter speed and if the speed drops below the point at which camera shake may occur (usually around $1/30$ sec), it will automatically increase the ISO setting. This can help you avoid taking blurred images, but it can also introduce noise. On some cameras the automatic ISO range is limited, so the camera avoids using very high ISO settings. Remember, manually set the lowest possible ISO if you're using a tripod as there's no danger of camera shake and you'll get noise-free images.

▼ **BELOW** At higher ISO settings (or larger print sizes), the differences between a digital compact camera's small sensor and the larger sensor of a dSLR become much more obvious. The compact camera suffers from far more 'noise', resulting in coloured speckles appearing in images.

Compact at ISO 100

Compact at ISO 200

Compact at ISO 800

Compact at ISO 3200

File Formats

As the light from a captured image passes through a digital camera it is turned into digital information. For this to be safely stored and retrieved, it must be digitally organized, or formatted. For those new to digital photography, the file formats and associated quality and size settings available in a camera's menu can be bewildering – not helped by the use of technical-looking abbreviations such as .JPG or .TIF – but in reality they are quite straightforward.

JPEG

Pronounced 'jay-peg', the JPEG format (.JPG/.jpg being the file extension) is the most widely used image format due to its versatility. JPEG stands for Joint Photographic Experts Group after the committee that developed the format. JPEGs are able to 'compress' the image files and so reduce their size. This allows you to fit more images on to the memory card. Most digital cameras use the

▶ **RIGHT** Basic JPEG files produce the smallest files. Fine compression gives the best JPEG image. Normal files are a good compromise.

JPEG format and allow you to select the amount of compression applied to the image. This is often expressed as 'High/ Medium/Low' or 'Fine/Normal'. However described, it should be clear which setting will apply the most compression, as the more the image is compressed the greater the amount of picture information that is lost.

Sophisticated interpolation algorithms, known as 'lossy' compression, assess which pixel information can be discarded without overly degrading the image. The trade-off for having more images on a memory card is reduced image quality, but depending on how the images are going to be viewed, the level of detail lost may be negligible. You'll need to

experiment with the settings to find the most appropriate level of compression suitable for your needs. If storage space is an issue, you'll want a high level of compression, but if image quality is the overriding factor, you should opt for a low level.

Resolution

Don't confuse the compression setting with the resolution setting (in other words the physical dimensions of the image). The menus for both are often combined into one setting 'Large/ Medium', or 'Small/Fine'. The first refers to the image size (in pixels) and the second refers to the amount of compression applied. More compression means smaller files, but lower quality.

Basic JPEG compression **Fine JPEG compression** **Normal JPEG compression**

IMAGE-RECORDING QUALITY

This table shows image settings, resultant file and print sizes (at 240ppi) and the number of images that can be stored on a 500MB card for a typical 8MP camera.

Image-recording quality	File format	File size in pixels and MB	Print size	No. of shots
Large/Fine	JPEG	3,504 x 2,336 (3.6MB)	A3 or larger	132
Large/Normal	JPEG	3,504 x 2,336 (1.8MB)	A3 or larger	266
Medium/Fine	JPEG	2,544 x 1,696 (2.2MB)	A5 > A4	224
Medium/Normal	JPEG	2,544 x 1,696 (1.1MB)	A5 > A4	442
Small/Fine	JPEG	1,728 x 1,152 (1.2MB)	A5 or smaller	390
Small/Normal	JPEG	1,728 x 1,152 (0.6MB)	A5 or smaller	760
RAW	RAW	3,504 x 2,336 (8.7MB)	A3 or larger	54

RAW + JPEG

Some cameras, particularly the higher-end models, provide a RAW and JPEG setting, usually called 'RAW + JPEG'. When using this setting, the camera will produce two files for every image captured – a RAW file, which is the unprocessed data recorded by the camera's sensor, and which can be saved on to a computer for further editing, and also a JPEG image that can be sent directly to a printer.

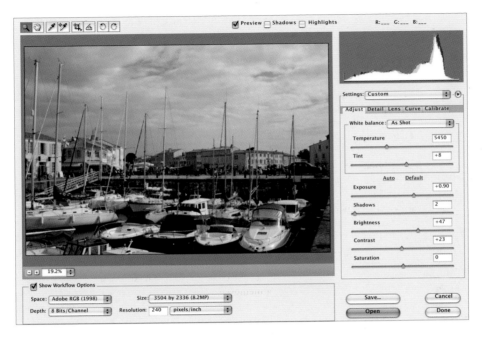

Processing

When images are saved as JPEGs, they will usually be adjusted by the camera's internal processors before being saved to the memory card. The specific processes and the level at which they're applied will depend on the camera and the settings you choose, but colours may be boosted, contrast and brightness levels adjusted, and the image may be sharpened. The idea behind these internal processes is that they help to ensure that any images stored on the memory card can be printed without further digital editing work on a computer. Most cameras will allow you to adjust the level of processing, but it's important to try out the various settings.

TIFF

The TIFF format (.TIF/.tif) is rarely available on digital cameras, but it's an important format as it is the industry standard. Most photographs that are published in books and magazines are saved as TIFF files, and almost all image-editing software allows you to save files as TIFFs. The reason TIFF is an important format is that no information is lost when the image is saved (unlike JPEGs). In other words, it is a 'lossless' file format. As a result, TIFFs are capable of producing higher-quality prints, but file sizes tend to remain large and so use up more storage space.

RAW

The third commonly used format is RAW; the file extension differs depending on the manufacturer. Canon use the file extension '.CR2'; other manufacturers will have their own extension names. RAW files comprise the unprocessed data exactly as recorded by the camera's sensor at the time of shooting. The benefit of RAW is that it can record up to 14-bit colour (compared with JPEG's 8-bit), which translates into billions of colours (compared with JPEG's 16.7 million). Having all this additional information gives you far greater control over adjustments to colour, contrast, brightness, tone and so on when you edit your images using image-editing software. Furthermore, the fact that RAW images are not compressed in-camera like JPEGs means that you can use your computer's powerful processor to make adjustments rather than relying on the camera's smaller processor. The drawback is that RAW images cannot be printed directly from the camera or card.

Memory cards

All cameras have memory cards. These come in a variety of shapes and sizes depending on the make and model, but all have storage space measured in gigabytes (GB). If you're buying a digital camera for the first time, it's probably wise to invest in a memory card that is capable of storing more images than the one that will have been provided with the camera, so you're less likely to run out of storage space before having to download the images.

Camera Phones and Compact Cameras

Imaging sensors have come a long way in the last few years. At around the year 2000, few digital cameras boasted sensors with more than a million pixels, whereas in the space of 10–15 years, mobile phones with 10MP cameras became commonplace, and many of today's compact cameras feature 14MP sensors or more.

Camera phones

From a purely photographic point of view, camera phones have some major disadvantages. The lenses are usually wide angle and fixed-focus, so they're designed to capture a broad view and ensure as much of the scene as possible is in focus. Although this helps you get sharp images, there's very little creative control. Although with the more recent phones it's possible to 'zoom' in to frame images, this generally means enlarging the image (known as 'digital' zoom) rather than employing a true optical zoom. In addition, the sensors in a

camera phone have to be very small, leading to 'noisy' images.

Setting these disadvantages to one side, however, a camera phone's portability, ease of use, and the fact that many people carry a camera phone with them at all times, encourages the taking of pictures. And as technology advances yet further – there are camera phones with 41MP sensors and 3x optical zooms – increasingly impressive photographic results will become attainable.

Compact cameras

A step further up the photographic ladder from camera phones is the plethora of compact digital cameras currently on the market. These vary from the inexpensive, 'entry-level' models to the feature-packed, high-specification and relatively expensive 'super' compacts. Basic compacts usually have a simple 3x optical zoom and are unlikely to have a separate viewfinder or a manual focus setting. They provide a few standard shooting modes, such

as 'sport', 'landscape' and 'portrait'. However, even in the hands of someone with little photographic experience, most basic 'point-and-shoot' cameras can produce good-quality holiday snaps up to large postcard size.

At the other end of the spectrum, there are compacts that feature large 20MP sensors, 15x optical zoom, a vast array of shooting modes, manual override, continuous shooting, image stabilization, and so on. In the right hands, and with favourable conditions, these super compacts are capable of producing photographs that are comparable to those of many digital SLRs.

Noise, dynamic range and response time

There are, however, some definite drawbacks to most compact cameras. The first is the perennial problem of noise. There's no getting away from the fact that, in many conditions and particularly when light is low, noise will be more apparent in images created by small sensors with small photosites, as found on the great majority of compact cameras.

The second issue with smaller sensors is their narrow dynamic range – their ability to record detail in areas of shadow or highlight. Compared with larger sensors, small sensors will tend to make more shadow areas black, and more highlight areas white.

The final drawback can be most noticeable to photographers moving from film to digital compacts. The first thing many people notice is the time it takes for the digital compact camera to actually take the picture once the shutter button has been pressed. Known as 'shutter lag', the delay is caused by the camera focusing, setting the correct exposure,

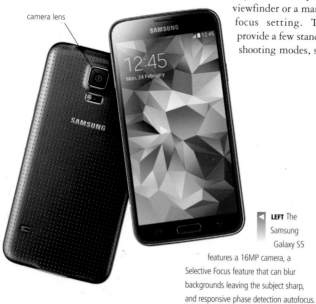

camera lens

LEFT The Samsung Galaxy S5 features a 16MP camera, a Selective Focus feature that can blur backgrounds leaving the subject sharp, and responsive phase detection autofocus.

On/Off switch
movie record
shutter release
flash

Nikon

COOLPIX

lens

4-way control button

Nikon

LCD screen
image playback

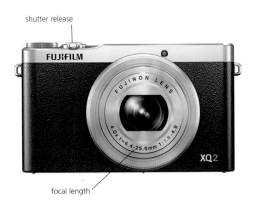

shutter release

FUJIFILM

FUJINON LENS

4.0x f=6.4-25.6mm 1:1.8-4.9

XQ2

focal length

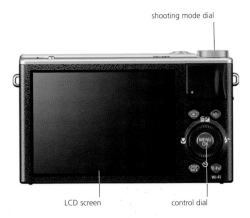

shooting mode dial

MENU OK
Wi-Fi

LCD screen
control dial

▲ **ABOVE** An entry-level compact, Nikon's S33 is a 13MP waterproof and shockproof camera ideal for family holidays.

and then 'charging' the sensor in preparation for capturing the image. In some entry-level compacts this can take up to 0.5 seconds – often long enough to miss a great shot, especially if it is a person's expression or pose.

Convenience

On the other hand, many of the more advanced compacts exhibit very little lag, produce good-quality A4 or even larger prints and provide the more experienced photographer with

▼ **BELOW** The Fujifilm XQ2, despite its compact size, features a large CMOS sensor similar to those found in many dSLRs. It's an ideal 'walkaround' camera for enthusiasts.

sufficient manual control for more creative images. In addition, many compact cameras are able to shoot bursts of relatively high-quality video with sound. These features, combined with their relatively low cost and the fact that most people want to pop a camera in their pocket rather than carry a bagful of equipment, are the

reasons why more compacts are sold than any other type of digital camera.

Before choosing a model, think about your photographic needs. A digital SLR is overkill for fun, quick holiday snaps and may attract unwanted attention; an entry-level compact, on the other hand, is unlikely to provide stunning A3 landscapes.

Zoom lenses

A compact camera's zoom lens is usually described as being 3x, 5x or 10x. For a 5x zoom, this means an object will appear five times larger when the lens is set at its maximum setting than when it appears at its widest setting. Digital SLR zoom lenses are described using focal length – from a wide-angle setting (e.g. 35mm) to a telephoto setting (e.g. 105mm). You may also see an impressive-looking 'digital zoom' figure, but since the zoom is artificially created by the camera's software, it's best to ignore this as, in general, the more digital zoom you use, the more you degrade the final image.

Bridge, Digital SLR and Mirrorless Cameras

Bridge cameras

Bridge, hybrid or 'prosumer' cameras, as they are also known, resemble dSLRs in several respects. So called because they 'bridge' the wide gap between compacts and dSLRs, bridge cameras are much larger than compacts and, in terms of shape, they can easily be mistaken for a dSLR.

Fixed lens

One of the key differences between bridge cameras and dSLRs is that the lens on a bridge camera is fixed, and so is not interchangeable. For this reason, most bridge cameras have powerful zoom lenses ranging from 10x (25–250mm equivalent) to 60x (24–1440mm) so that most shooting opportunities are catered for, from wide-angle landscapes to close-up sport or nature photography.

Manual control

Like dSLRs bridge cameras offer a good level of manual control, from manual focusing to complete manual exposure. This provides greater creativity and encourages experimentation. In addition, bridge cameras respond almost as quickly as dSLRs and behave very much like them when in use.

Electronic viewfinders

Unlike dSLRs, all bridge cameras have electronic viewfinders (EVFs). These relay exactly what the camera's lens is focusing on and framing – in fact, EVFs display exactly the same view as that shown by the camera's rear liquid crystal display (LCD). In this way, EVFs behave more like a dSLR's viewfinder, except that there is a slight delay as the image is digitized and relayed to the viewfinder.

In terms of sensor size, bridge cameras are usually fitted with similar-sized sensors to those found in the higher spec compacts, so are capable of producing good-quality images in most bright conditions, but will struggle in low light.

Digital Single Lens Reflex

The key differences between dSLRs and other types of digital camera are the ability to change lenses, bright, 'instant' viewfinders, large sensors and negligible shutter lag.

Lenses

Being able to use lenses of different focal lengths, such as 10–20mm wide-angle zooms, 100–300mm telephoto zooms or even fixed length lenses such as a 60mm macro lens, allows you to use the same camera body for extreme wide-angle landscape or interior shots, and for close-up action sports or nature photography. Lenses vary enormously in quality and price, and owning a dSLR body allows you to build up a selection of good-quality lenses that will resolve more detail than the 'mega-zoom' lenses that are trying to cover both wide angle and telephoto.

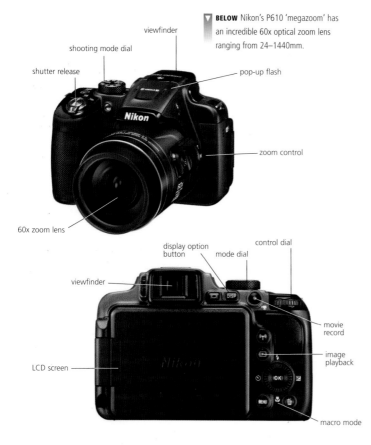

▼ **BELOW** Nikon's P610 'megazoom' has an incredible 60x optical zoom lens ranging from 24–1440mm.

viewfinder

shooting mode dial

shutter release

pop-up flash

zoom control

60x zoom lens

display option button

mode dial

control dial

viewfinder

movie record

image playback

LCD screen

macro mode

Instant viewfinders

All dSLRs have instant and bright viewfinders. This is because the light from the scene passes through the lens via a mirror set at 45° and then through a prism and out through the viewfinder. Thanks to this configuration of mirrors and prisms, the viewer is seeing exactly what the sensor will be exposed to when the mirror flaps up as the shutter release button is depressed to take the photo. This allows for more accurate framing and easier composition, particularly in poor light, when electronic viewfinders have trouble relaying a dark scene and also suffer from a slight lag.

Sensor size and shutter lag

At the risk of labouring the point, the large sensors used in all dSLRs provide almost noise-free images up to ISO settings of 800 or even 1600. Even at ultra-high ISO settings such as 25000, when viewed at normal viewing distances, noise is often difficult to detect. Having the option to use a much wider range of ISO settings allows the photographer to try a greater variety of exposure settings and experiment with depth of field (see pages 168–175) and other creative techniques. Also, dSLRs do not suffer from noticeable shutter lag, making it easier to catch fast-moving action.

The combination of high-quality (albeit expensive) lenses with large sensors results in extremely high-quality images. If you want the best possible images and intend to photograph a variety of subjects in various shooting conditions, a dSLR with a selection of lenses is far and away the best option.

REFLEX VIEW

The term 'SLR' stands for 'single lens reflex' and refers to the camera's viewfinder system of a mirror and prism that allows you to look through the lens to compose your photographs. Essentially, this means that what you see in the viewfinder is what you get in the final picture.

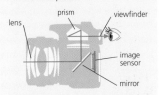

Light (red) passing through a dSLR

Mirrorless

Mirrorless interchangeable lens cameras (MILCs) are the most recent class of digital camera to hit the market. As their name suggests, these cameras lack the reflex mirror of a standard dSLR and are therefore much lighter and smaller. However, despite their compact size, mirrorless cameras can be fitted with different compatible lenses, from wide-angle to telephoto, offering almost the same versatility of a dSLR.

One distinct advantage of mirrorless cameras over most bridge and compact models is that they feature larger sensors, thereby gaining all the benefits in image quality associated with big sensors. In fact, most mirrorless cameras feature sensors of comparable size to many dSLRs. The larger the sensor, the more expensive the camera. It's this winning combination of portability, versatility and excellent image quality that have made mirrorless cameras the largest growing camera class. However, one drawback to mirrorless cameras is that they lack the bright optical viewfinder found in all dSLRs, instead relying on an EVF or just a rear LCD screen with which to compose images.

RIGHT AND BELOW With its large sensor and interchangeable lenses, a dSLR is the best option if you want to take high-quality photographs of a wide range of subjects in a wide range of conditions.

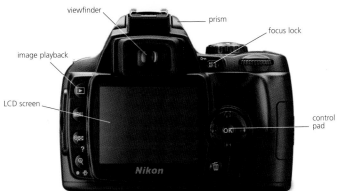

The Camera Lens

Since the advent of digital cameras, manufacturers – and to a certain degree, camera magazines and websites – have been preoccupied with the performance of the cameras' internal components, especially the sensors and pixel count. Anyone new to digital photography could be forgiven for thinking that picture quality was ultimately down to the number of pixels crammed on to the imaging chip. In many ways this is unsurprising given the relative novelty of the technology and the amount of money spent on research and development in that specific area of digital imaging.

However, more experienced photographers are aware that the obsession with pixel count is something of a red herring. While sensors are a big piece of a camera's jigsaw puzzle – they are the part of the camera that records the image, and it's vital that they can record as wide a dynamic range as smoothly as possible – many would argue that the lens that gathers the light information in the first place is equally as important, if not more so.

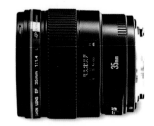

ABOVE This fixed 35mm lens would be a wide-angle lens in a 35mm film camera or 'full frame sensor' dSLR. However, because sensors are smaller in most dSLRs the effective focal length is around 50mm.

Lens technology

Although it would be difficult to argue that lenses have undergone a similar revolution to camera bodies, huge amounts of money have been spent on developing lens technology. At the turn of the century, if you said you could produce a lens that covered a zoom range of 28–300mm, weighed less than 1.1lb (500g), produced acceptable results throughout its focal length range and had the ability to

ABOVE Macro lenses have the ability to focus extremely close to objects and so provide a greatly magnified image. True macro lenses have a ratio of 1:1 (1:1 will be printed on the lens barrel).

focus within 1.6ft (0.5m) to boot, no one would have taken you seriously – yet such lenses now exist.

Modern lenses are lighter, sharper, focus faster and are less prone to flare than ever before. Throw in the fact that many now have image stabilization (or vibration reduction) systems that allow you to hand hold a camera using shutter speeds as low as $^1/15$ sec and still obtain sharp images, and it would be fair to say

Aperture range

A lens's maximum aperture is usually printed either on the barrel or the front of the lens. For example, a lens with a maximum aperture of f/2.8 will feature the figures 1:2.8. For zoom lenses, an aperture range is often provided, such as 1:4–5.6. This indicates that at the shorter focal length, such as 70mm for example, the aperture will open up to f/4, while at the longer focal length of the zoom, such as 300mm, the maximum aperture is reduced to f/5.6. These figures are important as they

indicate how 'fast' the lens is – the wider the possible aperture, the faster the lens. In other words, given the same lighting conditions a lens with a maximum aperture of f/2.8 will allow faster shutter speeds to be used, while still obtaining a correct exposure, than a 'slower' f/4 lens. The faster the lens the greater the creative control the photographer has, as it allows for a greater number of shutter/aperture exposure combinations, in turn resulting in greater control over depth of field and the shutter speed (see pages 76–77).

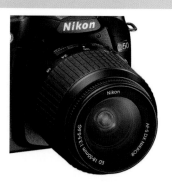

ABOVE This zoom lens has a wide aperture setting ranging from f/3.5 to f/6.5.

that photographers have never had it so good. Inevitably however, such technology does come at a price. There are lenses on the market today that cost the combined equivalent of a decent compact camera, printer, computer and all the software that is needed to edit images.

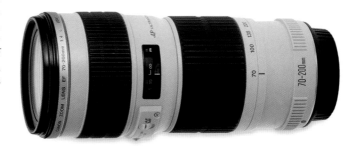

▶ **RIGHT** There are numerous types of zoom lens available for dSLRs. This 70–200mm zoom lens from Canon has the ability to zoom 3x.

OPTICAL LENS ELEMENTS

All lenses, whether interchangeable SLR lenses or those fixed to compact or hybrid cameras, are made up of a series of individual lenses known as 'elements'. Elements are one of either two types – diverging or converging. Both types of element exploit the fact that as light passes through glass (or clear plastic) with non-parallel sides, it will change direction. In a converging lens, the light will bend more at the thinner (top and bottom) parts of the lens than it does toward the thicker centre. This way the image converges to a point (known as the focal point) at some distance from the lens, and, if left, will continue to form an upside down image on any surface, such as an imaging sensor.

However, because of the optical aberrations that result from a single converging lens, a camera's lens employs a series of diverging and converging elements to try and correct these aberrations as far as possible. Other elements are also used to alter the focal length of a lens.

The number and exact shape of the elements in a camera lens, together with the space between each element and the type of glass or plastic used in their manufacture, are determined by the lens designer, who will use a computer to ensure that all the measurements are as precise as possible. The glass components are ground and polished and any plastic elements moulded to

extremely fine tolerances before being coated with anti-reflective materials. They are then assembled in the lens barrel together with the iris diaphragm (which controls the aperture), all of which are then optically aligned.

The overall construction must allow the optical elements to move in a controlled way so that the lens can focus accurately and consistently and, if necessary, allow a change in focal length in the case of zoom lenses. When you consider the fine tolerances and precise engineering used to create a lens and take into account that it must be strong enough to withstand minor knocks, it's not surprising that it can cost a great deal of money.

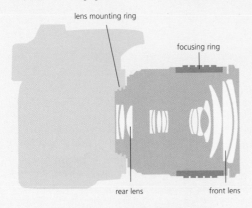

Typical lens array for a standard SLR lens

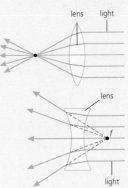

Light passing through a convex lens (top) and concave lens (bottom)

Choosing Lenses

The quality of any camera's lens will ultimately affect the overall image quality, yet all too often we overlook one of the most important elements of a camera system.

Compact and hybrid cameras

If you're looking to buy a compact or bridge camera, or intending to upgrade your existing one, make sure you find out as much as you can about the quality of the lens. Many such cameras come fitted with 'superzooms', offering as much as 60x magnification (equivalent focal length 20–1200mm). This is a big zoom, and the lens is unlikely to perform equally as well throughout the range. If you can, find out at what focal lengths the lens performs best, and see if that fits in with your photographic interests. If sports photography is your passion and you need to get close to the action, make sure the lens performs well at longer focal lengths. By contrast, if you're more interested in landscapes, you should ensure that the shorter focal length settings are its strong point.

▼ **BELOW** A diagram to show how moving the position of the same three lens elements can modify the path of light through a zoom lens.

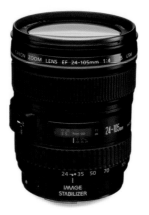

24–105mm lens

14mm lens

Alternatively, consider whether you need such a long zoom in the first place. Tempting as the figures are, a 3x (28–85mm) or 5x (28–140mm) lens may be perfectly adequate for your needs, in which case you may find a camera that, although featuring a lens with a smaller range, has superior quality glass and performance. As always, before spending large amounts of money on camera equipment, do as much research as you can. There are plenty of excellent magazines and websites that exist offering unbiased advice.

dSLRs

For those of you who have made the leap to a dSLR, the issue of lenses is much more complicated – and, unfortunately, more expensive. One of the great advantages of a dSLR is that the lenses are interchangeable and usually provide excellent image quality. On the one hand, this is a good thing, as it allows access to a vast variety of lenses, with focal lengths ranging from around 10mm to 500mm (even 1200mm lenses are available). The downside is that the choice (and prices) can be bewildering.

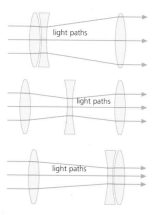

light paths

light paths

light paths

Zoom: digital versus optical

Some digital cameras boast an optical as well as a digital zoom, and the figures are often combined to make the camera's overall zoom capability sound very impressive. However, be cautious, as there is a distinct difference between an optical and digital zoom. When you use the optical zoom, the lens actually magnifies the image that is captured by the sensor; so as long as the lens performs well the image will be well defined. Digital zoom works by zooming in on the actual pixels already captured by the camera. So, although you're still magnifying the image, the camera is only magnifying the size of the pixels, which will usually lead to a fuzzy, degraded image. Avoid using digital zoom if you can.

OPPOSITE AND BELOW There are two types of lenses for dSLRs that you will come across. 'Zooms' cover a range of focal lengths in one lens, while 'primes' have a single, fixed focal length.

55–200mm lens

Zoom versus prime

One of the big questions for SLR owners used to be whether to buy zoom or 'prime' lenses (lenses with a fixed focal length). While zooms offered much greater flexibility, primes were far superior in terms of image quality. However, the general improvement in lens technology, construction and components in recent years has seen a great leap in the image quality offered by zoom lenses, to the point where their convenience outweighs issues of quality.

The one area in which primes do still outclass zooms is their speed. Prime lenses are typically much faster (have a wider maximum aperture) than zooms, and so offer greater creative control. On the whole, however, improved high ISO performance and image stabilization do mean that you get better value for your money with zooms than a series of primes. With two good-quality zoom lenses covering, say, 24–70mm and 70mm–300mm equivalent focal lengths (efl), you'll have most photographic situations covered from wide-angle landscapes to telephoto sports.

Upgrading

With camera technology seeming to move so fast these days, it's tempting to save up and upgrade your camera as soon as the latest version becomes available. But before doing so, take a long look at the supposed benefits. They may be an additional megapixel or two (which doesn't translate to much), or more program settings (which you may never use), in which case, consider investing the money in a new lens instead. Perhaps you could increase the focal range of your system by buying a really wide-angle

ABOVE The professional quality lens features image stabilization to help reduce camera shake. Tiny gyros in the lens are able to sense movement and move one of the lens elements to counter it.

lens. A wide-angle lens (such as efl 15–20mm) opens up all sorts of new compositional opportunities.

Alternatively, if you're happy with your range of focal lengths, trade in an existing lens and buy a higher-quality version – you'll notice a bigger improvement in image quality than with a slightly modified camera.

TELECONVERTERS

One way to add focal length to an existing lens is to fit a teleconverter. These effectively increase the focal length of the lens to which they're attached. Teleconverters are available for some makes of compact camera and screw on to the end of the lens, while others are designed for interchangeable lenses and sit between the dSLR body and the lens. The amount of magnification provided by a teleconverter depends on the specific type, but generally they provide a magnification of between 1.4x and 3x. These optical devices can be a less expensive way of increasing focal length, but can slow down the camera's autofocus system and reduce the maximum aperture setting of the lens.

Canon teleconverter

Nikon teleconverter

Basic Shooting and Composition

Having learned about the anatomy of a digital image, and the location of the main controls on your camera, it really pays to gain a good understanding of what these controls do to make the most of your photographic equipment. It may be tempting to leave the camera on fully automatic, but if you spend some time experimenting with the settings, you'll quickly see an improvement in the quality of your images. In this chapter, you'll find some basic tips and hints on composition – these are intended to act as pointers to help you start to think in visual terms and to find your own unique style.

Holding a Camera

Whether you own a small compact or are shooting with a dSLR fitted with a long telephoto lens, holding and supporting the camera properly will help to prevent camera shake.

Ultra compacts

Many 'ultra' compact-style digital cameras offer an LCD screen on the back of the camera to help you compose pictures. However, to use the screen, the camera has to be held away from the body, which can contribute to camera shake. In addition, many 'ultra' compacts are often smaller than the palm of your hand. People with larger hands sometimes hold the camera with the very tips of their fingers to avoid covering the lens. Although understandable, this can lead to camera shake as well.

Compacts

For compacts with a viewfinder, it's recommended that you use the viewfinder wherever possible. This will conserve power, help you keep the camera steady, and, in bright, sunny conditions, you will have a better chance of seeing the subject. The only time you really need to use the screen to compose a shot is when taking a close-up, as the offset viewfinder shows a somewhat different view to the one the lens is actually 'seeing'. This can lead to the subject being photographed slightly off-centre.

Digital SLR and bridge cameras

For those not used to a dSLR, its size and weight may come as a surprise. However, it's these aspects of dSLRs that make them stable and easier to hold steadily.

Many bridge cameras have a similar layout, with a long lens centred in the camera body, so much of the advice for holding a dSLR applies to bridge cameras. However, many such cameras are slightly smaller and lighter than a true dSLR.

Shutter release

Whatever type of camera you're using, avoid 'stabbing' the shutter release button. Instead, gently squeeze the shutter release button until the camera takes the photo.

Just before you capture the image, it also helps if you breathe in slightly and hold your breath. This will stop your chest moving up and down, which can potentially cause the camera to move just as you're taking the shot, which may well result in a blurred or out-of-focus photograph.

▲ **ABOVE** Some ultra compact cameras don't have viewfinders and are very narrow and small. The best way to support such cameras is with both thumbs resting on the base of the camera, and both index fingers on the top.

▲ **ABOVE** To keep the camera steady, use most of both fingers and thumbs, not just the tips. Also note how the remaining fingers are folded into the palms to avoid getting in the way of the camera's lens or flash unit.

▲ **ABOVE** If you're using a compact without a viewfinder, avoid holding the camera with both arms outstretched, as this increases the risk of camera shake. For a more stable position, tuck your elbows into your body.

| Landscape grip | Portrait grip | Lower-angle grip | Alternative lower-angle grip |

▲ **ABOVE** Viewfinder compacts are bulkier than ultra compacts, allowing you to grip the camera with all the fingers of the right hand. Keep the fingers of the left hand clear to avoid them wandering in front of the lens.

▲ **ABOVE** When turning the camera 90° to take a portrait shot, grip the top of the camera with the right hand, which will also be used to press the shutter release button. Support the bottom of the camera with the left hand.

▲ **ABOVE** When taking a shot from a lower angle, don't just crouch down, or you'll run a high risk of camera shake. If the ground is dry, sit down cross-legged and rest the part of your arm just above the elbows on your knees.

▲ **ABOVE** If the ground is too wet to sit on, kneel on one knee and rest your arm on your knee. Don't rest your elbow directly on your knee as you'll end up with bone contacting bone which is likely to cause camera shake.

Digital SLR lenses

The lens of a dSLR plays a key role in how you handle the camera. The left-hand base of the camera should rest against the fleshy part of the left palm beneath the thumb. Wrap one, two or three fingers of the left hand around the barrel of the lens, depending on its length and how comfortable you feel, to support the camera/lens, manipulate the focus and, if using a zoom lens, the zoom ring. In this way you can frame, compose and focus the shot without taking your eye away from the view-finder, while your left hand makes adjustments to the camera settings.

HANDLING A TELEPHOTO LENS

With a long telephoto zoom lens attached, the position of the hands is much the same as when using a shorter focal length. However, depending on the length of the lens, the camera may feel more balanced and stable if the entire left hand is used to support the lens, with only the right hand supporting the camera body.

With longer lenses, it's also a good idea to support yourself against a wall, or try kneeling or even lying on the ground to give yourself a little extra stability. This is especially important when using long focal length lenses. As well as holding the camera safely and steadily, it's also important to ensure that you use an appropriate shutter speed for the focal length of the lens, as this will also help you avoid camera shake.

Shooting Video with a Digital SLR

Today, shooting HD video with a dSLR is now widespread. Entire TV shows are now recorded using dSLRs. When coupled with good-quality, fast lenses, these cameras, thanks primarily to their large sensors, provide video comparable to much more expensive, bulkier, dedicated professional video cameras.

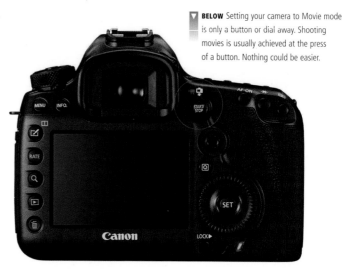

BELOW Setting your camera to Movie mode is only a button or dial away. Shooting movies is usually achieved at the press of a button. Nothing could be easier.

Settings

In many respects shooting video on your dSLR is as simple as selecting the video mode and pressing the start button. However, depending on your particular make and model of camera, there are a few things to consider that will improve the quality of your movie footage.

PAL vs NTSC

You may find lurking in your menus the option of choosing between PAL and NTSC. These are alternative television transmission standards. PAL (625 vertical lines) is the standard used in Europe and Asia, while NTSC (525 lines) is used in the Americas. Modern computer monitors will display both perfectly happily and you're unlikely to tell the difference, but if you're intending to eventually burn your movie to DVD to watch on TV, choose the appropriate standard.

Frame rate

Depending on which standard you use, and also what options are available to you with your specific camera, you may be given a choice of frame rates (measured in frames per second) – usually 25fps/50fps for PAL, and 30fps/60fps for NTSC. You may also see a 24fps option. In Europe the 25fps setting is the best all-round setting. Use 50fps (60fps in NTSC) for fast-moving action or if you want to create a slow-motion

sequence. The 24fps setting is inended to replicate the frame rate of cinema cameras for a 'filmic' look. It's barely perceptible, but try it for yourself. You may find that action shots looks 'choppy' with this rate.

Resolution

It's likely that you'll have a choice of resolution in Movie mode, as you do in normal shooting. The common options are 1080, 720 and VGA. When shooting normal video, it's best to shoot at the highest resolution as you can always downsize later, but

you can't interpolate up. However, if you want to shoot at a faster frame rate to capture fast-moving action or for slow motion, you may have to shoot at the lower 720 resolution.

Shutter speed

You may not have the option of adjusting your shutter speed when in Movie mode. If so, your camera will probably automatically set the shutter speed so that the reciprocal is twice the frame rate – in other words with a frame rate of 24fps or 25fps the camera will set a shutter speed of

LEFT Your dSLR will have various video settings to choose from. Familiarize yourself with these settings so that you know how to get the optimum movie quality for your needs.

1/50th sec. This will always provide the best results, so if you do have the option to adjust the shutter speed, try not to stray too far from this rule of thumb. If you do, you'll probably find your video has a strange strobo-scopic look to it. The exception to the rule comes when you want to shoot a sequence for slow motion. Use the fastest available frame rate and exper-iment with shutter speeds of around 1/2,000th sec.

Exposure

As with shutter speed, you may find that your camera will automatically adjust exposure as the lighting condi-tions change. This makes life easier because you don't have to think about making any manual adjustments. However, some cameras do offer man-ual control, in which case adjusting the aperture, changing ISO, and using exposure compensation will all affect the brightness of the image.

Shooting tips

When it comes to shooting your video, it's simply a case of selecting Movie mode and pushing the Start/Stop button. Few dSLRs will use continuous autofocus when in Movie mode, so a good tip is to prefocus on your subject before shooting, and avoid using the autofocus mode when filming as the sound of the lens focus-ing will be picked up by the camera's

microphone. Additionally, the focus may jump unexpectedly.

When you set the camera in Movie mode, the viewfinder will go black and the LCD screen will become active (as in LiveView mode). You will need to use the LCD screen to shoot all your video.

Controlling depth of field

One of the best things about shooting movies with a dSLR is that you can film with a narrow depth of field. Controlling depth of field when shoot-ing a video is exactly the same as when photographing stills, and it creates the cinematic look that is so popular. Use a tripod to keep the camera steady and set up your shot so that your subject sits in front of a pleasingly out-of-focus background. You can even try adjust-ing the focus so that the subject becomes blurred and the background comes into focus, but you need to be careful not to jar the camera.

Stability

Keeping the camera as still as possi-ble is the first rule of movie making.

RIGHT Once you start taking your movie-making seriously, you can buy all manner of accessories for your camera. This device is called a Steadicam and is made in England by SmoothShot. It features weights at the bottom to counterbalance the camera, thus keeping your movements as smooth as possible.

Viewers will quickly grow tired of shuddering images as the camera moves about. As you hone your skills, by all means start experimenting with moving the camera, and there are a number of handheld devices on the market that will help you to keep camera movements smooth.

Sound

Finally, a quick word about sound. Don't expect to be able to capture high-quality sound recordings with your camera's built-in microphone. Even professional film-makers add a sound track seperately to the moving images. If you won't take your movie-making to the next level, invest in a dedicated external mircophone that will cancel background noise and pro-vide a cleaner sound track. These can be attached to the camera using the hotshoe connection, with the sound being recorded via a cable that plugs into a socket on the side of the camera.

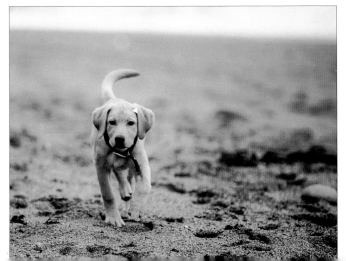

LEFT Shooting video with a wide aperture, f/2.8 or f/4, creates a narrow depth of field just as in still photography. This gives your movie a professional cinematic look, but can make it difficult to keep subjects in focus.

Automatic Shooting Modes

All digital cameras, from an entry-level point-and-shoot compact to a professional dSLR, have a variety of auto or preset shooting modes. These modes, such as 'Portrait', 'Landscape' or 'Sports', indicate the type of image or the conditions in which the photograph is being taken and allow the camera to decide on the most appropriate settings. These differ from the semi-automatic or manual modes, which determine how much and the type of manual control the photographer has over the camera.

Common preset modes

The number and specific type of preset or automatic modes that a camera has vary depending on the make and model, but just about all will feature the modes listed below. The icons indicating the modes will also vary, so if you're unsure about which icon represents which mode, look in the camera's manual.

Auto

As the name suggests, in Auto mode everything is automatic, with the camera taking complete control of all the settings. It will set the ISO, white balance and focusing mode, then focus the lens, assess light

Close-up/Macro mode

Beach/Snow mode

levels and set an appropriate exposure, plus fire the flash if necessary. This mode is often used by beginners or those unfamiliar with a new camera as it almost guarantees a correctly exposed and sharp image.

Close-up/Macro

The Close-up or Macro mode is used to take close-up pictures of small subjects such as flowers or insects. How close you can get to the subject depends on the camera and lens, but with most compacts it will be between $^2/_3$–6in (2–15cm). The depth of field at this small distance is very narrow (see pages 86–87), making it difficult to keep everything in focus. This can often result in effective, creative shots where only the centre part of a flower is in focus, for example. However, if you want the entire subject to be in focus,

Portrait mode

you should shoot from directly above (or directly below) the subject so as much of the subject as possible is at the same distance from the lens.

Portrait

In this mode, the camera will set the largest possible aperture (smallest number) to create a narrow

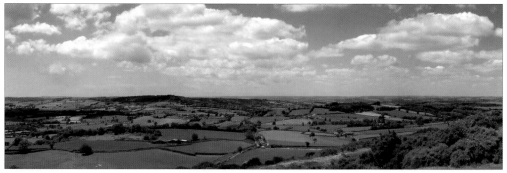
Panorama/Stitch mode

depth of field. This throws the background out of focus so that more emphasis is placed on the subject's face.

Landscape

This mode works in the opposite way to Portrait. The camera will set the smallest possible aperture (highest number) to create the widest possible depth of field. This ensures that as much of the scene – and ideally from foreground to background – is in focus.

Sports/Action

When photographing any fast-moving sport or action scene – such as football or motor racing – select the Sports (or Action) mode. In this mode, the camera will automatically select the fastest possible shutter speed (depending on the available light) in order to 'freeze' the action. You'll usually have better success if you follow, or pan, the subject through the lens for a few seconds before taking the shot. If the camera has a variety of focusing modes then it will usually select 'continuous focus' and also 'continuous shooting' if that's another option.

Night Portrait

The Night Portrait mode is designed for taking photographs of people outside during the evening or at night. The camera will set a relatively long shutter speed to ensure that the dark background is captured, while firing the flash to light and 'freeze' the subject. This is known as 'slow sync'. You should always make sure that your subject remains still – even after the flash has fired – as the camera may still be recording, albeit only for a fraction of a second.

Movie

Most recent compacts and bridge cameras have the ability to record video with sound. Although the quality of image and sound won't be as good as a dedicated video camera,

Sports/Action mode

for many people the option to record short video clips is important. Be aware, however, that recording video will use up a great deal of space on the memory card.

Other preset modes

Other common modes that appear on many digital cameras include:

Beach/Snow

Both these modes will ensure the camera accurately exposes images in conditions where you are faced with bright ambient light.

Panorama/Stitch

In this mode, after the first image of a prospective panorama is taken, the exposure and white balance

Fireworks mode

are 'locked' so that all subsequent images have the same coloration, tone and contrast. You then pan the camera to the next section of the panorama and align the next image with the previous one, of which about a third appears semi-transparent on the LCD screen.

Fireworks

Using Fireworks mode the camera will deliberately select a slow shutter speed so that the trails from fireworks are captured.

Black and White

Numerous cameras, including some dSLRs, feature a Black and White mode, which allows you to shoot black and white or sepia-toned images. You can often achieve better results using image-editing software, but if you print directly from the memory card and want black and white images this mode is essential.

Black and White mode

Semi-automatic Shooting Modes

In addition to the main automatic shooting modes found on almost all compact cameras and most dSLRs, many other compacts and just about all dSLRs also feature a number of semi-automatic modes. These are usually Program (P), Shutter priority (S), which is also known as Time value (Tv), and Aperture priority (A), which is also known as Aperture value (Av). These modes offer much more creativity in that you have greater control over aperture and shutter speed selection, but at the same time they also help you to achieve an appropriate exposure. If your camera has these modes, it will also have a Manual (M) option, which we will look at later (see Understanding Exposure on pages 76–77).

Program (P)

Depending on the make and model of your camera, the Program (P) mode will usually behave in a similar way to the full Auto mode, in that the camera selects a suitable combination of aperture and shutter speed to achieve the correct exposure. However, selecting P will also allow you to change the ISO setting, image size and quality, the metering mode and a number of other settings that are set automatically when the camera is in Auto mode. In other words, while Program allows you to tailor certain settings, you'll generally produce correctly exposed pictures.

Program shift/Flexible program

Another way in which Program differs to Auto in most cameras is that while Program mode will automatically set an initial aperture/shutter speed combination, it will also allow you to change that combination. If, for example, you want a fast shutter

LEFT Most digital cameras, including dSLRs, support modes that are selectable either by a dial or a menu.

ABOVE With the camera in Program (P) mode, it will set an aperture/shutter speed combination that is appropriate for the amount of light available.

speed to freeze action, you can select a faster shutter speed using a control dial and the camera will automatically increase the size of the aperture (select a smaller number) so that you will still obtain a correct exposure. This is usually known as 'Program shift' or 'Flexible program'.

In a similar way, if you want to reduce the size of the aperture (select a higher number) in order to ensure that as much of the scene as possible is in focus, the camera will select a slower shutter speed to make sure that the image is still correctly exposed. With most cameras, if you select a aperture/shutter combination that will produce an under- or overexposed image, the camera is likely to provide either a visual or audible warning. Altering the ISO setting so that a correct combination of aperture and setting is made available can often be the solution to this.

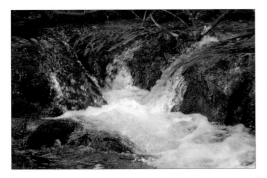

▲ **ABOVE** This image was taken in Shutter priority/Time value mode, with a fast shutter speed ($^1/_{250}$ sec) selected manually to 'freeze' the movement of the water. The camera then automatically set an appropriate aperture (f/4.5) to ensure accurate exposure.

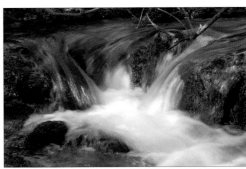

▲ **ABOVE** This image was also taken in Shutter priority/Time value mode, with a slow shutter speed ($^1/_6$ sec) deliberately chosen in order to capture the blurred movement of the flowing water. Again, the camera automatically set the aperture (f/22).

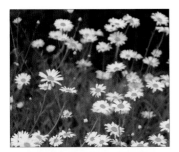

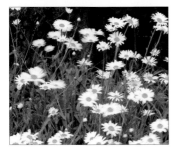

▲ **ABOVE** Both images were taken in Aperture priority/Aperture value mode. On the left, a wide aperture (f/4.0) gives a narrow depth of field and the camera automatically sets the shutter speed ($^1/_{1000}$ sec). On the right, a narrow aperture (f/22) is chosen resulting in a wide depth of field – the camera automatically set the shutter speed ($^1/_{50}$ sec).

▲ **ABOVE** Using the Program shift or Flexible program modes is a good way to begin experimenting with aperture and shutter speed combinations. In the top image, a fast shutter speed/wide aperture combination has 'frozen' the flowers, but because of the wide aperture (low number) some of the flowers are out of focus. In the lower image, the slow shutter speed/narrow aperture combination has resulted in an image that is sharply focused front to back, but the slow shutter speed has resulted in some blurry flowers as they were blown in the wind.

Shutter priority (S)/Time value (Tv)

In this mode you can set a specific shutter speed – fast to freeze action, or slow to deliberately blur people or objects. The camera will set an appropriate aperture depending on the available light. If the shutter speed is set too fast or too slow, the camera will either blink or beep to warn that the image will be incorrectly exposed, but the shutter will still fire in case the 'incorrect' exposure is deliberate. Or, you could alter the ISO to see if that produces an acceptable exposure.

Aperture priority (A)/Aperture value (Av)

This mode works in a similar way to the S/Tv mode, but the opposite way around. You can set a large aperture (small number) to throw a background out of focus, or set a small aperture (large number) to increase the depth of field (to ensure a landscape is in focus from foreground to background). The camera will automatically select an appropriate shutter speed to ensure a 'correct' exposure or warn you of an 'incorrect' exposure.

Autofocusing Modes

To make life easier for us, today's digital cameras have sophisticated autofocusing (AF) systems that help ensure our images are in focus while we can concentrate on composition or predicting someone's expression. Most AF systems in today's digital cameras are known as 'passive' autofocus and work in one of two ways.

Contrast measurement

This is the least complex AF system, which is used in entry-level compact cameras. It uses a simple sensor (as opposed to the camera's main image sensor) to detect at which point the lens produces an image with the highest level of contrasting pixels. This indicates the lens is sharply focused – an in-focus black and white stripe will have higher contrasting pixels than an out-of-focus stripe, which will appear more grey.

Phase detection

This more complex AF system is used on sophisticated compacts and most dSLRs. Known as 'phase detection', light from the scene is split into two from different parts of the lens. These parts are compared by the AF sensor, which will then direct the AF servos (tiny electrical motors) to make adjustments to the lens, depending on the similarity in light patterns between the two images.

Under most conditions both systems work well and can provide fast, accurate focus. However, if the light is poor, or the scene exhibits little contrast (such as a blue sky or a repetitive pattern), you'll hear the camera's AF system 'hunting' as it tries to find the point of focus.

To combat the first situation, the camera will automatically 'fire' a rapid succession of light beams from an

'AF assist lamp' so that the AF system can 'see'. If there is no AF assist lamp, most cameras will fire the flash. Where the scene is too uniform in tone and colour for the camera to accurately

▼ **BELOW** Many cameras feature a continuous AF system, which tracks the subject and keeps it constantly in focus. As soon as the shutter release is depressed, focus is locked and the picture taken.

▼ **BELOW** Occasionally, even continuous AF cannot keep up with the pace. Here, due to shutter lag, by the time the camera actually fired, the subject had moved too close to the camera to remain in focus.

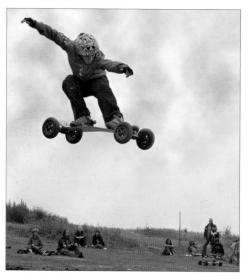

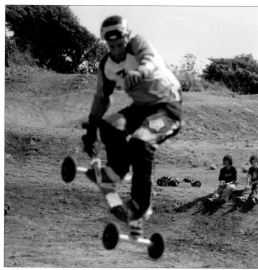

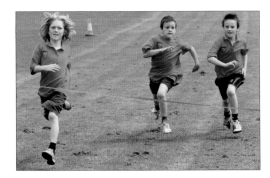

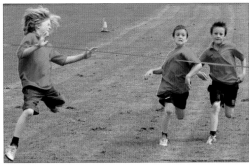

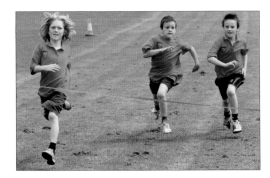
 ABOVE Advanced autofocus systems can track moving elements and predict where they will be at the exact moment the shutter fires. With 'predictive' or Artificial Intelligence focus, these racers are pin sharp.

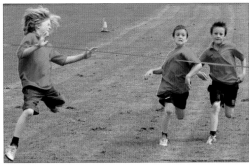
ABOVE Less than a second later, predictive autofocus has accurately estimated the runners' positions, counteracting the slight delay between pushing the shutter release and the camera firing.

differentiate pixels, the quickest way to resolve this is to find something the camera can focus on that is the same distance away. Otherwise, if the camera has the option to switch to manual focus you can focus the lens yourself.

Single AF versus continuous AF

Many cameras have two AF settings – single AF and continuous AF. Single AF (also known as 'one-Shot'/'single-Shot') should be used when the subject is relatively still, such as landscapes or portraits. Pressing the shutter release halfway will set the focus, and the camera will go on to take a picture if it focuses and the shutter release is fully

pressed. In continuous AF mode the camera focuses continuously, and only 'locks' onto the subject when the shutter release is pressed halfway. This makes a continuous AF mode useful for taking photos of moving subjects. The idea is to follow the subject through the viewfinder or on the rear LCD screen and the camera will try to keep it in focus until you want to take the photo. This mode is not without its problems. There is often a delay between pressing the shutter release and the camera taking the picture – and subjects in motion, by their very nature are moving – often resulting in images that will be out of focus.

Predictive AF

To combat such situations, some cameras (mostly dSLRs) incorporate a 'predictive' AF system. This mode works best when the subject is either moving toward or retreating from the camera at a constant rate. The camera's AF system will track the subject as it moves into the frame and attempt to predict where it will be at the precise moment the shutter fires. In effect, the camera is estimating the time it takes for the shutter release to be pressed and for a picture to be taken. In this way it helps to ensure the subject will remain in focus at the precise moment the exposure is made.

LEFT For stationary subjects, 'single' autofocus is recommended. Depressing the shutter release halfway will lock the focus.

ABOVE These diagrams illustrate how some cameras rely on contrast to achieve focus. The in-focus lines (left) have greater contrast than the out-of-focus lines (right).

Metering Modes

In order to produce an image that is not too bright (overexposed) or too dark (underexposed), all digital cameras need a way to assess accurately how much light is present in the scene that is being photographed. Historically, photographers used handheld light meters to measure the amount of light falling onto the subject – in fact many professional studio photographers still use such devices to ensure they know precisely what the light levels are. However, with these 'incident' light meters, you need to be able to place the meter very close to the object being photographed to 'read' the light.

For most of us this is not usually practical, so modern cameras have built-in light meters that measure the light reflected from the subject or from the scene as a whole. However, because light levels can vary drastically – even within the same scene – many cameras provide a

number of different ways to measure light to help you achieve the correct exposure. These are known as metering modes. There are three common metering modes, and all digital cameras will have at least one, while many will include all three.

Centre-weighted metering

This is the most commonly used metering system in digital cameras that do not offer any metering option, such as some compact cameras. In this mode, the metering is biased or weighted to the centre of the viewfinder and then averaged for the entire scene. The idea is that for most shots the subject of the image will be in the centre of the frame and therefore accurately exposed, while the rest of the scene is averaged out. If there is a big difference between the lightest and darkest parts of the image (such as land and sky), then the camera will attempt to find the

most appropriate setting to ensure that most of the photograph is exposed as accurately as possible.

This mode is very useful when taking portrait shots, particularly if the subject is standing in front of a light background (this is referred to as backlighting). However, if the subject of the picture is off centre, or the background or foreground is extremely light or dark, they may well be incorrectly exposed.

Spot/partial metering

As its name suggests, spot or partial metering takes a reading only from the very centre spot of the viewfinder and sets an accurate exposure for that part of the image only – no readings are taken from any other part of the scene. True spot metering measures the central 1–2% of the viewfinder area, whereas partial metering will measure around 9–10% of the area. This metering mode should

RIGHT When set to centre-weighted, the camera sets an exposure that puts most emphasis on the central part of the image, but takes into account the rest of the scene; here the flower is slightly overexposed because of the dark leaves around it. The schematic diagram (far right) shows how centre-weighted metering assesses the scene.

RIGHT When set to spot or partial, the camera sets an exposure appropriate only for the central part of the scene. Here, the flower is accurately exposed and the surround underexposed. The diagram (far right) shows how the metering assesses the scene.

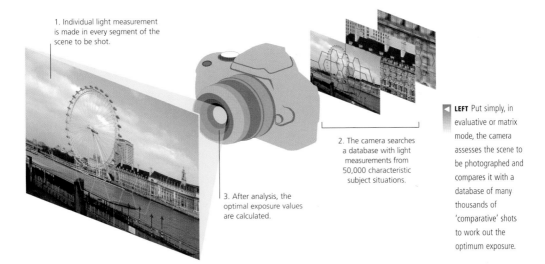

1. Individual light measurement is made in every segment of the scene to be shot.

2. The camera searches a database with light measurements from 50,000 characteristic subject situations.

3. After analysis, the optimal exposure values are calculated.

LEFT Put simply, in evaluative or matrix mode, the camera assesses the scene to be photographed and compares it with a database of many thousands of 'comparative' shots to work out the optimum exposure.

be used when the subject must be correctly exposed, no matter how much (or how little) light is falling on the surrounding areas, or during close-up photography. While this form of metering provides the most predictable results, if the area used to take the reading from does not provide the best average, the result will be unacceptably overexposed or underexposed. For this reason, spot or partial metering is often not available on many point-and-shoot cameras.

Evaluative/matrix metering

This is the most sophisticated of all the metering systems, and is the 'default' mode for most cameras that offer metering options. It works by taking multiple readings from various points in the scene, while also assessing the position of the main subject, foreground and background, overall brightness, any front- or backlighting, colour and so on. The camera then compares these readings with a database of tens of thousands of 'typical' photographic scenes and selects the exposure that most closely resembles one in its database. In other words, the camera guesses what type of picture is being taken, whether it's a landscape with a bright sky and dark land or a portrait at dusk. Most of the time, evaluative or matrix metering does a surprisingly good job at selecting the most appropriate exposure for any given scene, but it's by no means foolproof as it employs a certain amount of 'guesswork'. More experienced photographers often complain that they lose a certain amount of control when using evaluative metering.

Which mode is best?

Generally, if there are no marked differences in highlights and shadows, then evaluative or matrix metering is more likely to get the exposure right. If, however, there are distinct differences in light and dark areas, or if the subject is backlit, or you need to expose for a specific area of a scene, you will probably find that using either spot/partial or centre-weighted metering will serve you better.

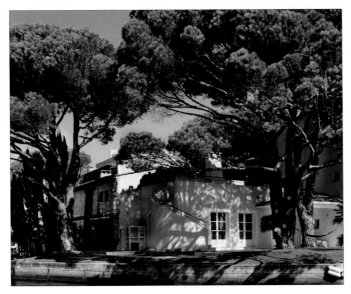

LEFT The camera's matrix metering has accurately captured this scene, which contains bright highlights and dark shadows.

Histograms

Working digitally has a number of benefits, one of the most important being that the colour, brightness and tonal values of the individual pixels that make up the image are recorded as soon as the image is taken.

These values can be reviewed in two ways on the camera's LCD screen – firstly, as the image itself or secondly, as a graphic tonal representation which is known as a histogram.

Being able to interpret histograms will help you to assess whether or not your image has the acceptable tonal values that make for a well-exposed shot, particularly in bright sunlight when it's difficult to see clearly a review of the image on the camera's LCD screen.

Interpreting a histogram

A histogram can normally be called up on the LCD screen on the back of your camera when shooting or playing back images. It is a form of graph where the x- (horizontal) axis represents the entire digital tonal range from black to white (0–255), while the y- (vertical) axis represents the number of pixels with a specific tonal value.

It can be helpful to try to mentally divide the x-axis into three sections – shadows to the left, midtones in the middle and highlights to the right. An ideally exposed image would generate a symmetrical, humped-shape histogram that smoothes gently out to the black and white points at either end of the histogram. For less well-exposed examples, a histogram that features the majority of the pixels in the left part of the histogram would indicate an underexposed, or dark (low-key), image, while one in which most of the pixels were grouped to the right would suggest an over-exposed, very light (high-key) image.

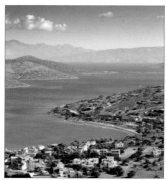

▲ **ABOVE** A snowy scene will produce a histogram that has a large number of pixels grouped to the highlight (right) end of the histogram. However, both ends of the histogram curve uniformly to both the black point (left) and the white point (right). This indicates a good range of tones from black to white.

▲ **ABOVE** Although exhibiting a number of individual peaks that represent specific regions of the image, such as buildings and mountain shadows, this image has produced an even histogram overall. Both ends drop gradually to the black and white points – indicative of a well-exposed image with a full tonal range.

▲ **ABOVE** This dark, reflective shot of a garden wall showing the garden beyond has resulted in a histogram with a grouping of pixels to the shadow (left) end of the histogram. But again, because the graph drops down to the base of the black point (albeit sharply) most of the shadow detail is discernible.

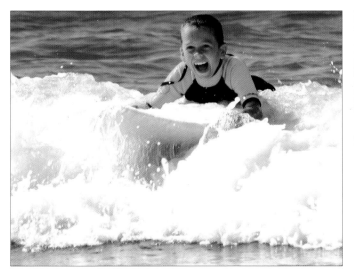

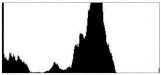

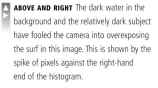

ABOVE AND RIGHT The dark water in the background and the relatively dark subject have fooled the camera into overexposing the surf in this image. This is shown by the spike of pixels against the right-hand end of the histogram.

ABOVE The boy's dark wetsuit has been underexposed in this image despite the relative lack of bright highlights. The spike of pixels at the black point of the histogram shows this and indicates that some shadow detail has been lost.

Clipped highlights/shadows

One of the most useful aspects of reviewing an image's histogram is that it will quickly alert you to any clipped highlights or shadows. Either of these can occur in a scene that exhibits a very wide tonal range – that is, an image that contains large areas of dark shadows and equally large areas of bright highlights. Depending on your specific camera and how its metering system works, in such a difficult lighting situation it's likely that the dark shadows will be underexposed and become entirely black with no discernible detail (clipped shadows) or the highlight areas will be overexposed and rendered entirely white (clipped highlights), or both. Bright areas of an image that are overexposed to the point at which they appear as pure white are often referred to as 'blown highlights'.

Both clipped shadows and clipped highlights are quickly detected on a histogram in the form of a large group

or distinct 'spike' of pixels stacked against either end of the histogram. If, when reviewing a histogram, you see that groups of pixels are pushed to either end of the histogram try recomposing the shot so that fewer bright areas or less shadows are visible in the frame.

Blown highlights are extremely intrusive and are usually impossible to remedy in photo-editing software as there's no information to start with. Detail can be far more easily extracted from dark shadows in editing software. For this reason, it's often better to ensure you get a more accurate

ABOVE AND RIGHT Unsurprisingly, this grey black and white image produces a fairly uniform histogram, apart from the peaks at either end created by dark shadows and bright highlights.

exposure for the lighter areas than for the darker ones, especially if you are using a compact camera. There are various techniques you can use to help you get the best possible results in difficult light situations and we'll cover these in the Manual Exposure section on pages 78–79.

Colour Temperature and White Balance

While watching a glorious sunrise, enjoying a spectacular view at midday, or walking down an artificially lit street at night, our eyes and brain make adjustments so that in most circumstances we compensate for the possible variation in the colour of the light – to us a white sheet of paper looks white no matter where or when we look at it. However, this is misleading, and in order to get accurate colours from your camera, it's important to understand a little about how light can vary in colour.

Natural light

Colour, or light, temperature can be accurately measured using the Kelvin (°K) temperature scale. During the course of a day (depending on where you live and the time of year), the light temperature will vary and this affects the colour of the light. For example, at sunrise, the light will often take on a reddish hue and has a temperature of around 2,500°K.

As the sun rises higher in the sky the light becomes increasingly white, until around midday when the light reaches a temperature of around 5,500°K. At this temperature there is no noticeable colour bias, which is why flash units also use this neutral colour temperature.

As the sun begins to set, the colour temperature drops again, and the light will often return to the red colours apparent at sunrise.

Cloud cover (or a lack of it) can also affect the colour of light. For example, while a cloudy day has relatively neutral light of between 6,000°K and 7,000°K, a bright blue sky has a temperature of around 10,000°K. This will cast a noticeably blue light, which can make your pictures appear cool.

Artificial light

It's not just natural light that exhibits varying colour temperatures. Various types of artificial light also have different temperatures, and usually these are much more apparent than natural colour temperature shifts. For example, a standard 60-watt incandescent (tungsten) light bulb, the type used in a great many table lamps, will generate a colour temperature of around 3,000°K,

ABOVE These three shots were taken at different times of the day – sunrise, midday and sunset. The top image was taken at around 5:30am and the sunrise was uninterrupted by cloud. The red quality to the light is typical of a colour temperature of around 3,000°K. By comparison, the second image appears much more neutral in colour. However, by sunset (bottom image), the colour temperature returns to around 3,000°K, reintroducing the red glow that accompanied sunrise.

Auto white balance

Daylight

Cloudy

Shade

◄ **LEFT** This series of images shows the same shot taken with different white balance settings. Setting aside the interior tungsten and fluorescent settings (which are irrelevant here) you can see how the 'outdoor' settings differ. Auto white balance, daylight, cloudy and shade become progressively redder, giving a different effect even though the light has not actually changed. This is because those lighting conditions have progressively higher degree Kelvin measurements (in the order noted). The higher the temperature, the bluer the light, and to compensate the camera has increased the red value in the daylight, cloudy and shade shots compared with the automatic setting.

creating a warm, reddish light, while some fluorescent lights have relatively high temperatures of around 7,000°K, creating a cold, green-blue colour cast.

White balance

Traditionally, photographers used to use a variety of coloured filters attached to the camera's lens to counteract the effect of colour casts. If the light was too blue, they would use a red-coloured filter to 'warm-up' the image, and vice versa. While using filters on a digital camera that accepts them is certainly one way of correcting colour casts, many compacts won't take filters. However, all digital cameras have a white balance (WB) setting that does the same job.

Auto white balance (AWB)

All digital cameras have an auto white balance (AWB) setting. In simple terms, this works by making the brightest element in the image white and then, using that as a point of reference, adjusting all the other hues to create true-to-life colour. However, if there's no 'white' reference point, or the scene is dominated by one particular colour, the camera's AWB

setting can be tricked into making the wrong decision. To counteract this, your digital camera is likely to feature a number of preset white balance modes, including incandescent (tungsten), fluorescent, daylight, flash, cloudy and shade. These modes use a fixed temperature setting common to those specific lighting conditions and will usually produce more accurate colours than the AWB setting.

In addition, more feature-packed compacts and many dSLRs also feature a custom white balance setting. With this setting you shoot a white card under the lighting conditions in which you're working. The camera will record this as white and use that setting for all subsequent shots. Some cameras will also allow you to input the exact Kelvin setting if you know the colour temperature of the light source being used.

Quick correction

If your images appear too warm or red, selecting a higher temperature setting ('daylight' to 'cloudy' for example) and retaking the photo should give you more accurate colours.

Similarly, if the image appears too cool or blue, selecting a lower temperature setting will warm the image. Finally, although we usually strive to get an accurate white balance, correcting a wonderful sunset shot so that pinkish walls are accurately rendered as white would detract from the picture. This is an obvious case where we might want to retain the colour cast, as it adds atmosphere to the picture. Similarly, the sickly green of certain street lighting may be exactly what you're after to portray an urban environment so, for creative effect, try using the 'wrong' white balance and see what results you get.

Colour temperature

The average colour temperature in Kelvin for a variety of typical light sources:

Candle light	1,500°
Incandescent/tungsten	2,500°
Sunrise/sunset	3,000°
Midday sun/flash	5,500°
Overcast sky	6,500°
Hazy sky	8,000°
Blue sky	10,000°+

Composition

Having covered basic automatic and semi-automatic shooting, metering and focusing modes, it's time to look at some basic composition principles. Learning about the added creativity these can bring to the photographer will not only help you visualize how your pictures will turn out, but give them greater impact, too.

Good composition

Over the next few pages we'll be looking at various techniques that have been employed by artists and photographers over many years to improve composition. But what is good composition?

On one level, good composition is all about 'arranging' the elements in the viewfinder or on the LCD screen so that their shape, form, colour and tone interact with one another in a way that looks visually appealing. Of course this is very subjective – an image that resonates with one viewer may quite easily leave another cold. Employing certain compositional techniques, however, is usually a good place to start.

Capture the moment

For many new photographers, one of the hardest skills to learn is how to capture the complete essence of a moment or scene, just as we experienced it when taking the image. For example, if we're at the beach we have the added benefit of experiencing the smell and the sound

of the seagulls squawking, the fine texture of sand and the heat of the sun – all of which formulate that very specific sense of time and place. Yet when we come to view our images on screen or in print we often find that they don't necessarily recreate the original sense of time and place.

Good composition is a way of using techniques that will help you create images that are visually pleasing and successfully conjure up the emotions and memories of a specific location or event. We're now going to examine a number of the basic rules of composition. However, it's important not to become preoccupied by these 'rules' as this can stifle creativity and hinder spontaneity, so consider these rules more as guidelines; something to help rather than struggle to adhere to.

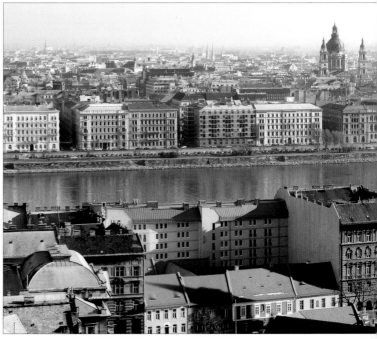

BELOW When faced with a seascape or landscape, most photographers will naturally use their camera in a horizontal, or 'landscape', orientation. But there is no rule that says you can't shoot an 'upright' image if the scene warrants it.

ABOVE The children in this picture aren't in the middle of the frame and there's a lot of background around them, but there is still no doubt that they are the focus of the photograph.

BELOW The landscape form of this city shot captures the sweeping river front of Budapest, with its uniform rows of windows.

ABOVE By using a fast shutter speed, the girl in this image has been frozen, making it possible to clearly see her expression and capture the moment.

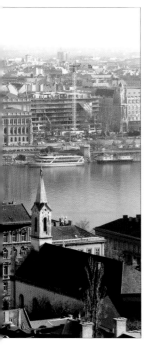

ABOVE Here the photographer has deliberately included some leaves in the top of the image. This is a form of 'framing' that adds depth to an image.

Finding inspiration

There will certainly be times when, as a photographer, you feel uninspired. Prolonged periods of poor weather or a sense that you have little in the way of subject matter will often bring on these periods. Joining a camera club is a good way of helping you through such moments. You'll meet like-minded people, be given specific photographic challenges and learn and share techniques that will improve your images.

Alternatively, join an on-line photographic community, such as Flickr (www.flickr.com). Most are free to join, have innumerable forums, and specific areas for certain subjects and styles of photography. They're also a fun way of getting feedback on your own images.

Fill the Frame

Of all the compositional rules and tips, perhaps the most effective (and straightforward to understand) is to 'fill the frame'. It's amazing how many photographs – especially portraits – are taken either from too far away or do not use the camera's zoom facility to its full potential.

Part of the reason for this is because our brains are excellent at 'filtering' out the sights and sounds that we're not specifically concentrating on. When we focus on something, it is that object that fills our 'mental frame' and has our undivided attention. In our mind's eye it appears to fill the frame even though we might physically be some distance away. This will almost certainly result in images that render the subject small and insignificant in the frame.

Optical proximity

Robert Capa, who was one of the greatest war photographers and one of the founders of *Life* magazine – once famously remarked that, "If your photos aren't good enough, you're not close enough". This is precisely what filling the frame is all about. Although at the time he said it, Capa was undoubtedly implying physical 'closeness' – and, of course, getting physically closer to your subject will certainly help fill the frame – with today's more sophisticated and superior lens technology, we can also get closer optically. Later on in the book, we'll be looking in more detail and focal lengths, and the impact a long focal length (or telephoto) lens has on an image, but for now, use your camera's zoom facility to get in close to your subject – you'll be amazed at the impact this can bring.

By filling the frame, you will not only reduce the risk of inadvertently including any distracting background or foreground clutter, but viewers will be left in no doubt about the subject of the photograph.

ABOVE AND RIGHT Our mind can play strange tricks on us when we're behind the camera. Because we're so 'focused' on the subject of a photograph, we're not always aware of the extraneous parts of the scene surrounding the subject. One good tip is to compose the image, then close your eyes and visualize the scene that you have just composed. When you open your eyes again you may be surprised to discover how different the reality is from the image you thought you were about to take in your 'mind's eye'. Always try to fill the frame with your chosen subject.

ABOVE Even something as mundane as a trailer window with two dish cloths can create an interesting, symmetrical composition if used to 'fill the frame' under favourable lighting conditions.

ABOVE Budapest's airport has some interesting geometrical shapes, patterns and lines that are difficult to capture in their entirety. After a while, the photographer stopped trying to capture the whole frontage and instead focused on the name and the structural elements that had first caught his attention.

RIGHT Here the photographer wanted to capture the wonderful purple of a species of flower growing on cliff tops. With the first image, the colour and quantity of the flowers is adequately captured, but including the beach and sea distracts the viewer from the subject – it's just not clear what exactly we're meant to be looking at. By filling the frame, the colour and abundance of the flowers are enhanced as they are the only subject in the frame with no added distractions.

Get in close

There are two ways of filling the frame for maximum impact and eradicating unwanted backgrounds:
• Move closer to the subject.
• Zoom in or use a longer focal length lens.

Keep it Simple

This next compositional tip is a logical extension of filling the frame. Almost all keen, novice photographers are guilty of trying capture too much – whether it's a landscape, portrait, architecture or still-life picture. It's difficult to know quite why this is – perhaps we're trying to provide the viewer with a more 'complete picture' of the scene in the hope that this will convey more powerfully what we want the viewer to see? But things work in exactly the opposite way – the less visually cluttered an image, the more powerful it becomes.

Pick your subject

One way of keeping your images simple is to pick a specific subject from the scene you're photographing. Say, for example, you're enjoying a holiday in a stunning tropical location and want to capture the sun, sea and sand. If you simply stand up and point your camera along the length of the beach and take a shot that includes just about everything you can see, you're likely to capture all the other sunbathers and swimmers, people walking down the beach, hotels and bars in the distance, and so on. When you show the image to friends and family back home,

ABOVE In this image, the tree, the moon and the foreground form three simple yet discrete elements, with the uniform blue sky adding to the image's simplicity.

they'll have a good idea of your physical environment, but not why your holiday was so special. However, pick a specific viewpoint, such as a trail of footprints in the wet sand or a colourful towel and beach umbrella and your shots will evoke a much greater response and the images will have a much greater visual impact.

BELOW These two images, which were taken at the same location, show the significant advantage of keeping your images simple. The photographer aimed to highlight the colourful house fronts juxtaposed against the yachts and dinghies. In the first image on the left, there is too much going on in the picture and no easily identifiable subject. By moving farther along the harbour wall, the photographer found a better position that not only provided an excellent view across to the houses, but also still captured the contrasting spirit of modernity in the modern sailing dinghies.

ABOVE A photograph of this parasol in its entirety would have meant including people and more of the building in the shot, which would reduce its impact.

ABOVE RIGHT The three main elements of this image, the window, door and drainpipe, provide a simple arrangement to the brick backdrop.

BELOW These simple footsteps in the sand are emotive, while also creating a graphic image. The surf and its recession have sorted the sand grains into clear patterns.

RIGHT We don't need to see the whole of this building to know that it was taken in an exotic location – the blue sky, terracotta walls, vibrant flowers and pristine white shutters suffice.

BELOW RIGHT A solitary figure placed in an urban setting can often create a powerful composition.

Rule of Thirds

LEFT The idea behind the rule of thirds is that it prevents you from placing the subject of a picture right in the middle of the frame, where there's a danger it will draw in viewers, and stop them from visually exploring the rest of the image. The image is divided into nine equal rectangles. Where the horizontal and vertical lines cross (the points of interest) is roughly where important elements of an image should be placed. This image is further balanced by the placement of the boat in the distance.

One of the most popular and widely used compositional tools is the rule of thirds. The 'rule' was developed in the mid-19th century, primarily as a guide for landscape artists, but was quickly adopted by photographers who spotted its value, first in landscape photography, then in other genres.

Grid

When employing the rule of thirds the photographer mentally imposes a grid over a potential scene. The grid is comprised of two vertical and two horizontal lines that divide the scene into thirds, both vertically and horizontally, or into nine squares (see example on the right). The rule works on the basis that any continuous horizontal line running the width of the image, such as the horizon or a row of distant trees, has greater dynamism and interest if placed on one of the horizontal grid lines than if it were placed in the centre of the image. Similarly, any strong vertical objects in the scene would be best placed on one of the two vertical lines.

Points of interest

In addition to using horizontal and vertical lines as guides, it is also important to consider the four points at which the dividing lines cross – these are known as the points of interest or the points of power. When composing a shot, try to ensure that principal elements in the scene are placed over one or more of these points of interest. Doing so will ensure that focal points in your image are kept away from the centre of the picture and add interest to the image. You don't have to slavishly ensure that key objects sit directly over points of interest – they are intended as guidelines only.

Portraits

Although the rule of thirds was devised primarily for landscape artists and photographers, it can also be used with other forms of photography. In portrait photography, for example, it is best to avoid having the subject's eyes run through the centre of the photograph if shooting a close-up of someone's head and shoulders. Instead place them along the top horizontal line. Similarly, if the portrait is a full-length shot, don't place the subject in the centre of the frame. Instead, try placing him or her along one of the two vertical lines.

In fact, the rule of thirds can apply to all styles or genres of photography – architecture and still life, as well as landscape and portraiture. It is worth bearing in mind, as mentioned earlier, rules are there to be learned, practised

RIGHT Portraits will often benefit if the subject's eyes are placed in line with the top horizontal rule.

Grid guidelines

The rule of thirds is a simple yet effective way of focusing the viewer's attention. Remember to:
- Mentally put horizontal or vertical lines in your image on thirds lines.
- Place key elements in your image on the four points of interest.

LEFT Like all composition 'rules', the rule of thirds is only a guide; there will be many times when placing the subject in the centre of the frame just feels right.

Viewfinder grid

On many of today's digital cameras, it is possible to electronically 'super-impose' a rule of thirds grid onto the viewfinder as you compose your image. As well as helping you to place the important elements of the scene on a point of interest, it can also help to remind you to hold the camera straight, so horizons or buildings don't slope off to one side.

and then broken. Once you try the rule of thirds for yourself, you'll likely find that many of your images become more balanced and dynamic. However, there are bound to be times when a piece of architecture or a tree just feels right when placed centrally, or when equal weight should be given to the land and the sky. In those instances, you should follow your gut instinct.

RIGHT In this silhouette shot of a boy throwing a stone, the figure has been deliberately placed in the right third of the shot. The composition is stronger and the stone consequently has 'space' into which it can be thrown.

BELOW Interestingly, research seems to show that compositions with one principal focal point are more successful if that element is positioned on the right-hand point of interest, rather than on the left, as we tend to look at images from left to right. It's thought that when the element is on the left, the viewer's eye stops travelling through the image as soon as it encounters its point of interest.

Frame Within a Frame

Like the rule of thirds, a 'frame within a frame' is a technique first used by landscape artists and subsequently by photographers. There is a number of ways the technique can be used to create very different results.

Landscape

One of the most popular frame-with-in-a-frame techniques is used in landscape photography, where trees or other foreground subjects are used to frame a distant view. Although the technique has been widely used (to the point where many consider it somewhat hackneyed), it can still be very effective and usually helps add depth to the composition, as well as enhancing the significance of the

subject of the image. Also, the person viewing the image will often get a sense of the photographer's point of view, helping to create a shared experience of the scene and making the viewing all the more intimate.

Focus

To create the perception of depth, this technique usually works best if both the foreground 'border' and subject are in sharp focus, but it does pay to experiment. Walk farther back from the elements that you're intending to use as the border, use

your camera's zoom to close in on the distant subject and ensure that the camera doesn't focus on any of the foreground elements. If necessary, temporarily recompose the shot so that the foreground is out of the picture, then recompose the scene so that the foreground elements are once again in the frame, only now they should be out of focus. Take the picture and compare the effect of having a foreground that is either in or out of focus. Some photographs work far better with one technique than the other.

▲ **LEFT** Frames not only help to focus the viewer's attention on the subject, they can also help photographers to pose their subjects for natural looking images.

▼ **BELOW** Using the branches of a tree is a classic way of framing a landscape image or a view of a historic building. Use this technique sparingly – it has been widely applied and is somewhat clichéd.

▼ **BELOW RIGHT** A more creative interpretation of the 'frame-within-a-frame' concept.

Portraits

This technique works in a slightly different way in portrait photography, as the subject is often within the object that is acting as the frame. Since the frame and subject are the same distance from the camera, you won't get the same perception of depth. Instead, the frame acts like a border, visually containing the subject and enhancing his or her significance. At the same time it will also contextualize the shot by putting the subject in a specific place or situation.

ABOVE When using a frame within your frame, experiment with the point of focus. Here, the doorway that acts as a frame is sharp, but the children in the background are out of focus.

TOP This image is about using frames within frames, although it has been taken further with the columns in the foreground and the smaller arched openings acting as frames.

ABOVE Sometimes the frames themselves can become the subject of the image. Here, the geometrical shape of the frame acts as the subject, making the viewer peer through to see the street.

RIGHT In this image the low-growing olive trees provide a frame or border for the bottom of the picture, while the bay is further framed by the rocky promontory near the top of the shot.

Point of View

When looking through a series of images, one of the biggest clues that gives away the novice photographer is that all the images have been taken from a standing eye-level view. There's absolutely nothing wrong with this point of view – some of the most striking images have been shot from it – but by altering the camera height and angle every so often, you're not only more likely to create images with a fresh and exciting perspective, you'll also train your mind's eye to visualize scenes differently.

People

Of all the different genres, it is with portrait photography that changing your point of view (POV) can have the most dramatic impact. This is most likely down to the psychological responses we experience when communicating with other people. Generally we become aware in a very short space of time if we converse with someone at a radically different eye level. Somehow it just feels uncomfortable – reinforced by

the expressions 'looking down on' or 'looking up to' someone. It's quite possible to recreate similar tensions by photographing people from above or below. However, be wary of overusing the technique. Just as we feel most comfortable talking to someone at the same level, so too do we feel most comfortable viewing portraits that have been taken at the same eye level. This is often most important when photographing

children and with close-up, head-and-shoulder portraits – it definitely pays to kneel down so that the camera is at the child's eye level.

ABOVE When photographing a person sitting down, or a child, avoid pointing the camera down at the subject as this can create tension as he or she looks up into the camera.

ABOVE By getting down to the same level as the subject, they can look directly into the camera, so avoiding any tension in their face from looking up or down at the camera.

ABOVE Similarly, avoid photographing people from below unless you're trying to make them appear more powerful and authoritative or you are making a deliberate photographic point.

Just as shooting the same scene from different heights can provide new perspectives so, too, can trying out alternative angles. Generally we react most positively to accurately aligned horizons, but occasionally, with an appropriate subject matter, a skewed horizon or misaligned vertical can create a sense of unease and add drama to an image. Experiment with all sorts of varying angles to see what results you can achieve.

General photography

If you come across an interesting scene worthy of photographing, try experimenting with shots from different heights. Kneeling or lying down will provide new perspectives, as will finding something to stand on or finding a much higher viewpoint from which to shoot.

In addition, there's no rule that states that the camera must be held either vertically or horizontally straight. Try taking a few shots with the camera at an angle as this, too, may add a fresh perspective on a common scene. Any unusual viewpoint is likely to create an image that will attract and hold the viewer's attention.

ABOVE Shooting from a great height can sometimes provide a new perspective on a familiar scene, with shape, form and line being made more apparent.

RIGHT The unusual viewpoint of a copy of Michelangelo's David, which stands outside the Palazzo Vecchio in Florence, helps to maintain our attention.

BELOW Taken from eye level, these mushrooms would have become lost against the field. By getting down low and using a wide aperture to give a shallow depth of field, they've become the focus of this photograph and have been put in the context of their surroundings.

BELOW Photographing buildings, and specifically skyscrapers, from below helps to reinforce their size.

Shape and Form

The visual building blocks that make up our images can be thought of as shape and form. Often it is their proportion and relationship to the space they sit in that make the difference between a good image and a great one. For many photographers – and, in particular, those who have had little art education – it can sometimes be difficult to differentiate between shape and form. So, let's look in more detail at these two elements and see how they fit into the overall composition of an image.

Shape

The simplest way to visualize the difference between shape and form is to think of shape as two dimensional and form as three dimensional. Our concept of shape develops at a very early age, and is something that we encourage our children to learn. Our almost instantaneous and positive reaction to shapes can be successfully

exploited in photography, so try to make a habit of looking out for both natural and man-made objects that have clearly defined shapes. Start by looking out for simple outlines such as circles, squares and triangles and progress to shooting more complex shapes, such as flowers, architectural details, the crook of an elbow or the curve of a back.

Silhouette

As another type of shape, silhouettes are an effective way of exploiting the outlines and shapes made by specific objects, especially if photographed against a strong light, such as the sun or a full moon. Alternatively, for a portrait photograph, place a table

LEFT Although the lighting is soft in this eye-catching photograph of decaying gears, the shadows between the teeth give them a three-dimensional form.

ABOVE Light coming from the side casts shadows that are the best tool for helping to describe a subject's form.

light behind the person's head and ask him or her to turn their head 90° to the camera for the shot.

Form

Although silhouettes exploit our recognition and understanding of shape, they can appear very two-dimensional and lack 'body'. This is where form comes into play. To appreciate the three-dimensional aspect of an object, we need to see its form, and for us to fully appreciate the form, we need light and shade. Look for smooth, rounded objects and photograph them in soft, even lighting. The relationship between the light and dark areas provides us with the visual information we need to recognize the object's form.

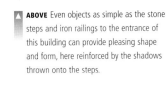 **ABOVE** In black and white photography, the relationship between the tones in an image is essential in describing the subject – without colour, it is only the interplay of light and dark that tells viewers what they are looking at.

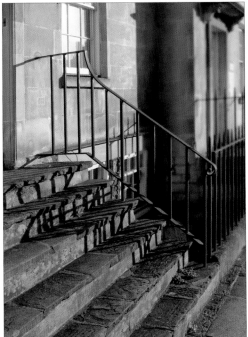

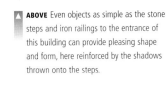 **TOP** It's not always necessary to see every last detail to recognize what something is or evoke a response. Here we can almost feel the heat from the sun, while the silhouetted flag and chair suggest a beach setting.

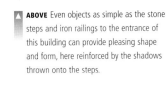 **ABOVE** Even objects as simple as the stone steps and iron railings to the entrance of this building can provide pleasing shape and form, here reinforced by the shadows thrown onto the steps.

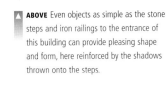 **ABOVE** Contrast plays a key part in describing form in a subject. Here, there is contrast between the lit and shaded sides of the monument, as well as between the light stone and brooding sky.

Pattern and Texture

Two other compositional tools to consider in photography are pattern and texture. Of the two, pattern is probably the visual element that you're less likely to think of as a strong compositional tool. When we think of patterns, many of us might initially consider the repetitive shapes and colours found in wallpaper or curtains, whose function is sometimes to create a visually relaxing backdrop that doesn't overly stimulate our senses or attract attention.

Lateral thinking

So how can you use a pattern to provide a visually stimulating image? As a photographer, your aim should be to provide a view of the world that others have not considered before. Spotting patterns in everyday objects and scenes will provide a fresh and new perspective on the world. More

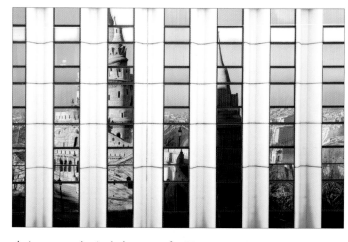

ABOVE There's a good contrast in this image between the regular pattern of the windows themselves and the irregularity of the old buildings reflected in the glass.

▼ **BELOW** Interesting patterns are all around us – we just don't tend to notice them. If you look a little harder, you will find potential subjects everywhere, such as these neatly aligned mobile homes.

obvious examples include a row of flowers of a similar shape, the uniform ripples in an area of sand, a tiled floor, a brick wall or a flight of stairs. But what about a row of identical cars on a production line or hundreds of stacked cargo containers? These all have the repetitive elements of pattern, and if shot sensitively – in the right light and following some of the other rules of composition discussed already – they

can create a striking image and, depending on the subject matter, may also convey a message.

Remember to look out for elements that break the pattern, as this will help to create an even stronger composition. Supposing in the sea of red cars or containers one or two were blue or silver – both would break the pattern and add drama. Once you've spotted a pattern, don't simply record it and move on. Consider other angles that might reveal other patterns that you had not seen initially.

Proximity and light

Unlike pattern, texture seems to have a much more immediate relevance and resonance as a compositional tool. Our sense of touch is highly developed and at times seems to have a direct link to our sense of sight – we only have to look at an object and in most cases we know instantly how it will feel to touch it. Teasing out the texture in the

objects we photograph will, therefore, elicit a strong response from viewers, even though they know it is simply a two-dimensional image of the object.

To really appreciate the texture of individual objects, you'll often need to focus as close as you can to the object you're photographing. Light needs to meet the object's surface at 45° or less so that the object casts shadows, which emphasize the texture itself. To ensure the texture is as pronounced as possible, the object is best lit from one side, as this will create the strongest shadows. So, if you're shooting outdoors and you want to capture the texture of peeling paint on an old wall (at 90° vertical), shoot when the sun is high in the sky (at around midday). However, if the object is flat on the ground, shoot early in the morning or late in the afternoon when the sun is lower.

Although we usually get in close to isolate an object's texture, this isn't a hard and fast rule. Texture can also be appreciated on a much larger scale, particularly if it helps to convey an emotion or message. For a texture-filled landscape, for example, set your lens to its widest angle and get low down to the ground to ensure you focus as close as you can to what's beneath you. Point the camera up slightly so that the distant view is also visible and then make a couple of exposures.

Composing with Lines: Horizontals

In photographic composition, lines, no matter how they are formed, whether artificial or natural, are a key element – from the horizontal horizon of a serene landscape, through the powerful, towering verticals of a cityscape, to the diagonal lines that can lead a viewer's eye through a photograph.

On the next few pages, we will look at how lines can add structure to a composition, and how – if badly managed – they can spoil an otherwise good composition.

Landscapes

Horizontal lines in the composition of an image are likely to be most apparent in landscape photography, where a horizontal format best suits the subject matter. Horizontal lines tend to imbue an image with a feeling of calm and stability, and even timelessness and permanency.

▼ **BELOW** The unbroken horizon works well with the much smaller broken horizontals of these hay bales.

Horizons

The most commonly occurring horizontal line is the horizon of a landscape or seascape, which will often be the basis from which the rest of the image emanates. An unbroken horizon can sometimes make an image appear flat and lifeless, so try to punctuate it with other elements, such as trees, hills or buildings, unless

▲ **ABOVE** This image mixes horizontals and verticals. The groynes, clouds and the sea form strong horizontals, but the groynes themselves are also vertical, contrasting with the clouds.

▼ **BELOW** The repetitive horizontal lines of the bridges running off into the distance create a sense of tranquillity in this late afternoon photograph of Prague.

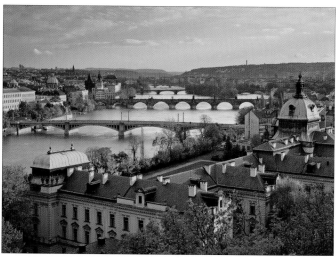

you're trying to convey a specific message or visual impact. Additionally, concentrate on ensuring that the horizon is as straight as possible.

Rule of thirds

When deciding where the horizon should be positioned in your image, remember the rule of thirds (see pages 50–51). As a general rule, images tend to work better if the horizon is either a third up or down the image – but this is only a guideline and there are plenty of successful images that feature horizons in the centre of the frame. Horizontals also help to add depth to photographs by providing visual breaks. Think of a view down a city river that features a number of bridges or a landscape image that shows fields of different crops running off into the distance.

Portrait format

If there are a number of strong horizontals in the scene, try turning your camera through 90° and taking a portrait-format photograph. Too many horizontals can cause the eye to tire, but as a portrait-format shot, the eye will tend to look down and register the depth of the image.

▲ **ABOVE RIGHT** When an image displays so many horizontals that the image, if shot in landscape format, would tire the eye. In these instances, it's better to shoot portrait.

▶ **RIGHT** The numerous broken horizontals of the roofs of the houses add to the chaotic atmosphere of this image.

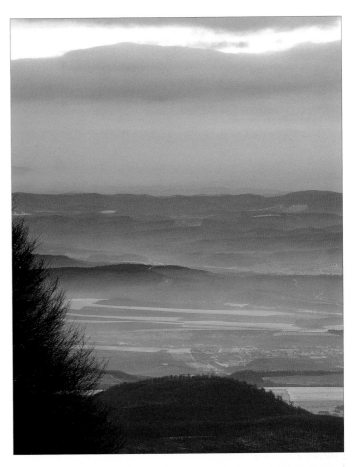

Straight horizontals

If horizontals are a significant element of an image's composition, it's essential that they are straight. If you don't intend to edit your images on computer, use a tripod with built-in levels to ensure horizontals are exactly straight.

Composing with Lines: Verticals

Like horizontals, vertical lines can also convey strong emotions. Power, grandeur and strength are all words that are associated with images that feature numerous vertical lines.

Many of the rules that apply to horizontals also apply to verticals, not least trying to keep them parallel to the edge of the image. This can be quite difficult, as they often feature in images in which the camera has been pointed upward in order to capture the entire scene. This can create the problem of 'converging verticals', where a building or other tall object seems to grow increasingly narrow the higher up you look. It's the same as the vanishing point effect in which railway lines appear to reach a single point as they stretch out into the distance – only with converging verticals you're looking 'up' rather than 'along'.

If you have a single, vertical object in the image, use the rule of thirds and don't place it in the middle of the frame, unless the resulting symmetry adds to the composition.

Landscape format

Most photographs that contain strong verticals are usually shot with the camera held vertically, not only to better accommodate the image, but also to accentuate the height of the vertical lines. As with horizontals, however, it doesn't always have to be this way. Experiment by shooting the odd frame in landscape format. Numerous vertical lines all in a row can accentuate the width of the scene or form a pattern. In addition, try to remember that your images will be reproduced in two dimensions and visualize this when you are out taking photographs. For example, lines that are painted on a flat road

RIGHT The strong vertical lines of the trees are exaggerated and emphasized by choosing a portrait-format shape for this photograph.

BELOW The verticality of many modern cities makes for very dramatic images and conveys a sense of scale.

leading off into the distance will translate as converging verticals in your two-dimensional image, adding not only a sense of depth to the image but also leading the eye.

▶ **RIGHT** Look out for the pattern that occurs in repeating vertical structures.

▲ **ABOVE** The height of this imposing bell tower has been exaggerated by using a wide-angle lens placed at the base of the tower and pointed upward.

▶ **RIGHT** The mix of vertical lines in the field and the horizontal row of trees in the distance work in either a portrait or landscape format, with the horizon remaining central in the frame.

Composing with Lines: Diagonals

While strong vertical and horizontal lines provide structure to an image and create visual boundaries, they can at times 'ground' an image, making it solid yet static. If you want to add a sense of movement to an image, look for strong diagonal lines instead. These tend to produce the most dynamic results and lead the viewer's eye through an image, especially when they lead to the subject of the photograph.

Symmetry

It's unlikely that it would happen, but avoid recording a line that runs directly from one corner of the image to another. Diagonals work better when they appear from one-third/two-thirds up or one-third/two-thirds along the frame – and usually from bottom left if they are to serve as a leading line.

Of course, if you're trying to show how different two areas of a specific scene are, then dividing them exactly in half with a diagonal that runs corner to corner may well provide a striking image.

ABOVE The diagonal representation of this common wildlife scene helps to make the image a little more dynamic.

BELOW The breaking waves form a diagonal, leading the viewer to San Francisco's famous Golden Gate Bridge – the subject of the image.

ABOVE Diagonal lines work best when they don't run from corner to corner, but instead enter the frame one-third or two-thirds up or across the image, as in this shot of a lone ski lift chair.

Most of the time, one diagonal line will be enough to add dynamic effect and to lead the viewer's eye into the frame, but look out also for clashing diagonals as these can add tension to an image and create a sense of chaos (which may or may not be a good thing).

Vanishing point

One of the most powerful ways in which diagonals are used is when they converge to create a vanishing point. When we first think of vanishing points, we usually think of the somewhat clichéd railway tracks or roads, but vanishing points occur naturally as well, it's just that they're usually less well-defined in form, tone or colour. For example, you may find you can create a vanishing point by using a diagonal line of clouds converging on a hedge that runs from you into the distance.

ABOVE The wall in this image runs diagonally, but it isn't that successful as it runs across the frame in the wrong direction – from left to right and out of the frame.

BELOW The raking diagonal highlights add to the sense of movement and purpose in this shot, and create a contrast with the pattern of the tiled floor.

ABOVE The converging diagonals of the power lines take the viewer into the shot and out the other side.

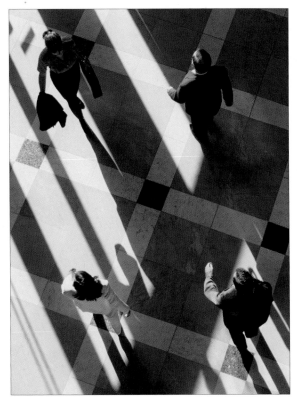

Composing with Curves

Lines – whether horizontal, vertical or diagonal – can all help to add structure, inject movement and elicit specific emotional responses from a composition. But what do curves do for an image? Curves, like diagonals, tend to add dynamism and movement to an image and help to lead the viewer's eye through it. Furthermore, several conflicting curves can add tension and chaos to a composition.

S-curve

The most powerful compositional curve is the S-shaped curve, or S-curve. This not only provides motion to an image, but it also adds balance and grace. Look out for S-curves both in nature, such as a meandering river or the edge of a stand of trees, or ones that have been made artificially, such as a winding path. The latter provide a visual way through the image and suggest to the viewer both a literal and metaphorical journey.

ABOVE The curves of this Greek Orthodox church contrast against the vertical and horizontal lines of the cross.

LEFT Most of the compositional curves that appear in photographs are likely to be made up of something solid and fairly permanent – such as hedgerows, roads or river courses – but remember you're freezing an instant in time, during which anything can form a curve for a short time.

Leading lines

During our discussion of diagonal lines and curves, there has been a number of references to 'leading lines' and 'leading the eye'. As their names suggest, leading lines lead the viewer into the image, and should ideally lead the viewer's gaze to the subject of the image.

Leading lines tend to work best when they start from the bottom left of the frame, as it's more natural for the eye to 'read' from left to right. An important tip to consider, however, is that while it's good practice and recommended that the line can lead in from an edge, in most cases it's unwise to have it running out of the frame at the other side. The reasoning behind this is that while you want to encourage viewers into the frame with a leading line, you don't want them then to follow the line out of the frame, without stopping and considering the image for a while.

BELOW In this image, the curve of the tree wraps around the figure, drawing our attention to the subject.

BELOW The slight S-shape to the remains of the sea at low tide adds movement to this image, as well as drawing our attention to the boat.

Using curves

When walking around looking for potential landscape images, remember that not all landscapes are shot with a wide-angle lens or zoom setting. Telephoto lenses or settings can reveal compositional elements that were not immediately visible with wide-angle lenses.

TOP Curves, like diagonals, can act as leading lines, taking or guiding the viewer through an image. The most successful are leading lines or curves that lead the viewer from the edge of the frame into the body of the image where the subject can be found.

ABOVE Here, a rusty old mooring chain revealed only at low tide acts as a leading line curve to the house beyond.

Landscape versus Portrait

A clue to the novice photographer's picture collection is that it's likely to contain images shot solely in the horizontal, landscape shape, or format. Convention used to dictate that landscapes were shot horizontally and portraits vertically, but it doesn't have to be that way, and nor should it be.

Fresh perspective

There are plenty of examples when turning the camera through 90° will provide you with a much better shape for your landscape image. Trees obviously spring to mind, especially if you've had to retire some distance to fit your subject into the landscape format. By photographing a golden, autumnal tree in the vertical format, not only are you more likely to be able to get closer, you'll also avoid having unwanted elements to the left and right of the tree in the frame.

ABOVE Not all portraits have to be taken in an upright, portrait format – the rules can be broken. The lines of the gate and the gatepost contain this image, while the subject is perfectly placed using the rule of thirds.

LEFT Using a portrait format has emphasized the shape of the terracing of these paddy fields and helped to add depth to the fields in the distance.

There are many examples where shooting landscapes vertically will offer a much more complementary framing shape – mountains, valleys and rivers may all benefit from this treatment. Try to get into the habit of framing a potential landscape in the vertical format, even if you've successfully captured the scene in the more conventional horizontal landscape format. After a while, you'll look at landscapes in different ways and when you come to show your images to other people, particularly when putting a small portfolio or exhibition together, you'll be grateful for the variety of images in both shapes.

Architecture

Buildings and cityscapes offer more opportunities to experiment with both horizontal- and vertical-format photographs. Once you've become used to turning your camera, you'll start to see how certain elements make for an attractive landscape format image, while changing your angle or point of view slightly may bring other background elements into play that would make for a more pleasing portrait-format shot.

In context

While full-length portraits lend themselves to the vertical format, not all portraits need to be shot this way. A landscape format may be the better option, depending on the position of your subject's arms – especially if outstretched – or whether you want to include contextualizing background. Also, don't forget the rule of thirds. Even if the portrait is just a head-and-shoulders shot, you may want to position the subject to one side to avoid it being in the centre of the frame.

LEFT AND BELOW Both of these images are of the same scene taken from an identical viewpoint, but they both look very different. In the first image (left), a wide-angle lens and portrait format show us much more of the scene, while in the second image (below), a long focal length lens and a landscape format create a tightly cropped picture.

LEFT It pays to experiment with a landscape or portrait format. Here the photographer has used a portrait format to emphasize the long reflection of the sun on the sea.

ABOVE In this landscape version, the sun's reflection plays a less important role, but the wider format includes more of the delicately coloured sky and the calming horizontal of the land.

Compositional Balance

When you look at certain images, particularly those that feature two or more key elements, you may often get a sense that things aren't quite right, although the reason for this is not immediately apparent. If so, it may be that the image is unbalanced in terms of its composition.

Vertical axis

Balance in composition is mostly determined by how well the primary elements of the image are divided by the vertical axis that runs more or less down the centre of the image.

Balance can also be achieved through the horizontal axis, such as the reflection of a tree in a pond.

Symmetrical balance

The easiest and most straight-forward compositional balance is often referred to as 'symmetrical' balance. As its name suggests, symmetrical balance is achieved when two objects of equal 'weight' are positioned on either side of the central vertical dividing line, so that one object on one side of the image balances out the other object on the other side.

Symmetrical balance creates a sense of stability, order and tranquillity in an image, and it is used successfully in architectural photography, formal group portraits and for any number of 'artificial' landscapes, such as an avenue of trees or a formal garden.

Asymmetrical balance

While symmetrical compositions certainly provide visual balance and bring a sense of order and calm to an image, viewing a succession of symmetrically balanced images would ultimately be a rather dull and boring affair. Of much greater visual interest are asymmetrically balanced images. These can provide a sense of depth to an image and are much more dynamic, but you do need to think harder about how balance is achieved.

Asymmetrical balance works on the basis that objects in an image each have their own visual 'mass' – whether it's their physical size, how colourful they are, how bright they are, whether or not the object is in focus and so on. A well-balanced image will have the various components arranged in such a way

◀ **LEFT** This picture is a strong example of a symmetrically balanced composition, where the two towers in the background balance each other perfectly.

◣ **ABOVE** This scene also relies heavily on a symmetrical composition to balance the image – in this case with the row of trees and their reflections in the water.

that their various 'weights' are balanced. For example, objects with greater contrast have more weight than low-contrasting elements, therefore to achieve balance the low-contrasting element needs to be bigger than the high-contrasting one.

There's no quick way to master asymmetrical balance, and rather than stifling your creativity by

ABOVE Colourful subjects and larger subjects may carry more weight in a composition, but this is balanced here by the figure in the foreground being in sharp focus.

rigidly sticking to the 'rules', it's better to keep shooting and simply be aware of how objects of a different size, colour, contrast and visual appeal interact with each other.

ABOVE This asymmetrical composition is well balanced thanks to the colours of the sea and the sand, their relative sizes and the isolated subjects at the bottom and top.

Asymmetry in action

It is important to be aware of the weight that the different components in an image carry. The basic ideas are:

- An object at the edge of the frame has more weight than a centred one.
- Irregular shapes have more weight than regular ones.
- Colourful elements carry more weight than less-colourful ones.
- Isolated objects carry more weight than those that are surrounded by other objects.
- More interesting objects attract greater attention than less interesting ones. For example, people's faces have greater weight than buildings or landmarks.
- Objects in focus take precedence over out-of-focus objects.
- Objects being looked at by people in an image gain emphasis.

ABOVE While our attention is initially grabbed by the larger boat in the foreground, the image is balanced thanks to the smaller boat in the background and to the right.

ABOVE Symmetrical balance is easily achieved in this image of an avenue of trees in a misty parkland setting. The trees also create a pleasing vanishing point.

Basic Composition – Try it Yourself

Now that we've looked at some of the basic compositional tips, it's time to get shooting. Below is a short summary of the compositional 'rules' discussed so far, with some key assignments that will help you to explore them further so you can begin to see for yourself how following some of the rules some of the time can help make your images more dynamic. Remember, it's important not to get too tied up with these rules, particularly if you start to find that you're not taking any photos at all because your scenes don't apparently meet any of the compositional requirements. Often a scene will look inviting, yet you can't quite understand why. Don't stop and try to work out what compositional rules it's fulfilling; simply take the shot and review your image later.

Shape and form

Fill the frame

Keep it simple
Take several shots that make it very clear to the viewer what the subject of the picture is. Try to ensure there isn't any marginal clutter or any other distracting objects.

Framing

Fill the frame
Take a few shots of different objects that appeal to you because of their shape, colour or form, or because the light reflecting off them is attractive. Really zoom into the subject to ensure that there is no surrounding clutter.

Rule of thirds
Try to find different scenes that fulfil the 'rule of thirds'. Bear in mind that you don't have to find four key elements to fit all the 'points of interest'. Sometimes just one or two will do to make an effective composition.

Framing
Create some instances where you have the opportunity of putting a frame within a frame. Remember that the key word is 'create', so you can be proactive here and take a picture of someone looking through a window or even take a shot looking out of a window. Bear in mind that the

frame should ideally be attractive in its own right and it should also complement the subject of the image in some way.

Camera height and camera angle
Take some shots with a radically altered camera height and others using different camera angles. The objective is to give a fresh perspective to a scene that will make the viewer take a closer look at the image.

Shape and form
Remember that we tend to use two-dimensional shape to recognize objects, while form gives an object a three-dimensional appearance. Take several shots of various objects so that the viewer gets only a sense of its shape, and then use different lighting conditions or a different angle to take some more shots of the same objects that provide the viewer with a sense of the objects' form.

Vertical lines

Landscape versus portrait

Leading lines

Texture

Pattern and texture

A fun and surprisingly rewarding exercise; simply take several images that exploit an object's pattern or texture. Remember to consider the angle of the light to emphasize texture, and think laterally about what constitutes 'pattern'.

Horizontals and verticals

Shoot a few objects or scenes that evoke a sense of peace and calm due to the presence of horizontal lines and three objects or scenes that use vertical lines.

Working with diagonals

Look out for scenes in which a diagonal line leads the viewer through the image. Ideally it should take the viewer to the subject of the photograph.

Curves and leading lines

S-curves and leading lines help viewers into the image, and ideally take them to the subject of the image.

Look for S-curves and leading lines in both nature and man-made scenes and try to take five images that feature these compositional aids.

Portrait versus landscape

When you find a good subject for a photograph, it's worth considering the benefits of turning the camera through 90° to see if it provides a fresh perspective. Remember that landscapes don't always have to be shot in a landscape format, and nor do portraits always have to be shot in the standard portrait format.

Compositional balance

From now on, try to think about achieving compositional balance in your images. If one of the subjects of your image is large, try to offset it with one that is smaller, but pushed more to the edge of the image area, or is more colourful, brighter, has greater visual appeal and so on.

Creative Capture

Armed with a sound knowledge of the camera's settings, we put that knowledge to more creative uses in this chapter. The key principles of exposure, depth of field and selective focusing are covered – all of which are essential concepts to understand in order to advance your photography. Also explored is the significance of shutter speed and how it can be used to creative effect. We take a look at lighting and the pivotal role it plays when taking photographs. Finally, following a review of focal length, the chapter concludes with an examination of black and white photography and how to achieve stunning black and white photographs in the digital age.

Understanding Exposure

The most fundamental technical aspect of photography is perhaps exposure. The positive news for experienced film photographers is that when it comes to exposure, digital cameras behave almost exactly like film cameras. For those who are new to photography, exposure governs whether a picture is too bright, too dark or just right – although this is often subjective.

There are three settings that govern exposure – the shutter speed (which determines how long the sensor is exposed to light); the aperture (which determines how much light reaches the sensor); and the ISO setting (which determines the sensitivity of the sensor – see page 14). These three elements combine to provide a specific exposure – if one element is altered, one of the other two settings must also change if the same exposure is to be retained.

Shutter speed and aperture

To provide complete information about a specific exposure you need to know the shutter speed (usually a fraction of a second, but it can be much longer than a second), the aperture (expressed as an 'f'-number) and the ISO setting; this is why you will often see an exposure setting written as $^1/125$ sec at f/5.6 (ISO 200). If these individual settings provided the 'correct' exposure, then altering one setting without altering either of the other two would result in an 'inaccurate' exposure. For example, if the shutter speed was reduced by half to $^1/250$ sec, the image would be underexposed. If, however, at the same time the shutter speed was reduced by half the size of the aperture was doubled (from f/5.6 to f/4), or the ISO setting was increased to 400, then the exposure would remain the same – in this way, $^1/125$ sec at

f/5.6 (ISO 200) provides the same exposure as $^1/250$ sec at f/4 (ISO 200), which in turn provides the same exposure as $^1/250$ sec at f/5.6 (ISO 400).

ISO settings

It is only since the advent of digital photography that the ISO setting has played such an integral part in governing exposure. Previously, the relationship between shutter speed and aperture primarily governed exposure, since you couldn't change the film in a camera with every shot. Now that digital ISO can be altered at will, this setting can be used in a proactive way to get the optimum exposure for every shot you take. The lowest ISO setting will always provide the best image quality, so you should aim to use the lowest possible ISO setting at all times (especially if you're using a compact camera), and only increase the sensitivity if, for example, there's a risk of camera shake due to slow shutter speed.

ABOVE In difficult lighting situations such as this, where a dark subject appears in front of a light background, the camera may underexpose the subject (as seen on the left) if left on Auto. By manually enlarging the aperture, the subject is accurately exposed (on the right).

Low ISO

Assuming, that you set the ISO at the lowest possible setting (while still being able to hold the camera without the risk of camera shake), it's the relationship between shutter speed and aperture that will ultimately dictate the exposure.

As we shall see over the coming pages, these are the two most important elements to control. The aperture setting determines the depth of field (how much of the scene is sharply in focus) while shutter speed determines whether a moving object is blurred or not. Aside from general composition, these two photographic controls govern how your images will look.

 ABOVE These three images were taken at the same time of day, but they appear very different. Using a tripod to ensure the scene was exactly the same, the first shot, the darkest, was given a manual exposure of f/5 at $^1/_{3200}$ sec (ISO 200); the second shot was taken using f/5 at $^1/_{200}$ sec (ISO 200); while the final image, the brightest image, was exposed at f/5 at $^1/_{16}$ sec (ISO 200). Manually altering the shutter speed has greatly affected the exposure of each shot.

| f/2 | f/2.8 | f/4 | f/5.6 | f/8 | f/11 | f/16 | f/22 |

EXPOSURE ALTERNATIVES

Aperture	f/2	f/2.8	f/4	f/5.6	f/8	f/11	f/16	f/22
Shutter speed	$^1/_{1000}$	$^1/_{500}$	$^1/_{250}$	$^1/_{125}$	$^1/_{60}$	$^1/_{30}$	$^1/_{15}$	$^1/_8$
ISO	100	100	100	100	100	100	100	100

ISO ALTERNATIVES (TABLE A)

Aperture	f/2.8	f/4	f/5.6	f/8	f/11	f/16
Shutter speed	$^1/_{30}$	$^1/_{30}$	$^1/_{30}$	$^1/_{30}$	$^1/_{30}$	$^1/_{30}$
ISO	100	200	400	800	1600	3200

ISO ALTERNATIVES (TABLE B)

Aperture	f/2.8	f/2.8	f/2.8	f/2.8	f/2.8	f/2.8
Shutter speed	$^1/_{30}$	$^1/_{60}$	$^1/_{250}$	$^1/_{500}$	$^1/_{1000}$	$^1/_{2000}$
ISO	100	200	400	800	1600	3200

LEFT This sequence of graphics shows the range of aperture sizes available on camera lenses. Not all lenses will have such a wide range; many for example will only offer from f/4 to f/16, but the diagram shows how the higher the number; the smaller the aperture. This has a direct bearing on depth of field. It also shows that changing the aperture from f/5.6 to f/8 halves the amount of light reaching the sensor, or alternatively how changing the aperture from f/16 to f/11 doubles the amount of light reaching the aperture.

LEFT With digital cameras, ISO setting plays a much more proactive role in determining exposure. If settings of f/2.8 at $^1/_{30}$ sec with ISO 100 provide an accurate exposure, by changing the ISO setting you will also either have to change the aperture (Table A) or the shutter speed (Table B). For example, in Table A changing the ISO to 800 has enabled an aperture of f/8 to be used, which provides much greater depth of field than f/2.8, so more of the image will be in focus. In Table B, changing the ISO to 800 has enabled a shutter speed of $^1/_{500}$ sec, which would be much more appropriate for fast-moving action.

Manual Exposure

Up to now, we've concentrated on the camera's various preset automatic and semi-automatic settings and modes found on almost all digital cameras. These help us to obtain sharply focused and accurately exposed photographs between 80–90% of the time in a variety of popular shooting scenarios. For many people, understanding these modes and settings will provide them with everything they need to get the photographs they want. However, if you want to stretch your creativity, take control and make the most of your camera in more challenging lighting conditions, it's important to understand how to use your camera in its Manual (M) mode. Experimenting with a variety of shutter and aperture settings with the camera in Manual, ensures that you end up with more accurately exposed images – more consistently.

Exposure

Having discussed how the relationship between aperture and shutter speed (and ISO setting) works to determine exposure, we're halfway there to understanding how to use a camera in its Manual mode.

With the camera in Manual you set both the shutter speed and the aperture independently of one another. This can lead to horrendous exposure miscalculations, particularly if you're used to using automatic or semi-automatic modes. You may, for example, set the shutter speed to $^1/_{500}$ of a second (sec) to freeze action and an aperture setting of f/11 to get as much of the scene as possible in focus, but unless you're in anything other than an extremely bright lighting situation at the time you press the shutter release, you're going to end up with a very underexposed image.

Alternatively, in the heat of the action, you may simply forget that the aperture is set on f/4 and keep firing away only to find that all your images are overexposed.

Viewfinder scale bar

To help you obtain the correct exposure in Manual mode, look through the viewfinder and there should be a form of scale bar. It will usually have a '0' in the centre and then some marks to both left and right (or above and below), with perhaps the figures '-1' and '-2' to the left (or below) and '(+)1' and '(+)2' to the right (above). The '0' indicates 'correct' exposure, while the minus figures indicate slight underexposure and the positive figures overexposure. Each mark is referred to as a 'stop', so +2 indicates 2 stops overexposed. You'll notice that as you adjust either the aperture or shutter speed settings, the marker will indicate the new exposure on the scale bar.

Aim for 'zero'

While ideally you're trying to 'zero' the exposure, anything within the -2 to +2 range will usually provide a usable image. In fact, this is the whole point of shooting in Manual mode. You may in fact find that when you review your images, the one with a -1 or even -2 setting (slightly underexposed) provides a better overall image than '0', which is theoretically more accurately exposed. This is down to complex lighting situations when the camera's metering system, however sophisticated, is not able to read your mind and know exactly what it is you're exposing for. For example, with the camera set in an automatic mode, in very shadowy conditions, the camera will often

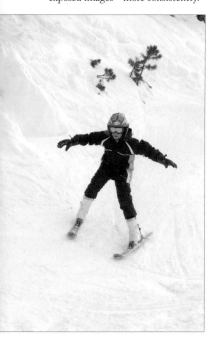

LEFT AND ABOVE Under certain lighting conditions, especially those in which there is a lot of reflected light, the camera's metering system is likely to underexpose the scene (as on the right). In cases such as this, exposure will need to be set manually.

overexpose the subject as the dark ambient light tricks the metering system into thinking it's darker than it really is. Similarly, in very light conditions, such as snow scenes, the opposite will often occur – the bright, reflected light will fool the camera into thinking it's brighter than it really is and underexpose the subject. When ready to shoot, set an appropriate exposure (aiming for close to 'zero'), take a shot and review the results using the histogram and image preview on the LCD. Adjust any settings if necessary and fire the shutter again.

If at any point during your exposure adjustment the pointer reaches the end of the scale bar and flashes, this may well indicate that the image, if taken, will be so over- or under-exposed that it will be un-usable.

Creativity

One of the principal reasons for using Manual mode is when you deliberately want an under- or over-exposed image for creative reasons. In any automatic or semi-automatic setting the camera will always aim to achieve a 'correct' exposure. As we'll see later, shooting in Manual mode is also often the only way to capture very low-light or night scenes.

Doubtless you'll find that when you first start shooting in Manual mode you'll work more slowly and make a number of exposure errors, but stick with it and you'll soon be reaping the benefits.

ABOVE Cameras with less sophisticated metering systems, such as centre-weighted metering, are more likely to get exposure wrong. Here the camera has exposed for the plants (left) resulting in an overexposed beach. Reducing the exposure by 2 stops (right) resulted in a far better photograph.

RIGHT Many cameras have a 'blown highlight warning' facility. When switched on, any 'blown' highlights in an image, when reviewed on the LCD screen, will flash (here shown in red) to let you know parts of the image are entirely overexposed.

BRACKETING

Most advanced compacts and dSLR cameras have the ability to 'bracket' images. Usually described as 'auto exposure bracketing' (AEB), the camera will fire three shots in quick succession, each with a slightly different exposure compensation setting. The amount of compensation can be pre-selected, but usually it's $\frac{1}{3}$-stop, $\frac{1}{2}$-stop and 1-stop (i.e. the bracketed images would be say '–$\frac{1}{3}$, 0, +$\frac{1}{3}$' or '–$\frac{1}{2}$, 0, +$\frac{1}{2}$'. The images below were bracketed a full stop.

Exposure -1 stop Exposure 0 Exposure +1 stop

Manual Focus

With digital camera manufacturers spending so much money on research and development into increasingly sophisticated autofocus modes, a novice photographer might wonder why we need to focus manually?

While your camera's autofocusing system is likely to provide sharp images the majority of the time, as we've already seen, there are occasions when even the most advanced autofocus modes can fail to work. These include in low-light conditions when the camera cannot 'see' well enough, or when there is insufficient contrast for the camera to detect the point of focus. Similarly, if there are a number of potential subjects, the camera may not know which one to focus on. While you can often select a specific focus point that the camera will use as its reference point, it can sometimes be quicker to focus manually.

In addition, focusing manually may be necessary when the main subject of an image is behind a distracting foreground, such as a window, iron railings or the bars of a cage. In these instances, the camera's autofocusing system may continually try to focus

ABOVE In landscape photography, there's little need for a fast autofocusing system. With subjects like this, the camera may not always focus where you want it to.

BELOW This image was taken through an airplane window. The photographer manually focused on the land in case the camera autofocused on the window.

Focus ring

Cameras that are best suited for manual focus are those that feature a focus ring on the camera lens, such as dSLRs or fixed-lens dSLR-like cameras. Although many compacts have a manual focus option, this will often involve the use of buttons, which can be cumbersome to operate, slow to react and use up valuable power. A manual focus ring, on the other hand, is quick, intuitive and uses no power.

on the foreground object rather than the background – switch to manual and your problems are solved.

Shutter lag

In our earlier discussion of autofocus modes, we covered the issue of shutter lag, which is particularly apparent in sports and action photography. One way to avoid this annoying time lag is to set the focus to manual and prefocus on the area in which the action is about to take place. Half press the shutter release so that the camera makes its other calculations, such as setting the correct exposure and white balance, and as soon as the subject comes into view, fire the shutter. This can work using autofocus as long as the camera has something to focus on that is on the same focal plane as the action, but often the area you'll want to focus on is empty until filled by the action, and the camera may well focus on an object beyond the area of interest. Of course this will only work in those sports, such as motor racing, in which you can predict where the action is going to take place.

Close-up/macro

In some instances, especially with close-up or macro photography, it becomes almost impossible to use autofocus, as the subject is so close to the lens. As we'll discover, more often than not, it's much easier to set the camera to manual focus and the lens to its shortest focusing distance, and physically move the camera backward and forward, until the specific element you're trying to capture is in focus.

▲ **ABOVE LEFT** Using manual focus may well be the only way to deliberately shoot a scene out of focus for creative effect.

▲ **ABOVE** With low light scenes, focusing manually is essential as very few cameras will be able to 'see' to focus in such dark lighting conditions.

▼ **BELOW LEFT** An increasing number of dSLRs feature 'Live View', in which the LCD screen can be used to focus a shot. This is a more convenient way of focusing macro shots.

▼ **BELOW** If your camera's autofocus can't keep up with fast-moving subjects, pre-focus on the ground, for example, on which the action will take place and wait for your subject to enter the frame.

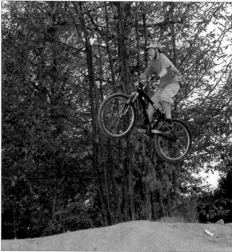

Depth of Field

RIGHT These three images show narrow depth of field. Using a wide aperture of f/4, depth of field has been restricted so the photographer can simply focus on different areas in turn to bring them into focus.

Focus on farthest trees

Although we've yet to cover the topic in detail, the term 'depth of field' has already cropped up in numerous places. That's unavoidable as, after 'exposure', it is the second most fundamental aspect of photography.

Depth of field (DoF) is a technical way of describing how much of an image is in focus – its 'zone of sharpness'. An image with narrow or short depth of field is one that has a small zone of sharpness, while an image with a wide depth of field has a large zone of sharpness.

Point and shoot

If, up until now, you've been using a point-and-shoot camera, you may never have given depth of field a second thought. That's because the lens on a point-and-shoot camera, especially a fixed (non-zoom) lens, is deliberately designed to provide the maximum possible depth of field – the rationale being that for holiday and similar snaps most people will want their images to be sharp all the way from the foreground to the background.

However, with advanced compacts and dSLRs, you can control the depth of field so that a selected area of the image, whether foreground,

Aperture priority

The safest way to experiment with depth of field is to set the camera to Aperture priority (A/Av). In this semi-automatic mode, you can alter the aperture setting, and thus change the depth of field, knowing that the camera will adjust the shutter speed automatically, and/or the ISO setting (when set to Auto) to ensure you still get an accurately exposed image.

background or the middle distance, is in focus. Selective focus is a key element in more advanced photography.

Aperture

Let's look in more detail at the factors that control depth of field; there are essentially three.

The first and most obvious factor determining depth of field is the aperture. It's been impossible to avoid any discussion of how the size of a lens's aperture affects depth of field as they are so closely related. But to reinforce the concept here, a large aperture (small number, such as f/2.8) will create a small or narrow depth of field, while a small aperture (large number, such as f/16) will create a large or wide depth of field. Because the amount of available light has a direct impact on the aperture setting (in other words the amount of light that reaches the sensor), it therefore follows that the amount of available light also has some impact on depth of field. For example, in low-light conditions (assuming an ISO setting of 100), the only way to achieve a wide depth of field (using a small aperture of f/11) would be to have a long exposure of, say, 2 sec or longer, in which case you'll certainly need a tripod. The opposite happens in very bright conditions, where the only way to achieve a very

narrow depth of field (using a large aperture of f/2.8) would be to have an extremely fast shutter speed of, say, $^1/_{4000}$ or even $^1/_{8000}$ sec. Many cameras don't have those fast shutter speeds, so the only way to achieve such a shot would be to use dark filters over the lens to restrict the light striking the sensor. Although extreme, these examples illustrate why it's so important to familiarize yourself with your camera's manual controls so that you can achieve the shots you want in the conditions that are available to you.

Focal length

The second factor affecting depth of field is the focal length of the lens. Wide-angle settings on zoom lenses (such as 28mm) provide greater depth of field at the same aperture setting than telephoto lenses or telephoto settings (such as 200mm). We won't go into the optical rules that make this so, but it's important to understand how depth of field is affected by focal length so that you can begin to 'previsualize' the results you can expect from varying focal lengths. Having done so, you will then begin to make considered judgements about how different lenses or zoom settings can achieve different creative results. There's

Focus on middle tree

Focus on nearest tree

certainly more to focal length then simply getting 'closer' or 'farther away' from your subject.

Focusing distance

The final factor that determines depth of field is the distance between the subject and the lens. The closer the subject is to the lens the narrower the depth of field. As the subject moves farther away from the lens the depth of field increases, up to a point where – depending on the focal length of the lens and the aperture setting – everything beyond will be in focus. This is often referred to as 'infinity' (∞).

Preview button

Many dSLR cameras have a depth of field preview button that helps to show an image's zone of sharpness before taking a photo. Simply press it after setting the aperture. The viewfinder will likely darken as the aperture closes to the chosen setting, but you'll get a preview of what will be in focus.

APERTURE

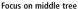

50mm f/1.4

50mm f/5.6

50mm f/16

LEFT Changing the size of the lens aperture radically alters the amount of the scene, from foreground to background, which is captured in focus (represented by the yellow blocks). The wider the aperture (the smaller the number), the less of the scene is in focus.

FOCAL LENGTH

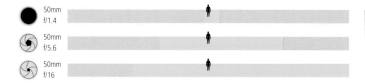

28mm f/5.6

50mm f/5.6

200mm f/5.6

LEFT The second factor affecting depth of field is focal length. As the diagram shows, the longer the focal length (shown in millimetres), the narrower the depth of field. Compare the wide-angle (28mm) lens with the telephoto (200mm) lens.

FOCUSING DISTANCE

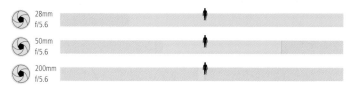

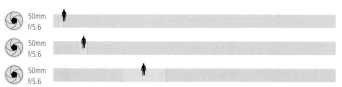

50mm f/5.6

50mm f/5.6

50mm f/5.6

LEFT Finally, distance affects depth of field, although compared with the other two factors, the variation is much smaller. With the same focal length lens set at the same aperture, depth of field increases the farther the subject is from the camera.

Wide Depth of Field

Landscape photography springs to mind most readily when we think of wide depth of field, with photographers traditionally aiming to ensure that the zone of sharpness is as great as possible.

Sweeping views

For broad, sweeping, pin-sharp landscape views choose a wide-angle lens or zoom setting (around 28mm is appropriate) and 'close' the aperture down as far as it will go – in other words set the aperture to its smallest opening (highest 'f' number). The most appropriate mode for controlling the aperture setting is, unsurprisingly, the Aperture priority (A/Av) mode. If possible, place the camera on a tripod or a stable surface and select the camera's self-timer; alternatively use a shutter-release cable or remote shutter release.

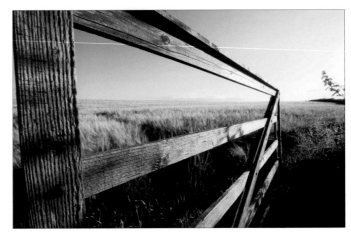

Next, frame the shot, focusing a third of the way into the image (see Hyperfocal distance box), which should provide you with the deepest possible depth of field. Using both a

ABOVE A wide depth of field coupled with a wide-angle view can be used to good effect to show scenes from unusual viewpoints.

tripod and self-timer/remote or cable shutter release will ensure that the camera is as stable as possible when the shutter actually fires. This is particularly important in low-lighting conditions when the shutter speed may be a relatively slow $1/15$ sec or $1/30$ sec. Fixing the camera to the tripod and then using your finger to press the shutter release is somewhat self-defeating as you're likely to shake the camera, although only by a tiny fraction, which can soften the image.

Review

Once you've taken the shot, review the principal elements of the image to check that they're sharp. You may want to make adjustments to the point of focus depending on which parts of the image are more significant. If the foreground plays a more important role in the composition than the background for example, you'll want the foreground to be sharper than the background.

HYPERFOCAL DISTANCE

One technique employed by all professional landscape photographers is hyperfocal focusing. This works on the basis that when you focus on a subject, a third of the scene in front will be in focus, while two-thirds behind will also be in focus – the point of focus is known as the hyperfocal distance. Focusing here will give you the maximum possible depth of field. There exist fairly complex charts (www.dofmaster.com) that will tell you exactly what the hyperfocal distance will be for a given focal length at a specific aperture.

However, an easier, if not absolutely accurate way to find the hyperfocal distance is to focus manually a third of the way into the scene. This will give you maximum depth of field.

ABOVE By focusing at the hyperfocal distance, everything from foreground to background is sharp in this shot.

ABOVE Ensuring that the path from the bottom of the image is sharp has helped to reinforce it as a leading line.

ABOVE Keeping the view of Budapest in focus in the distance helps to reinforce the relationship between the statue and the city.

Handheld photography

If you don't have a tripod or anything on which to rest the camera when shooting landscapes, check that, having set the aperture, the shutter speed is sufficiently fast to prevent camera shake. You may need to increase either the aperture slightly or the ISO setting to get a suitably fast shutter speed. You'll find yourself increasingly making this sort of compromise the more you take control of the camera. But doing it manually, rather than letting the camera choose the settings, means you're the one making the important decisions; and if you don't get the image you want when you come to preview it, you'll have a better idea about how to improve it.

ABOVE When using wide depth of field with a wide-angle lens in landscape photography, it's natural to want to include the horizon and sky. But remember, this can lead the viewer's eye out of the image. To contain the viewer in the picture, dispense with the horizon and sky. In the second image (right), by excluding the sky our attention remains much more focused on the bay and the picturesque town.

LEFT By including some sharply focused foliage in the foreground, the photographer has added a sense of depth and scale to this view of the Art Deco district of Miami.

Narrow Depth of Field

Deliberately throwing regions of an image out of focus might seem counterintuitive, particularly if you're used to a point-and-shoot camera that is designed to keep as much of the scene as possible in focus. However, being able to select which parts of an image are in focus and which are blurred is a fundamental aspect of creative photography and is often referred to as differential focus.

In the discussion on compositional balance in Chapter 2, we learned that an in-focus element attracts our attention much more than one that is out of focus. Photographers can use this to their advantage in a variety of situations by keeping depth of field down to a narrow margin.

Portraits

One genre of photography where restricting depth of field is often critical is portraiture. The ability to throw a potentially distracting background or foreground out of focus is the key to many successful

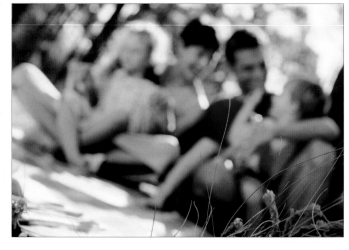

portrait shots, as it concentrates the viewer's attention on the subject of the image. The most effective way to obtain a narrow, or shallow, depth of field – so that only the subject is in focus – is to start with a telephoto lens or zoom setting between 100mm and 300mm. This is because telephoto lenses have a narrower depth of field

than wide-angle lenses, making it easier to throw backgrounds out of focus. Then, in Aperture priority (A/Av) mode, 'open up' the lens by selecting the largest aperture setting (smallest 'f' number). You'll find that this is exactly what the camera does automatically if you select Portrait mode. Having selected the largest aperture, make sure that the shutter speed is sufficiently fast to prevent camera shake. This is particularly important with longer focal length lenses or zoom settings, as these are more prone to suffering from camera shake because slight movement is exaggerated over distance. Position yourself at an appropriate distance from the subject so that just the head and shoulders are in the frame and fire the

LEFT Using a narrow, or shallow, depth of field can make a background less distracting, so the main subject stands out.

ABOVE As depth of field decreases the closer you are to your subject, there's a very narrow depth of field in macro photography.

LEFT A narrow, or shallow, depth of field helps the viewer to focus on the main subject of an image – in this case the baby.

BELOW We know what the subject of this picture is, despite most of it being blurred, but this adds to the creative effect.

shutter. When reviewing the image, you should find that the subject is nice and sharp and that the foreground and/or background is so out of focus that your eye glosses over them.

Evidently, it's not just portraiture photography that can benefit from controlling depth of field. Narrow depth of field has its place in just about all genres of photography, especially when it comes to nature and art photography. Later on in this chapter we shall be looking in more detail at close-up and macro photography, where a narrow depth of field can be particularly effective with shots of insects and flowers, or any small object photographed close up.

BOKEH

As your skill at controlling depth of field and using differential focus increases, you'll become aware of blurry hexagonal shapes, particularly in highlights. These are created by the shape of the lens's aperture blades as they close down to the aperture setting, and are called 'bokeh', the Japanese word for 'blur'.

Bokeh is a subjective aesthetic quality, but the general consensus is that the smoother and more circular the bokeh, the more pleasing the out-of-focus area. Much relies on the lens quality, and as such is out of your control. However, by adjusting the aperture you can control the amount by which the background is thrown out of focus, thus controlling the size of the bokeh highlights.

ABOVE 'Bokeh' are the circular, defocused highlights seen in the right of the image.

Depth of Field – Try it Yourself

Having covered the theory of controlling depth of field and armed with a knowledge of how to maximize or minimize the zone of sharpness, it's time to put that knowledge into practice. The exercises below are much easier to carry out, and the results more apparent, if you use a tripod, but it's not essential.

Increasing depth of field

Let's begin by learning how to increase depth of field, or the zone of sharpness. Place three objects about 24in (60cm) apart in a line on a long table. Size is not an issue, but apples and oranges are an appropriate size. Set the camera on the tripod about 3ft (1m) from the front object, but slightly higher and off to one side. Now, adjust the zoom lens so that the front object almost fills the viewfinder and the other two objects are still visible.

Focus on the lead object and select the largest aperture (smallest number) setting your camera lens has (for example, f/2.8). Take a photo and review it. You should find that only the lead object is in focus, while the other two are out of focus, with the rear object more out of focus than the middle one. Now, close the aperture down by about 3 stops (to f/8 in our example) and take another shot. On reviewing the second shot, the first two objects should now be in focus, but the final one still out of focus. Finally, close the lens right down (to f/22, for example). The final shot should feature all of your objects sharply in focus.

Focal length

As we know, adjusting a lens's focal length also impacts on depth of field. For this next exercise, take the camera off the tripod if you've been using one. Set the aperture to f/4 and set the camera lens to its longest focal length (in other words zoom right into the first object, but make sure the other two objects

are still visible), and take a picture, but from a slightly higher position than previously. Then set the lens to its shortest focal length (zoom out), but move closer to the objects so that the first one still fills the frame, and take another shot.

When comparing these two images, you should be able to see how the zone of sharpness is greater with the shorter focal length setting. It should also be apparent how the longer focal length has foreshortened the distance between the three objects. When we look at focal length we'll discover how this foreshortening effect can be used to our advantage.

Selective focus

In this next exercise, we're going to selectively focus on one of the three objects. Simply set the aperture to f/4, focus on the first object and take a shot. Next, focus on the centre object and take a shot, and then do the same with the rear object. When you review your shots you should find that each object in turn is sharp while the other two remain blurred. This is an excellent way of placing emphasis on specific elements in a scene.

Real world

Next time you're out and about with a camera, look to repeat the exercises above, but on a larger scale, such as with a line of trees. At larger scales the differential focus should be more apparent, and you should start to get a feel for how controlling depth of field can be used in your real-world photography.

▲ **ABOVE RIGHT** This sequence of three images shows how closing down the aperture increases depth of field. Compare the zone of sharpness from f/2.8 with that from f/22.

▶ **RIGHT** These three images demonstrate how effective selective focus can be at drawing the viewer's eye to a particular part or element of a scene.

Longest focal length **Shortest focal length**

◀ **LEFT** These two images demonstrate the effect of focal length on depth of field. The first image shows a narrower zone of sharpness compared with the second (compare the walls at the end of the room). But also note how in the first image the three objects appear much closer together than in the second – this is because longer focal lengths foreshorten the distance between objects.

f/2.8 **f/8** **f/22**

Focus on first object **Focus on centre object** **Focus on rear object**

Shutter Speed

Along with the aperture setting, shutter speed is the other factor that governs how much light reaches the camera's sensor. The faster the shutter speed, the less time the sensor is exposed to light. Shutter speeds are usually measured in fractions of a second (sec), although much longer exposures are sometimes used, and historically each setting is either half or double the next. For example, a typical digital camera may have the following shutter speeds: $^1/_{1000}$ sec; $^1/_{500}$ sec; $^1/_{250}$ sec; $^1/_{125}$ sec; $^1/_{60}$ sec; $^1/_{30}$ sec; $^1/_{15}$ sec; $^1/_8$ sec; $^1/_4$ sec; $^1/_2$ sec; 1 sec; 2 sec; 4 sec; 8 sec, 15 sec and 30 sec. More sophisticated cameras may have a wider range, featuring faster shutter speeds of $^1/_{2000}$ sec, $^1/_{4000}$ sec and $^1/_{8000}$ sec, or include $^1/_2$-stop or $^1/_3$-stop 'intermediary' speeds such as $^1/_{80}$ sec or $^1/_{100}$ sec.

Shutter speed: $^1/_{60}$ sec

Shutter speed: $^1/_{125}$ sec

Camera shake

When deciding on the shutter speed to use, particularly with 'hand-held' photography, try to ensure that you select a shutter speed that is fast enough to prevent 'camera shake'. Camera shake occurs when the camera moves while the shutter is open, resulting in a blurred image. Depending on the focal length of the lens or the zoom setting, different shutter speeds are needed in order to avoid camera shake. For example, with a short (wide-angle) focal length setting of 28mm, a shutter speed of $^1/_{30}$ sec should be fast enough to prevent camera shake, but with a long

ABOVE This sequence of images clearly shows how increasing shutter speed freezes movement. Compare the slowest shutter speed ($^1/_{60}$ sec) with the fastest ($^1/_{1000}$ sec).

(telephoto) focal length setting of 200mm, you'll need a shutter speed of $^1/_{250}$ sec. This is because the longer the focal length; the more camera shake becomes apparent.

Minimum shutter speeds

As a rule of thumb, to prevent camera shake the shutter speed should be close to the reciprocal of the focal length of the lens. For example, if the focal length is 60mm the shutter

FAR LEFT In this shot a tripod was used with an exposure of around 1 sec. This way the buildings and stalls remained sharp but the bustling crowd blurred.

LEFT This deliberately blurred shot was hand held with a shutter speed of around $^1/_{15}$ sec. The blurred effect conveys the pace of city life.

Shutter speed: $^1/_{250}$ sec

Shutter speed: $^1/_{500}$ sec

Shutter speed: $^1/_{1000}$ sec

speed should be a minimum of $^1/_{60}$ sec, while a focal length of 125mm requires a shutter speed of at least $^1/_{125}$ sec and a 500mm focal length needs $^1/_{500}$ sec. Remember, however, these are only guidelines and they won't guarantee that you'll get sharp pictures every time.

In addition to using the minimum shutter speed as described above, try leaning against a solid support, such as a wall or tree, and gently squeeze the shutter release rather than 'press' it. Some professionals, whenever they're shooting hand held, set their camera's drive or shooting mode to 'continuous' and fire off three or four shots so that they can select the sharpest image from the set. Of course, by doing this, you'll use up far more memory, but if it's an important shot and you're worried about potential camera shake, it is certainly an option to consider.

Alternatively, you can increase the ISO sensitivity setting to obtain a faster shutter speed. As we know, the more sensitive the camera's sensor is to light, the less time the sensor needs to be exposed to the light from the scene being photographed. Each incremental ISO setting allows you to halve the shutter speed. So, if you're worried about camera shake at $^1/_{30}$ sec at ISO 100, set the ISO to 200

and you can set the shutter speed to $^1/_{60}$ sec, or use ISO 400 for a shutter speed of $^1/_{125}$ sec.

Shutter speed and exposure

The shutter speed chosen for a specific shot also plays a role in determining how an image will look – whether, for example, motion is blurred or frozen, or whether the image has a wide or narrow zone of sharpness. This latter is due to the relationship between the shutter speed and aperture setting.

For example, the lack of a tripod in low-light conditions may well need a fast shutter speed of, say, $^1/_{125}$ sec. Such a fast shutter speed in low-light situations will need a wide aperture to allow more light to reach the sensor, and the wider the aperture the narrower the depth of field.

Over the next few pages, we'll look at when slow or fast shutter speeds are appropriate, their effect on your images, and how shutter speed can be used creatively for artistic effect.

IMAGE STABILIZATION

Some cameras and individual lenses for dSLRs have image-stabilization (IS) systems. These work in a variety of ways, but generally they feature gyroscopic motors that detect and counteract any movement in the camera or lens. The systems vary in how successful they are, but generally you can expect to reduce the shutter speed by 2–3 stops and still retain sharp images. For example, if you had selected a shutter speed of $^1/_{250}$ sec without image stabilization, with image stabilization enabled you would be able to shoot with a speed as slow as $^1/_{60}$ sec (or even $^1/_{30}$ sec) and still get blur-free results.

IS off

IS on

Fast Shutter Speeds

Shutter speeds of around $1/250$ sec and shorter are generally considered fast. With the most commonly used focal lengths ranging from around 40mm to 125mm, using fast shutter speeds should certainly prevent camera shake. In fact, speeds of $1/500$ sec and shorter will freeze fast-moving action beyond the perception of the human eye.

Freezing action

Ever since the 19th-century English photographer, Eadweard Muybridge, shot his famous sequence of a horse galloping, we have been fascinated with the ability to freeze photographs of fast-moving action.

The actual shutter speed required to arrest movement very much depends on the direction the object is moving. A speeding car heading toward the camera, for example, won't require as fast a shutter speed as someone walking across the viewfinder or something moving directly up or down in front of the camera. In addition to the direction of movement, the distance of the object from the camera and the focal length of the lens are also critical factors. The farther the

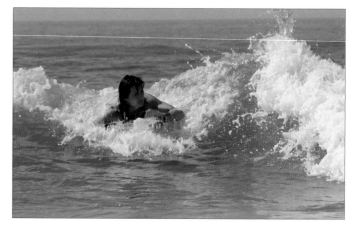

object is from the camera, and the shorter the focal length, the slower the shutter speed can be before action is frozen. Or in other words, the farther away a fast-moving object is, the slower it appears to move.

However, for sports photography, when you're likely to be using the longest focal length setting available on the lens, such as 300mm, in order to get optically as 'close' as you can to the action, speeds of around $1/1000$ sec are probably necessary to freeze the action. At these shutter speeds it's

ABOVE A shutter speed of $1/400$ sec has been used to make sure the surfer and the water are 'frozen'.

BELOW A fast-moving subject that is travelling across the frame requires a fast shutter speed to prevent blur – in this instance $1/620$ sec.

likely you'll need to use the lens's widest aperture setting to get a correct exposure, and unless the lighting conditions are very bright you may need to increase the ISO.

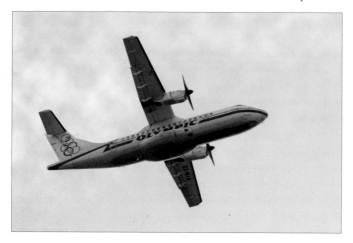

Fast-motion freezing

In order to freeze motion you need to make sure you've set a shutter speed that's fast enough, so follow this guide:
- Subjects moving across the frame need a faster shutter speed than subjects moving toward (or away from) the camera.
- Use the Shutter Priority (S/Tv) mode in order to control the shutter speed, and let the camera select the aperture.

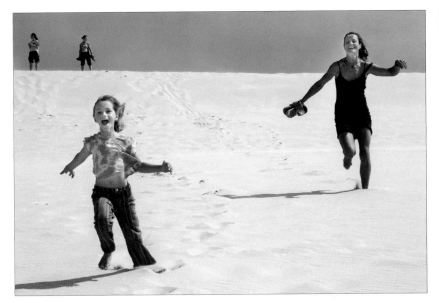

LEFT Fast-moving subjects moving toward the camera don't necessarily need as fast a shutter speed as a subject moving across the frame, but here a shutter speed of $^1/_{500}$ sec was used to freeze the action.

Shutter priority

The best way to experiment with shutter speeds is to select the Shutter Priority setting (S/Tv), choose an appropriate shutter speed, then focus on an area where the action will take place. Check in the viewfinder to see if an underexposure warning is flashing. If it is, you'll either need to increase the ISO setting until an acceptable exposure is available or, if that still doesn't provide the correct exposure, reduce the shutter speed slightly as well.

RIGHT Although the photographer has used a sufficiently fast shutter speed to capture this beautiful shot of a hummingbird hawk moth, its wings are beating so fast that even a very fast shutter speed of $^1/_{1000}$ sec can't freeze their movement.

LEFT Although moving across the image, the horses are still relatively small in the frame, allowing $^1/_{320}$ sec to be used for this action shot.

Standard Shutter Speeds

For most hand-held photography, shutter speeds of between $^1/_{30}$ sec and $^1/_{250}$ sec are most commonly used. At these speeds, images that are captured tend to replicate our perception of the world around us, so some parts of a scene will be sharply in focus, while more rapidly moving elements may appear slightly blurred.

The essence of speed

While on one level it's interesting to look at images that freeze time, there are occasions when freezing an object entirely can detract from the sense of action, especially if the background is also frozen. An obvious example is high-speed motor sport, in which a racing car or motorbike, if captured with a fast shutter speed, can look static and lose the sense of speed.

▼ **BELOW** Not all images have to be pin sharp. The slow shutter speed used in this hand-held urban shot provides a sense of movement and adds to the atmosphere of the image.

Deliberate blur

There are two ways to stop action shots appearing static and dull, both of which involve deliberately introducing blur. The first method is to select a slower shutter speed than you would usually use to freeze the action. Begin around 3 stops slower, so set $^1/_{30}$ sec instead of $^1/_{250}$ sec, for example, then prefocus on an area into which you know the subject will enter and take the shot as it enters the frame. If the subject is relatively stationary, for example a golfer, simply take the shot using the slower shutter speed. The result will be a blurred, or partly blurred, subject in front of a sharp background (or foreground). Depending on the amount of blur and the subject matter this may evoke the sense of action you need. The golfer is a good example, as ideally the head, shoulders and legs should remain relatively still and therefore sharp while the arms and club form a blurred arc.

Panning

For many types of action photography, and in particular fast-moving sports photography, the danger with the technique described previously is that the sharp background becomes the focus of attention, while the blurred subject – especially if it's entirely blurred with nothing sharply in focus – will not attract the viewer's eye. To overcome this, try using the well-known technique called 'panning'. Ensure that your feet are well planted and hold the camera to your eye. Frame the subject of the shot and by turning your body from the waist up only, follow the subject through the viewfinder. As the subject passes, take a shot, using your camera's continuous shooting mode if it has one. Continue to turn

▼ **BELOW** For subjects that are moving across the frame, panning is a great way of showing speed. Just follow the subject with the camera as it moves.

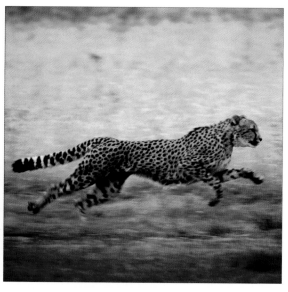

Framing

It takes time to learn how to pan successfully. Don't start by zooming close in to the subject so it fills the frame, as any error will result in part of the subject being cut off. Instead, zoom out a bit to give yourself a better chance and crop away excess background later if required. Also, start by trying to get the subject in the centre of the frame, so you're less likely to cut the front or back off the subject. As you become more proficient, try zooming in with a longer focal length lens or setting to get 'closer' to the subject and framing the shot so that there is more space in front of it than behind. Moving subjects look better if there's space in the frame into which they can move.

your upper torso and track the subject as it moves out of view, while you are making the exposure. You'll find that you can probably only comfortably turn through around 45°, but the result should be a sharp subject in front of a blurred background. This will not only give you a sense of speed, but it will also show a well-focused subject that holds the viewer's attention.

When panning, select the same shutter speed as in the previous technique – that is around 4 stops less than necessary to freeze the action (between $^1/_{30}$ sec and $^1/_{125}$ sec usually works for most sports). If it's possible, also try to position yourself in front of a background that features a lot of light and dark tones, as these will make the blurred effect more apparent.

TOP Slow shutter speeds can be used to add a sense of movement to landscapes. Here the waves have become a 'mist' thanks to the use of a slow shutter speed.

LEFT A wide-angle lens has increased the dramatic perspective here, while a slow shutter speed records the snowball hurtling toward the photographer as a blur.

Long Exposures

Although most photographs are taken using shutter speeds of a fraction of a second, most advanced digital cameras have the facility to shoot much longer exposures – anywhere between 1 and 30 seconds. Some cameras also feature a 'Bulb' (B) setting, which keeps the shutter open for as long as the shutter release is held down (or until the battery runs out). But when would you use such long exposures?

ZOOM BURST

If your camera has a manual zoom control, try creating a 'zoom burst'. With the camera on a tripod, select the smallest aperture and a slow ISO setting to obtain a long shutter speed – anything from around ¼ sec to ½ sec or longer is sufficient. Focus on an area that contains a mix of light and dark tones and centre it in the viewfinder. With the lens zoomed in, set the camera's self-timer and press the shutter release. When you hear the shutter fire, gently twist the zoom control so the lens zooms out. The result should be an abstract zoom burst.

ABOVE Shooting indoors using a slow shutter speed to get an appropriate exposure has resulted in blurred figures, which add to the movement of this photograph.

Low light

Normally, exposures of a second or more are used in low light, where you won't be able to hand-hold the camera and still obtain sharp images. To start with, you'll need to use a tripod, or at least rest the camera on a sturdy support, to avoid blurry night-time (or early morning) shots. Also, use either the camera's self-timer, a shutter release cable or a remote control so you don't run the risk of moving the camera with your finger while firing the shutter.

Because the camera is mounted on a stable platform it's not necessary to set a high ISO setting, so set the ISO to the lowest setting available to produce less noisy images. In addition, use the camera's noise-reduction setting.

Some of the most effective extended exposures taken during night-time – especially in towns and cities – show the trails made by the lights of passing cars. Find a vantage point overlooking a busy thoroughfare, set the camera on a tripod, and experiment with a variety of long exposure times.

RIGHT Use a long exposure to record several fireworks in a single frame for eye-catching shots such as this one.

Trails made by stars can also create effective long-exposure images. For these, you'll probably need to use the camera's Bulb setting as exposures often have to be several minutes long, if not longer, to chart the progress of the stars. For best results, choose a clear night that's free of cloud and other ambient light, and experiment with the length of your exposures.

ABOVE For this night-time cityscape, a long shutter speed was essential to record the beautifully lit buildings. With shots like these, a tripod is essential.

Extended daytime exposures

It's not just at night that you can use long exposures for creative effect. Certain daytime scenes also benefit from extended exposures, especially scenes featuring flowing water, mist or low-lying cloud. The long exposure will smooth out the water or cloud so it appears as a soft, nebulous mass.

Because of the relatively high light levels present during the day, the smallest aperture and lowest ISO settings might not allow you to set a suitably long exposure, so you'll have to reduce the amount of light reaching the sensor some other way. To do this you'll need to use a neutral density (ND) filter. These filters work a bit like sunglasses in that they reduce the amount of light hitting the sensor, but they don't affect the colour of the light – hence 'neutral' density.

WHITE BALANCE

Because most extended exposures are shot at night, and many are city- or townscapes, you'll instantly become aware of the colour cast created by sodium, tungsten and mercury vapour lights. If there is a sufficient variety of lighting in the shot, it may add to the effect of the image, but a dull overall orange cast simply looks unpleasant, as shown in the image below left.

In such instances, it's likely that the camera's Auto White Balance won't be able to address the problem, and you'll need to resort to fixing the colour cast using image-editing software to bring back the whites, or by setting a manual white balance if your camera has this option available.

Auto White Balance

Corrected White Balance

Creative Exposure

Armed with a better understanding of the concept of exposure, how the various metering systems operate and how to use the camera's manual settings, you should now feel much more confident to experiment with exposure settings. As sophisticated as your camera's matrix or evaluative metering system is, and as tempting as it is to let the camera work out the shutter speed/aperture setting for you, you're really missing out on producing some great shots if you let the camera do all the work. The beauty of shooting digitally is that experimenting with seemingly 'inaccurate' exposures doesn't cost a thing, apart from a bit of battery power. If you don't like an image, simply delete it and start again. There's nothing to lose by experimenting a little, and nothing to be gained if you don't.

Light

Often, the difference between an average shot and one that attracts a little more attention is the quality of light and the relationship between the light and dark areas. You may find that if you leave the decision about the

exposure to the camera, it will attempt to set an exposure that ensures detail is visible in both highlight and shadow regions. Of course, in many cases this is absolutely the right course of action, but if the interplay of light and dark areas is the key to the image, rather than specific detail, it's time to override the camera and experiment with different exposures.

▼ **BELOW LEFT** This is a well-exposed floral study enhanced by the backlighting and the lone pink flower in a sea of blue and green.

▼ **BELOW RIGHT** The same shot as the one on the left, but this time a longer shutter speed has been used, and the camera moved during the exposure. The result is an abstract blur of colour that creates an entirely different effect to the first picture.

◀ **OPPOSITE** There's absolutely nothing 'wrong' with the exposure for this building, but the exposure has retained all the shadow areas, and it appears to be lacking contrast.

▼ **BELOW** Here the exposure has been adjusted slightly, so the scene is a little darker than the first one. Deepening the shadows makes the windows stand out more for a dramatic effect.

You may find that deliberately under-exposing a shot brings richer tone and colour to the highlight areas, and although the shadows may 'fill in' a little, so detail becomes less visible, the viewer is struck more by the contrast between light and shade. Similarly, there may be times when overexposing an image, so that many of the highlight areas are 'blown out', has more impact and evokes a greater impression of heat, light or even space than an accurately exposed image.

Movement

As we've discovered over the last few pages, you can use shutter speeds to bring a creative touch to an image – either fast shutter speeds to freeze fast-moving action or slow shutter speeds to generate a sense of movement in an image. With longer shutter speeds, general wisdom suggests that you use a tripod to avoid camera shake, so ensuring that your images are pin sharp. However, images don't always have to be sharply focused to be

successful. People have experimented by deliberately moving the camera when the shutter is open in all sorts of ways to see what results can be achieved, a process known as 'kinetic photography'. The online photography site Flickr (www.flickr.com) even has a group called 'Camera Toss', which demonstrates the results you can achieve from simply throwing your camera in the air during an exposure of $^{1}/_{2}$ sec or longer.

While going to such extremes with an expensive camera may not be advisable, there's absolutely nothing to stop you from setting a very slow shutter speed and moving or waving your camera around to see the results. Bear in mind that it's best to try such exposures in front of a scene that has contrasting tones or colours, as that way the movement will be more apparent. There are countless ways to experiment with light and movement with a camera, and while a lot of the time the results may not come to much, every now

▲ **TOP** Using the camera's evaluative/multi-segment metering pattern gives a nice record shot of this scene, and it wouldn't look out of place in a holiday album.

▲ **ABOVE** By overexposing a similar photograph, we have a shot that's fit for exhibiting. The overexposure has helped to blur the tonal distinction between the foreground sand and the sky in the background. This focuses our attention on the middle of the frame – the strip of blue water in which the subjects of the image can be found.

and again you'll end up creating an image that will be unique, personal and striking.

Exposure – Try It Yourself

You should by now have a better understanding of the relationship between shutter and aperture, and having run through the 'depth of field' exercises, be more confident with your camera's semi-automatic and manual settings.

The exercises here will help to reinforce your familiarity with the camera's aperture and shutter controls, and also get you to think about how adjusting exposure can introduce atmosphere into an image, or create a sense of movement. Unlike the 'depth of field' exercises, which dealt with how the mechanics and optical properties of the camera and its lens can be used specifically to draw attention to certain elements of an image, these exercises are far more subjective, and the final results will be very personal to you.

Controlling light levels

First, reacquaint yourself with the camera's controls. Having a tripod and a form of remote shutter release will make life easier, but they are not essential. Try this exercise outdoors, using objects and a setting that exhibit good tonal variation – such as a dark object on a light table.

Set your camera to its Manual mode, select a medium aperture (such as f/8), and a focal length of 100mm. Look through the viewfinder, focus on an object 16ft (5m) away, ensuring that you can see regions in front of and behind the object. Adjust the shutter speed until the exposure level indicator is set to '0', and fire the shutter. Now reduce the shutter speed 2 stops (from say $1/500$ sec to $1/125$ sec) and increase the aperture to compensate (from f/8 to f/16). The exposure indicator should still read '0'. Fire another shot and compare the two images. You should see little or no difference in the overall exposure, but the second image should have a wider zone of sharpness – as we would expect having completed the 'depth of field' exercises.

Next, having reduced the shutter speed, don't increase the aperture to compensate. The exposure level indicator should read around '-2' – take a shot. Increase the shutter speed 2 stops (the level should read around '0'), but reduce the aperture by 2 stops to take the reading back down to around '-2' again. These last two shots will be underexposed by 2 stops, but look closely, first at the overall tones of the images. Although the darker areas are likely to be underexposed, the lighter tones may well have become richer and easier to define, and where colour is present these tones may appear more saturated. This is because the lighter an image is, the less saturated the colours. When comparing the zone of sharpness between the two images, the second image should show a wider depth of field.

Carry on experimenting with the exposure settings so that you underexpose by 1 stop and overexpose by 1

Aperture: f/8

Aperture: f/16

Underexposed by 1 stop

Underexposed by 2 stops

LEFT Different but correct exposure variations result in the same overall exposure, but both images at the top have greater depth of field; the underexposed images have richer colours.

$^1/_{30}$ sec shutter speed

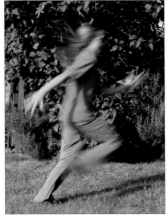

$^1/_{60}$ sec shutter speed

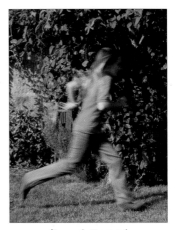

$^1/_{125}$ sec shutter speed

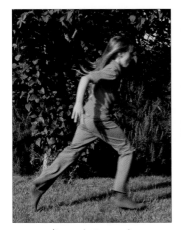

$^1/_{250}$ sec shutter speed

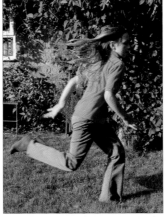

$^1/_{500}$ sec shutter speed

$^1/_{1000}$ sec shutter speed

and 2 stops. Compare the images to see how over- and underexposure affect tones and colours.

Controlling blur

Using a focal length of about 50mm, set the camera to Shutter Priority (S/Tv). Begin with a slow shutter speed ($^1/_{30}$ sec) and ask a friend to run in front of the camera at approximately 10ft (3m) from the lens. When your subject appears in the viewfinder take a shot. Repeat the exercise, increasing the shutter speed by 1 stop each time. By around $^1/_{500}$ sec most of the movement should be frozen, and by $^1/_{1000}$ sec the figure

ABOVE AND RIGHT The simple exercise described here shows you how shutter speed controls sense of movement. Although it's tempting and seems natural to use a fast shutter to freeze fast action, this may result in a static-looking image.

should be entirely sharp. Reduce the shutter speed to $^1/_{30}$ sec and focus on your friend as he or she begins to run forward. Start panning and fire the shutter when your friend moves directly in front of you. Continue to pan as the exposure is made and the image should show your subject more or less frozen, but the background should be blurred.

Panning

Tonal Contrast

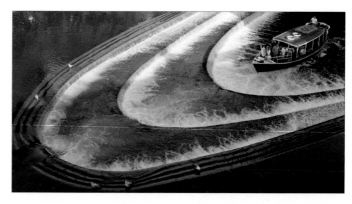

The vast majority of us have an inherent understanding of how a high-contrast image and a low-contrast one differ. However, it's important to understand what factors make an image exhibit a high or low degree of contrast, so that you can quickly spot high- or low-contrast situations in order to make the most of them.

High contrast

Essentially, images that are comprised of very dark and light tones, with little in between, are referred to as high-contrast images. In fact, many of us still most closely associate high-contrast images with black and white photography. However, the juxtaposition of the tones can also influence our perception of how much contrast there is in an image. If, for example, dark and light tones sit next to one another, then the image appears to have higher contrast

than if the dark and light tones are separated by more neutral tones, even though the overall tonal content is similar. In this respect, it's the subject that determines the contrast of the photograph.

Lighting

A second factor that contributes to contrast is lighting. If you fold a piece of paper continually back and forth to make a zigzag shape, then lay it on the surface of the table and light it from above, it appears almost continuous in tone with very little contrast. But shine a light from the side

and the shadows created by the ridges of the paper make the surface appear almost black and white.

Silhouettes

By their very nature, silhouettes are the most extreme form of high-contrast shots. Placing the subject against a light background and then exposing for the background will ensure that all detail within the subject is severely underexposed, leaving just the outline.

Silhouettes have passed out of fashion slightly for being somewhat clichéd, but they can still create

ABOVE The contrast in this shot doesn't come from the lighting, but from the subject – in this case the light and dark curves of the water.

LEFT Silhouettes work best when the background is much lighter than the subject. Here the sun acts as the background, turning the trees black.

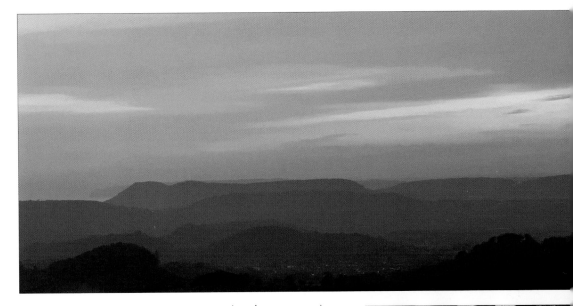

some powerful, atmospheric images. Remember to pick your subject carefully for its shape, rather than its form. Always bear in mind that you will not only lose the subject's form but pretty much all of its colour, too.

Low contrast

Shots that are said to be 'low contrast' rely on the image's neutral tones graduating into one another, creating a calm, gentle atmosphere. We tend to associate low-contrast images with hazy distant hills, the soft, shadowless lighting you get before the sun has risen or after it has set, or on a cloudy day – all conditions that the majority of photographers don't like because everything appears dull and flat. But striking images can be found under such circumstances – it's simply a case of finding subjects that emphasize the serene, tranquil and ethereal nature.

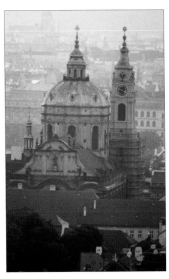

TOP Taken just before sunrise, the light in the sky is diffuse and soft, resulting in a low-contrast image. However, this suits landscape photographs, as does the light at the end of the day.

ABOVE RIGHT Hard lighting that gives a high-contrast result suits strong graphic shapes, such as this detail of a park bench.

LEFT Soft, diffused lighting created by an early misty morning will even out colour variation and create a low-contrast scene.

RIGHT Hard, directional lighting produces bright highlights and deep shadows – perfect for the shiny, silvery scales of these fish. The result is an almost monochrome high-contrast image.

Colour Contrast

Although we usually think of tone as a decisive element that dictates whether an image exhibits high or low contrast, determined by the presence and juxtaposition of light and dark tones, there is another factor that determines our perception of contrast – colour. In the same way that tonal variation can determine the contrast in black and white images, colour variation can have the same effect in colour photography.

High colour contrast
Later we'll look in more detail at the emotions that certain colours can elicit and the effect of colour saturation, but here we're going to concentrate on how colour can be used to augment or reduce contrast, and the impact that it has on the viewer.

When closely juxtaposed, colours that lie opposite one another on the colour wheel, such as cold blues and warm reds, create a high-contrast effect and, as with high tonal contrast, this adds dynamism to an image. When using colour in this way, the most important thing is to ensure that the colour in the image is the main

Colour wheel

Colours that occupy adjacent areas on the colour wheel create a calming, low-contrast effect, while those that sit opposite each other add high-contrast drama to a picture.

subject. In many ways it's irrelevant if the subject is unrecognizable, as the response you're aiming to get from the viewer is triggered by the colour,

▼ **BELOW LEFT** These umbrellas provide a high colour-contrasting image, helped by the fact that the orange and blue sit almost opposite one another on the colour wheel.

▼ **BELOW RIGHT** The reds and oranges of these fruits create a strong colour contrast when seen against the green leaves and blue sky beyond.

rather than by the subject. The best way to explore high colour contrast is to look for subjects that feature only two colours, that are ideally situated opposite one another on the colour wheel. The impact will be greater if you zoom in as much as possible to exclude any other potentially distracting objects or colours.

Low colour contrast
Colours that share similar regions of the colour wheel create low colour contrast, and have a soothing or calming effect. The same applies to images that are made up primarily of only one colour (although this can vary depending on the colour).

The principal difference between high and low colour contrast is that with the former it's the colours, or rather the juxtaposition of the colours, that evokes the viewer's response, whereas with low colour contrast, the image needs to feature additional compositional elements in order for it to work successfully. Elements such as texture, form or even subtle tonal differences will all help to reinforce the colour harmony.

BELOW This image of an old Moroccan town is striking for the uniform brown colour of the buildings, which encourages the viewer to focus on their shape and pattern.

ABOVE The bold colours of the nets and the barrels on the fishing boat appear even stronger as they sit next to the neutral tones of the boat itself and the dark water.

RIGHT An incredibly simple image that would lose all its drama if it wasn't for the highly saturated colours and perfectly placed vapour trail.

BELOW With lots of tones of the same colour, low-contrast colour shots like these abstract petals have a calming and soothing effect.

Low-key Photography

Low-key images are those that comprise large areas of dark midtones and shadows. For this reason, such images are often perceived as sombre, moody and even threatening, and indeed most low-key images are exactly that. However, successful low-key images will often feature areas of bright highlights, which, as well as offering a visual balance to the mass of dark tones, can also inject an uplifting note into the image.

Many people when confronted with an overcast, cloudy day or a grey flat interior, will put their camera away and wait for the sun to come out. However, these occasions can often provide just the sort of light required for an effective low-key photograph – and, in fact, conditions just before or just after a storm are often the best time to capture a really dramatic landscape. Look for a break in the clouds, try to establish when the sun is likely to make a brief appearance and position yourself so that you have a suitable backdrop against which you can capture the sun's rays.

Expose for highlights

Remember in such conditions, and in fact in any low-key image where the small highlight areas are very bright, it's essential that you correctly expose for these areas. They are likely to become the focal point of the image, and it's better for the surrounding areas to be underexposed than for the highlights to be overexposed, or 'blown out'. This may be unavoidable if you're actually pointing the camera toward the sun or any other very bright region or object, for example, but such areas should be restricted to

▼ **BELOW** A classic low-key image; the dark, brooding sky and dark silhouetted landscape are uplifted by the sun's rays.

as small an area as possible. Use the LCD preview screen on the back of your camera and also take a look at the histogram (see pages 40–41) after each shot to make sure that the highlights are correctly exposed. Your camera may also feature a 'blown highlights' warning option, which will indicate overexposed areas on the LCD preview image through the use of a flashing colour.

Image editing

Once you have some candidates for potentially striking low-key images that include some interesting highlights, open them on the computer and begin by cropping any excess dark background or foreground areas. You can then experiment with your imaging software's brightness controls to add even greater contrast and impact to the image.

Black and white

Since the vast majority of low-key images comprise expansive areas of dark and shadow tones interspersed with a few areas of bright highlights, such images lend themselves particularly well to black and white photography.

ABOVE Even mundane items, such as these kitchen utensils, can make effective low-key subjects.

LEFT The dark harbour walls and mud are offset by the white rowing boat in this low-key image.

ABOVE Here the dark flag stones are nicely juxtaposed with the woodwork and light columns.

LEFT Low-key effects can create sombre portraits, but here the Halloween costume sets the scene.

High-key Photography

In the way that successful low-key images rely on large areas of dark midtones and shadows juxtaposed with small areas of bright highlights, successful high-key photographs utilize expansive areas of white and light tones in which are found small regions of dark tones, or even black. Although not essential from a purist's point of view, these regions can often form the focal point of the image, so it's important that exposure is set to ensure that as much detail as possible is captured there.

High-key landscapes need to have a prevailing area of light tones and, for this reason, snowscapes, seascapes and large sand-dunes are ideal subject matter.

In terms of weather conditions, a dark, stormy sky full of forbidding clouds is unlikely to provide you with the ideal lighting conditions for high-key landscapes, but, at the same time, a clear, blue, cloud-free sky isn't entirely necessary either.

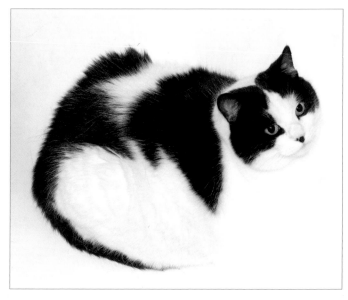

BELOW High-key portraits result in a loss of skin texture and will often flatten facial features. Here the girl's face is framed by the darker hair, and the dark eyes make a strong focal point of the image.

ABOVE This image was shot against a white background and deliberately overexposed. The white fur of the cat merges into the background, helping to emphasize the cat's monochromatic coloration.

Overexposure

The metering system in most digital cameras will always attempt to expose for a neutral grey. In other words, when faced with a potential high-key scene, the camera will automatically attempt to underexpose, in order to hold detail in the highlight areas.

You can set the camera's exposure compensation (EV) control to +1 or +2 to overcome this. It's quite probable that you'll get a 'blown highlight' warning if you review the image on the camera's LCD screen, but ignore this, as overexposed highlights are part of the artistic effect in high-key images.

Ideally, you'll want either hazy summer skies or misty, thin layers of cloud – as is often found during the late autumn and early winter months in temperate regions.

Expose for dark areas

Just as you should expose for highlights in low-key images, the opposite is true for high-key images. If you expose for the dark, shadowy areas, you'll capture any detail there – which is likely to be the focal point of the image – while it's less important to retain detail in the lighter areas. Most high-key images work best if little or no detail is visible in these lighter areas, as this helps to evoke and reinforce the light, delicate and airy nature of high-key images.

LEFT If you left the camera's metering system to its own devices with an interior shot like this, it would most likely underexpose, so the white walls came out a darker grey.

BELOW LEFT Setting the exposure to 1–2 stops more than the camera suggests (effectively overexposing the image) will help keep highlight areas light.

BELOW RIGHT Shadows that are dark, but not necessarily black, typify high-key images and give this style of photograph a light, airy feel.

BOTTOM An extreme example of a high-key picture, with very little highlight detail, and very few black tones.

Image editing

As with low-key pictures, once you have some candidates that you think would make great high-key images, open the photographs on your computer and begin experimenting. Start by cropping any excess background or foreground areas. You can then experiment with your imaging software's brightness controls to add even greater contrast and impact to the image.

Composing with Colour

Colour is an amazingly emotive and evocative subject. People will react to it whether they're aware of it or not, so for this reason, it must be considered with care in photography. Volumes have been written about how colour affects our emotions, and we can only touch on it briefly here. Much of it we inherently know. We all perceive red to be a passionate, powerful colour, for example, and a warning sign in both nature and the human environment. However, it is also a warm colour, of course – the colour of sunsets.

Red is generally considered the most 'advancing' colour in that it's often perceived as being closer than it really is, and therefore more likely to attract our attention. **Blue** is one of the most 'receding' colours in that it's often perceived as being more distant than it really is. Blue is a cool colour that evokes a sense of calm and peace in an image and it also provides a great contrast with red. **Green** is associated with nature, which is perhaps why it is often used to symbolize renewal and hope. It shares the same neighbourhood on the colour wheel as blue and is another receding colour that contrasts

▼ **BELOW** Brightly coloured, man-made objects are often great for bold abstract images, such as this swimming pool shot.

▲ **ABOVE** At sunrise and sunset the colour of light changes toward red, which gives landscape photographs a warm feel. This can be enhanced through the use of coloured filters, as demonstrated here.

with red. **Yellow** is more akin to red in that it is an advancing colour and one that helps to add warmth; it is the colour associated with the hot midday sun and fire.

These four colours are the most important in the visible spectrum. From these we get not only the additive primary colours (red, green, blue) of television sets, computer screens and digital cameras, but in terms of light, these colours mixed together to provide the secondary colours cyan, magenta and yellow. Also from our initial four colours we get the primary colours of the artist's paint palette (red, blue and yellow), from which we get the secondary colours violet, orange and green.

Saturated versus muted

Surprisingly, while vibrant, saturated colours have an initial impact and are good at attracting our attention – hence their liberal use in advertising, packaging and warning road signs – it's the muted colours that usually leave a longer-lasting impression in art and photography, particularly in landscapes and portraits. Unsaturated colours are more evocative and thought provoking, and the colours won't detract from the subject of the picture. However, if you're using colour to emphasize contrast, then they should be as vibrant as possible. Colours are most saturated in the

RIGHT Although bright, saturated colours grab our attention initially, it is often muted and gentler colours that have a longer-lasting impact.

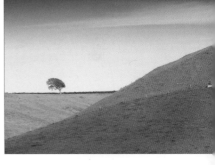

RIGHT Colour is the key to this simple yet striking landscape photograph. The richly saturated greens of the grass and blue of the sky are incredibly eye-catching.

LEFT Less saturated colours, such as those found in some flowers, might not jump out of the page, but the effect is less jarring and far more calming.

BELOW The powerful flavour of chillies is successfully evoked by the rich, saturated reds (which contrast well with the green stalks) in this image.

middle of a clear sunny day, when there are fewer shadows to interfere with expanses of colour. However, the cooler colour temperature at the end of the day can make reds, yellows and oranges more vibrant.

Desaturation

You can desaturate strong colour by using a long focal length under soft lighting conditions, as over long distances the light is more likely to be diffused by particles in the air. However, if you're using a long focal length lens or zoom setting, you may not get the framing that you want. Alternatively, you can also tone down the colour on your computer using your image software's colour controls.

Lighting

The significance of lighting in photography cannot be overestimated – in fact the very word photography is derived from the Greek, literally meaning 'drawing or writing (*graphis*) with light (*photos*)'.

The strength, angle, temperature and quality of light – the last of which is affected by time of day, time of year, location and countless atmospheric conditions – will affect just about every aspect of an image. They will determine how bright the colours will be rendered, how strong and long the shadows will be, how visible distant objects are, and how much detail is obvious in foreground objects.

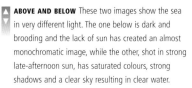

LEFT Despite being shot in the shade, the bright red flowers contrast with the pale-coloured walls and green leaves, while the shadows in the background add to the sense of warmth.

ABOVE AND BELOW These two images show the sea in very different light. The one below is dark and brooding and the lack of sun has created an almost monochromatic image, while the other, shot in strong late-afternoon sun, has saturated colours, strong shadows and a clear sky resulting in clear water.

LEFT After midday, as the sun gradually sinks lower in the sky, colours tend to become increasingly saturated and textures more discernible, all helping to impart a picture postcard feel to an image.

Certain types of lighting can make objects appear flat or uniform in tone, while other lighting can make the same objects appear highly textured, pitted or undulating, and full of contrasting tones. In fact, the only parts of an image in which light does not carry as much significance is the subject, and the juxtaposition of the image's various elements to one another. In many ways, this is the very essence of photography. Setting aside studio photography, as a photographer it's essential that you are aware of the possibilities (and limitations) of different lighting situations.

Almost all of us, when we first become interested in photography, fall into the trap of assuming that you need bright sunny weather to create successful images. While it is true that these conditions do make for glorious photographs, so too can grey, overcast days – they're likely to elicit entirely different emotions in the viewer, but both conditions have the ability to produce striking images. As far as photography goes, there's no such thing as bad light. There may be inappropriate light for a specific shot, but in photography, 'bad' light should never stop play.

Timing

One of the most important traits all photographers should have, or need to develop, is patience. There will be many times when you know that the quality of the light is perfect for the scene in front of you, but you need some rays of light to highlight a specific element. It pays dividends to wait, as it could be the difference between a good photograph and an excellent one.

BELOW Early morning light enhances the soft misty atmosphere and brings a rosy glow to this shot of the river Thames, London.

Quality of Light

You will no doubt have heard or read about photographers discussing the 'quality' of light. While on a general level the term is used to describe anything from light temperature (such as the warm, red colour cast of a sunset), through to brightness levels, and the angle at which light is striking objects, more specifically, 'quality of light' strictly refers to how 'hard' or 'soft' it is.

Soft lighting

As its name suggests, soft lighting is a gentle, diffuse illumination and, outdoors, is usually the result of a layer of cloud. The water droplets and particles in the cloud scatter the sun's light rays as they pass through the cloud, sending the light in different directions. The most characteristic aspect of soft lighting is the lack of strong shadows, or sometimes any shadows at all. However, clouds come in an infinite variety of types, and different layers of cloud can often be moving at different speeds in relation to one another. For these reasons, the soft light of cloudy conditions can vary slightly from minute to minute.

In particular, with thick cloud conditions, when even the position of the sun in the sky is not discernible, objects can appear flat and free of texture, and colours somewhat muted. But that does not mean that such light cannot serve a useful photographic purpose. The lack of strong shadows and bright highlights can render complex shapes and scenes in a more intelligible fashion. Portraits are also sometimes more pleasing when there are no shadows to distort and alter peoples' features.

Hard lighting

Lighting is at its hardest when there's no cloud or haze to diffuse it – on clear summer days, for example. In these conditions the visibility tends to be good, making hard light ideal for 'long-view' landscapes. As we know from looking at texture, hard lighting can turn an apparently flat, featureless object into a mass of minute peaks and troughs. This is due to the strong shadows cast by direct, undiffused light. While this is often desirable and can be used to the photographer's advantage to create crisp, high-contrasting and dramatic images, deep shadows also have their drawbacks. They can render a busy scene, such as a shot of a market or street, too complex to view clearly because of the number of shadows, and they rarely help in portraits either.

RIGHT To make your subject stand out from its surroundings, try taking the shot when the light on the background is soft.

BELOW Soft, even lighting has ensured that the colours of the holly and berries are captured accurately, while the lack of strong shadows doesn't create a confusing image.

LEFT Hard lighting offers good visibility and crisp, clear photographs with sharply defined shadows.

SOFT AND HARD

Whether you shoot in soft, diffused light or strong, direct light has a significant impact on a photograph's appearance. Hard light will increase the contrast and colour saturation, while diffused light makes colours softer and also reduces the contrast for a more 'natural' appearance.

Angle of light

One crucial aspect of hard light that must be considered is its angle and direction in relation to the subject or scene. The general characteristics and colours of an object lit from the front can look entirely different if lit from the side or from the back. So, having assessed the generic qualities of hard light, let's now look in more detail at how these qualities can alter the way in which individual objects or indeed entire scenes appear, depending on the direction of the light.

BELOW Strong, direct light is rarely flattering for portraits, but here the hat diffuses the light, so the face is softly lit.

Soft light

Hard light

Direction of Light: Front and Side Lighting

With heavily diffused light, the position of the light source – which in most cases is likely to be the sun – is of little consequence in relation to the position of the subject. With hard light, however, the direction from which the subject is lit is fundamental to how it will appear in a photograph. How high or low the sun is in the sky also plays a significant role.

Frontal lighting

When the sun is located behind the photographer and falls directly onto the subject, the subject is said to be 'front lit'. This is perhaps the most common way to capture photographs and even those of us not that familiar with photography will probably remember being told that we should always shoot with the sun behind us.

Frontal lighting certainly has its benefits. With the sun directly behind us, shadows are cast away from the camera and, depending on the viewpoint, may well be out of our line of sight. Without strong shadows to cater for, getting an appropriate exposure for both light and dark areas is more straightforward with front-lit scenes due to the lack of contrast (or

ABOVE Lit from the front, these houses appear almost two-dimensional, so the shot is about their flat colour, rather than form.

BELOW This partially buried wooden fence has been shot with side lighting, creating shadows that make for a pleasing, almost abstract effect. The side lighting also helps to bring out the texture in the sand.

low dynamic range). The photograph's colours also tend to be more evenly illuminated, so subtleties in tone become increasingly apparent.

The drawback of frontal lighting is that the lack of shadows will underplay the visibility of any texture the subject might have, and potentially reduce perspective across the entire scene. For these reasons shots may appear rather flat and lacking in any depth.

For really successful frontally lit images, you should be relying on interesting and strong colour and tonal contrast. Bear in mind, too, that reflective surfaces will throw back most light when front lit. Finally, do be mindful of your own shadow when shooting with the sun behind you. Depending on how low it is in the sky, the sun could cast your shadow a surprisingly long way into the scene you're photographing and potentially ruin a great shot. Some photographers, if confronted with this problem, will

RIGHT The light coming from the side helps describe the form of the towers' unusually shaped roofs. If the light was coming from the front they would lose their form.

try to disguise their body shape so that it resembles less a human figure and more an anonymous shrub, or whatever is appropriate for the scene.

Side lighting

With the sun to one side of both you and the subject, the image is said to be side lit. While front lighting tends to flatten objects, side lighting emphasizes texture and form as shadows are prominent and potentially long, depending on how low the sun is.

Side lighting also adds drama to an image. Parts of a scene may be well lit and the colours saturated, while other parts may be in shadow and their colours muted. In very bright, side-lit situations, the scene may be so heavily contrasting, with bright, white high-

lights and dark, almost black shadows (creating a very high dynamic range), that the camera's sensor won't be able to capture all the detail in the scene. In these situations you must decide to expose either for the shadows or the highlights. The decision will ultimately be down to the subject matter and the emotions you are trying to evoke in the viewer. For these reasons, it's sensible to bracket high-contrast, side-lit scenes, as that way you'll have a greater chance of getting an exposure that works. You can further increase your chances of success by shooting RAW (see page 17).

Front versus side

- Front lighting reduces the texture of a subject, but can help make strong colours appear even bolder.
- Lighting coming from the side will reveal a subject's form, but watch out for confusing shadows.

BELOW Strong side lighting creates bright highlights and deep shadows, which gives a greater idea of the subject's form.

BELOW LEFT Shooting group shots in bright sunshine has many pitfalls. To avoid subjects squinting into the sun and strong shadows running down their faces, try positioning the group so that they're lit from the side.

Direction of Light: Back Lighting

Another popular way of working with direct, undiffused light is to place the subject more or less between the sun and the camera. This is known as back lighting a subject, and the technique is sometimes referred to as *contre jour*, French for 'against the day'. Back lighting can create dramatic results due to the high contrast inherent in back-lit scenes.

Silhouettes

The best-known back-lit technique is the silhouette. To shoot a silhouette, simply position the subject directly in front of a large bright area, or indeed the sun itself, and the camera will usually automatically underexpose the subject to create the silhouette. Ensuring that the sun is masked by the subject usually works best, otherwise you run the risk of not being able to capture any information at all due to the brightness of the sun. Unless the subject is translucent you're unlikely to capture any detail, colour or texture. The only clue as to what the subject is will be its outline shape. Silhouettes can, of course, make for very powerful images, but it's important to choose your subject on the merits of its shape alone and to position it so its shape is shown to best advantage. The most striking silhouettes have an almost uniform, light-coloured background to make the subject most obvious.

Buildings (particularly structures with interesting shapes such as bridges or piers), trees, a face in profile – in fact anything, as long as it has an interesting or emotive shape – make excellent subjects for a silhouette.

Translucency

For variation, try shooting a translucent object placed in front of the light source. Depending on the object, fine detail will be visible, such as the veins of a leaf, and colours will be bright and saturated. You do need to be careful, however, not to overexpose the subject.

Rim lighting

As dramatic as silhouettes are, the effect should be used sparingly in any portfolio. There are other back-lighting effects that are just as striking. Rim lighting is a form of back lighting in which the light source is behind, but also slightly off to one side. The resulting shot, depending on the object being photographed and the background, will have brightly lit, almost glowing edges, and can make for a spectacular image.

BELOW Shooting directly into a light source increases the risk of 'lens flare' in your picture. Here, it is shown by the purple and green patches of colour in the corners.

RIGHT Back lighting can be used effectively to throw long shadows toward the camera creating a dramatic result.

ABOVE The most striking silhouettes are made when you have a subject that is recognizable, even when there is no detail – as in this shot of a boy fishing.

BELOW Rim lighting produces very striking results, with the heavy lighting from behind and to the side of the subjects, creating glowing highlights.

Flare

Lens flare is apparent in silhouettes or other forms of back-lit shots in the form of rows of hexagonal-shaped circles of light emanating from the sun (or any other light source). The shape of the light pools is determined by the shape of the lens' aperture (or diaphragm) when the shot is taken. Although this type of lens flare (which is caused by reflections within the camera's lens) can add atmosphere to a shot, it is better to try to prevent it. This is why you sometimes see a lens fitted with a lens hood, which is a petal- or cup-shaped piece of plastic that fits on the end of the lens and acts as a sunshade for the lens.

Taking back-lit shots

- Silhouettes work best when you can identify the subject only by the shape of its outline.
- Use light from behind and to the side of the subject for intense highlights and added drama.
- Avoid lens flare by shielding the front of the lens from the light by using a lens hood.
- Remember that colour will usually be very muted with most back-lit shots; if colour is an important element of the shot, try front lighting.

Available Light

In photography 'available light' refers to any natural light source used to light a scene, and while this includes daylight for outdoor photography, here we're going to concentrate on daylight (and standard domestic lighting) for indoor photography and certain natural sources for night-time.

Although some keen amateur photographers may own a small lighting set-up, many will not, so all photographers will have to rely on available, or 'existing' light, such as standard tungsten light bulbs, at some point, especially when taking photographs indoors or outdoors during late evening or at night.

Of course just about every camera today has a small flash built into the body of the camera (and later we'll be looking in more detail at what we should expect from built-in flash units), but as useful as they are, such units usually only provide relatively low light levels and often subjects are harshly lit.

▼ BELOW Simple side lighting from a window was used in this pet portrait.

▲ ABOVE Using the available light from the two 'windows' in this cave, the rocks on the floor have been picked out and appear to be incredibly three dimensional.

Indoors

Using available indoor light, by which we mean daylight from windows shining into a room and normal domestic lighting, can result in very pleasing images. Pictures taken using available light are often much more atmospheric and exhibit a greater sense of realism than those that have been painstakingly lit using a variety of studio lights and accessories.

The most important aspect to bear in mind when taking photographs under such lighting conditions is that, when captured, images will appear to have far more pronounced areas of light and shade than seemed apparent to the naked eye. When we spend time in a room our eyes are constantly and almost instantaneously

◀ **LEFT** Using solely the light entering from the arched window has resulted in a highly atmospheric photograph.

Using natural light

- Ambient light will allow you to retain more of the atmosphere of a scene than flash will.
- Use slow shutter speeds, wide apertures or high ISO settings in low-light conditions.
- Remember, however, that high ISO settings will introduce digital noise.

▲ **ABOVE** Here the light from a window not only illuminates the image on the wall, it also becomes part of the picture.

▼ **BELOW** Using the light from the fire has kept all the atmosphere of this scene. Flash would have ruined the shot in an instant.

adjusting for the well-lit and dimly lit areas as we look around, which create the appearance of a fairly evenly lit room. However, the camera is only capturing one specific part of the room at one specific moment, so resulting images will appear to have greater contrast. Use this to your advantage to place emphasis on certain elements or people – for example, sit someone in a chair that has been positioned in a brighter area of a room and you'll notice that the darker regions of the room will recede, placing greater emphasis on the sitter.

Setting exposure

If you're including a window in the shot, the comparative brightness of the window in relation to the rest of the room needs to be accounted for when setting exposure. Take a reading from a bright region near to the window, press the exposure lock button, recompose the shot and take the picture. Depending on the strength of the light coming through the window, you should be able to hold most of the detail in the room without 'burning out' too much of the window

itself. Try bracketing the exposure if you're uncertain and checking the results on the camera's LCD screen.

Colour cast

Given the relatively low temperature of tungsten light bulbs – the most commonly used bulbs in the home – make sure that the camera's white balance setting is set to Tungsten or Auto to counteract the orange colour cast caused by such lighting. Even then, you may find that images will suffer from a colour cast that you'll have to correct using editing software.

Tripod versus ISO

With low-light conditions there's a risk of camera shake if the shutter speed is insufficiently fast. If you don't have a tripod, increase the ISO setting, but do this in stages as noise from high ISO settings is more apparent in dark scenes (see pages 14–15). If you do have a tripod, then you can shoot at the lowest possible ISO setting without the risk of camera shake. Bear in mind that even relatively slow-moving action may blur at speeds of $^1/15$ sec or longer.

Shadows

Any discussion about the significance of light in photography would not be complete without turning our thoughts to shadows. In many ways, shadows help to reinforce the prevailing lighting conditions and add atmosphere to an image. We recognize the presence of bright sunlight in an image not just by bright highlights or saturated colours, but also by deep black shadows. Equally, the lack of strong shadow will lower the overall contrast of an image and give a softer look to a picture.

Almost all photographs that are taken outdoors during daylight hours will contain shadows, except for those taken under the most diffused lighting conditions. However, shadows are very easy to overlook when composing an image, as we tend to focus our attention on the subject of a shot. Also, because shadows are such a common phenomenon they don't register – until we review the shots and discover that strong shadows have spoiled the composition.

▲ **ABOVE** Without the shadows in this wintry scene the snow would be a flat, featureless expanse of white.

▼ **BELOW** The Grand Canyon with the sun low in the sky is modelled by the shadows, which help to reinforce the Canyon's peaks and troughs and add scale and perspective.

Strong light

When taking photographs outdoors, it is worth deliberately looking for the shadows in a potential scene. Check to see if your position in relation to the sun results in any shadows falling across an important compositional element of the photograph. Although altering your position won't change the direction in which the shadows are cast, you may discover that an alternative angle provides a similar shot that makes the shadow invisible, or less of a distraction.

Composition

An alternative to eliminating shadows from an image is to look deliberately for ways in which to include them. Not only can they add to the image by introducing their own unique, obscure shapes, but they can also help to draw the viewer into an image – often a shadow can act as a leading line taking the viewer directly to the subject of the photograph.

Shadows can also provide visual clues about an image – such as the time of day the photograph was taken, how bright (or overcast) the conditions were and even the type of environment in which the image was shot. While it may be obvious from the subject of the picture itself whether the image was taken in a city or in a forest, shadows cast by objects not visible in the scene will help to evoke the atmosphere, whether they're the geometric, blocky shadows of buildings or the organic shapes of branches or leaf fronds.

Form and texture

With light coming in at a low, raking angle, shadows can also help to tease out the texture from objects and to emphasize their form. This modelling attribute can be used in a variety of

photographic genres – from nudes to landscapes – whenever you want to reveal the texture of your subject.

▲ **ABOVE** Although taken on a sunny day, the cool shadows contrast pleasantly with the pale yellow sand.

▶ **RIGHT** Low-angle light casts shadows that help describe a subject's form.

▼ **BELOW** In this woodland scene, the long shadows add another layer to the image, making it all the more dramatic.

Low-light and Night Photography

If captured well, low-light and night scenes can result in wonderfully strong, atmospheric shots. Quite understandably, people are often put off capturing low-light or night-time shots thinking that the lack of light throws up too many technical difficulties to overcome. However, with a little perseverance and a certain amount of trial and error, the skills of low-light photography can be quickly mastered.

Just about any scene is suitable for low-light treatment – especially cityscapes. With their numerous and variously coloured lights and towering skylines, cityscapes usually provide the most dramatic night images, while rural scenes often work best just after the sun has set rather than late at night. As a rule of thumb, when taking photographs of low-light landscapes, there will still be sufficient light available to capture a photograph that will adequately show the surrounding countryside up to around 30 minutes after the sun has set, or less in the Tropics.

Noise

A recurring issue with low-light photography is digital noise and, depending on your camera, it may well always be present in night shots. However, there are actions you can take to keep noise to a minimum. The most obvious is to use as low an ISO setting

ABOVE A sunset on a clear summer's day is a good time for photographs of silhouettes. Here, the light of the lighthouse is a focal point.

BELOW Cities at 'night' can create colourful and evocative images. The best time to capture city lights is at twilight, about 45 minutes after the sun has set, rather than at night.

as possible. This means that you'll need a tripod or a makeshift surface on which to rest the camera while taking the shot. If there is a noise-reduction facility available on your camera, try using this. It will double the time it takes for the images to be saved, but may help reduce background noise.

White balance

With long exposures, there is a chance that the auto white balance setting (which neutralizes colour casts created by certain temperatures of light) will be tricked by the various light sources, especially in cityscapes where light sources may include car headlights, neon signs, streetlamps and so on. The variety of light sources and resulting colour casts can often create a pleasing result.

However, if you want white objects to appear white, you need to manually set the white balance. Most advanced cameras allow you to do this with a 'custom white balance' setting. With the camera set to 'custom white balance' (the setting name may vary depending on the manufacturer), fill the frame and photograph a white object that you wish to be reproduced as white. The camera will automatically allow for the overall colour temperature and white objects will appear white.

ABOVE At sunrise and sunset the sky can turn from a rich blue to a deep orange-red in an instant, but choosing the right white balance is crucial.

RIGHT This shot almost looks like a toned black-and-white picture, with its matching sky and water. Only the distant yellow light tells you it isn't.

BELOW Towns and cities at night make for good low-light subjects thanks to the mix of colour temperatures in the lighting – from 'white' to orange.

Low-light composition

Stunning results can be achieved in low-light conditions and it certainly pays to experiment with different sources of light, whether it's the warm glow of a sunset or the artificial lighting from office blocks or street lighting.

Look out for reflective surfaces, such as ponds, lakes or even wet pavements. The reflected light will not only give you more illumination to experiment with, but the reflected image can add another dimension to your composition.

Using Flash

At one time or another, all of us need a relatively powerful, if short-lived, light source that enables us to take photographs at night or indoors, using shutter speeds that are fast enough to freeze action. For that reason most digital cameras, from point and shoot to dSLRs, come equipped with a built-in flash.

Built-in flash

As useful as built-in flash is – and it certainly makes it possible to shoot in some situations where, without it, you may not have any usable images at all – such units do have limitations.

The first drawback is the effective range, as most on-camera flashes are only capable of throwing light a distance of between 5ft (1.5m) and 10ft (3m) from the camera, which won't be powerful enough to light larger groups or scenes.

The other significant problem is 'redeye'. This occurs because the flash unit is so close to the axis of the lens. When the flash fires, it fires directly into the subject's eyes, bounces off the retina in the back of the eye, and

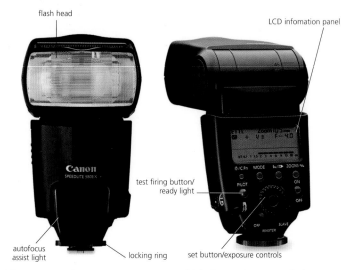

flash head

LCD infomation panel

test firing button/ ready light

autofocus assist light

locking ring

set button/exposure controls

▲ **ABOVE** External flash units, such as this Canon model, provide more powerful lighting and a much greater degree of control than on-camera flash units.

illuminates the eye's blood vessels. The proximity of the flash to the lens can also be a problem with wide-angle lenses on dSLRs, as the flash isn't designed to cover the width of a scene visible through a wide-angle lens. The result is a vignetted image, in which the corners appear darker than the central part of the image. Finally, perhaps the worst problem of all with built-in flash is simply the quality of light it produces. Built-in flash will often produce stark pictures with harsh shadows. While this can be partly remedied by reducing the strength of the flash using the camera's 'flash exposure compensation' setting (if it has one), you may find that large parts of the image are underexposed.

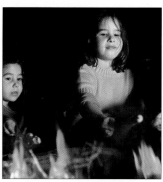

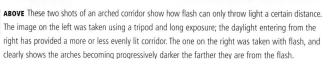

▲ **ABOVE** These two shots of an arched corridor show how flash can only throw light a certain distance. The image on the left was taken using a tripod and long exposure; the daylight entering from the right has provided a more or less evenly lit corridor. The one on the right was taken with flash, and clearly shows the arches becoming progressively darker the farther they are from the flash.

▲ **ABOVE** Flash units are a convenient way of lighting a subject when there is insufficient ambient light available. However getting natural looking light can be problematic.

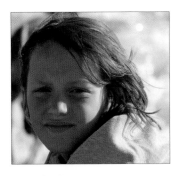

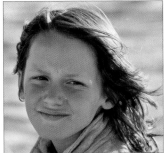

Fill-in flash

Despite these drawbacks, built-in flash is an excellent tool for 'fill-in' lighting. It may seem strange to use flash during the day, but you'll probably have noticed that whenever you see wedding photographers or photo-journalists in action, they'll invariably have a flashgun attached to their cameras, even if the weather is bright and sunny. This is used for fill-in flash.

Fill-in flash throws additional light onto a subject that may be in shadow or underexposed due to strong back lighting. In both cases using flash will improve the quality of the images, adding brightness and colour to an otherwise drab element of the image. Because fill-in flash doesn't need to be particularly powerful, a camera's built-in flash is often ideal for the job.

Flashguns

If you find that you're increasingly relying on the camera's built-in flash and you're not happy with the results, you may want to consider buying a flashgun. These are self-powered flash units that are fixed to the top of the camera via the camera's 'hot shoe' plate. Flashguns vary enormously in price depending on how powerful they are and how sophisticated the metering system, but for a relatively modest outlay you can improve the quality of your flash photography enormously using such a device.

Most of today's flashguns can be set to synchronize automatically with the camera so that the shutter opens at the same time the flash fires, as it does with the built-in flash. Often a 'pre-flash' is fired so that the camera's metering system can set the correct exposure for the subject (known as Through The Lens, or TTL, flash). Sophisticated flashguns will also take information from the camera's focusing system to gauge the distance from camera to subject, and therefore determine more precisely how much light is needed for an accurate exposure.

Power and bounce

The greatest benefit of using a flashgun is that it produces more light than a built-in flash. One obvious advantage of this is that more distant objects can be lit, but there's another, more significant benefit. The most useful flashguns have heads that tilt (and swivel), allowing you to 'bounce' the light off walls, ceilings or other reflective surfaces. Bounced flash produces much softer light, as in effect the light is coming from a much larger surface area, which has the effect of diffusing shadows. You need the increased power from a flashgun to make the most of this bounced flash effect. Additionally, because the light is not coming directly from the camera, but from above (or to the side), the lighting appears more natural. Finally, because the flash unit of a flashgun sits much higher than that of a built-in flash unit, there's a much reduced risk of redeye.

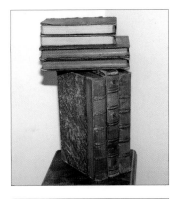

▲ **ABOVE** When used direct from the camera, a flash creates hard shadows (top). Bouncing it off the ceiling will give a much more natural looking result (bottom).

Diffusers

Another way in which to soften light from a flashgun is to fit a diffuser. Diffusers are moulded pieces of white translucent plastic that fit over the head of the gun and spread the light when the flash fires. By their very nature, diffusers drastically cut down the range of the flashgun – another reason why professionals opt for the most powerful units – but they give a light that looks much softer and far more natural than direct flash.

When to Shoot

So many factors govern lighting that to make any hard and fast rules about the best time to take photographs would be meaningless – season, location and local weather conditions all affect the quality, strength, direction and colour of light.

The environment in which you live will offer varying photographic opportunities depending on the prevailing weather conditions. For example, a gentle mist and low-lying cloud may provide the perfect conditions for certain rural landscapes but they would do absolutely nothing for a city shot.

However, it's important to know what sort of results you can expect under certain lighting conditions, so you learn to know what type of photograph works best in the conditions you're shooting under. This, of course, can only come with experience, using your eyes and a certain amount of common sense.

Morning
Sunny mornings, and specifically within an hour of the sun rising above the horizon, will provide a low, raking

▲ **ABOVE** Clear, late afternoons in temperate regions can often impart a warm, rosy glow to images. Make sure the camera's Auto white balance doesn't try to 'correct' the red glow resulting in a more neutral white colour.

light that offers the opportunity to shoot all four major variations of lighting – frontal, side, back and rim. This makes early morning one of the most dynamic times to be out with a camera. Depending on the season, you may also have early morning mist in low-lying areas or over standing water, and the sun will reflect strongly off tall buildings. At this time of day, the light temperature will be relatively low, creating a glowing orange cast, while the sun itself can make a spectacular subject.

Mid-morning can provide a good compromise between the first hour or so after sunrise and midday. There's variation in the direction of light, and shadows will be flattering, but the light is more neutral and colours will reproduce more accurately. Look for texture, modelling shadows and subtle, yet distinct, colour.

By midday, with the sun high in the sky, light is at its harshest and you need to turn your attention away from subtle modelling and flattering shadows and look for well-defined, interesting shapes, and bright, saturated colours. The consistent quality of light at this time of day tends to produce sharp, crisp images, but remember that strong shadows may add confusion to certain scenes.

▼ **BELOW** These two images of the Taj Mahal, although not taken from the same place, still show how the light at different times of the day can radically alter the same scene.

LEFT Although early morning haze reduces visibility and distant detail, it's perfect for atmospheric landscape shots, especially when using a telephoto lens or zoom setting.

Mid-afternoon and sunsets

As with mid-morning and dawn, from mid-afternoon until about 30 minutes after the sun has set, the light temperature will decrease and take on an increasingly golden hue. Shadows will lengthen and light levels will gradually decrease. This is a good time to look for potential silhouette subjects, as a glowing red sun can make for a more interesting backdrop to a silhouette than a bright white mass. Even after the sun has set, keep taking shots, as successful low-light images during twilight can be among the most atmospheric, with the sun's afterglow helping to create soft and subtle tonal gradations.

Finally, consider indoor light shots available at this time of day. With the sun low in the sky, you may find that some parts of a room are lit with shafts of strong light, throwing other parts into shadow.

Cloudy days

The quality and strength of light on cloudy days will vary depending on the types of cloud and how numerous they are. Generally, cloud will soften light and help diffuse shadows. On windy, predominantly sunny days, scudding clouds create fluctuating levels of light, which require patience on the part of the photographer as he or she waits for the clouds to pass over and bathe the scene in sunlight. This is often a time when strong light and shade can be captured, adding tonal interest to a composition.

A vast blanket of cloud will have a dulling effect. Shadows will all but disappear, along with the chances of exploiting texture and form. However, such soft, consistent light can often simplify potentially complex scenes such as woods and forests, so use this light to exploit intricate shapes and subtle colour variations.

RIGHT Around 30 to 45 minutes after the sun has set (or less in the Tropics), is the best time to photograph buildings that are artificially lit. The light remains strong enough to show surrounding detail, but the building still appears well lit.

RIGHT Around midday, when the sun is high in the sky, light is at its most neutral colour, and if the sky is clear, this is when images will be at their sharpest.

Some of the most dramatic shots can be taken just before or just after a storm. At such times it's not unusual to have a backdrop of black, forbidding skies while the foreground is bathed in strong sunlight. Furthermore, sooner or later, as the clouds disperse, the sun's rays will break cover and appear as powerful beams of light.

Hazy days

Haze can bring unique qualities of light to a variety of scenes. As well as diffusing harsh light and helping to soften shadows, haze can add a sense of depth by flattening and desaturating colour. This can result in an evocative layering effect if there are distant ranges of hills. To make the most of this effect, shoot with a telephoto setting or lens.

Lighting – Try it Yourself

An effective way to discover the impact of different lighting conditions is to use a 'source' scene and shoot it at different times of the day, and preferably at different times of the year and under varying weather conditions.

For the sake of convenience, select a scene that is within easy reach; the more varied the scene the better. For example, try to find a location that includes natural objects such as fields, trees, rocks and grass, as well as artificial ones, such as buildings, roads or any other man-made structures. That way, you'll hopefully see how the changing quality of light impacts on a wide variety of surfaces, textures, shapes and forms.

Time of year

When the weather looks set to be predominantly sunny, aim to get to your location just before sunrise. Set up the shot with a focal length of around 50mm, using a tripod so you can shoot at the lowest ISO setting. Carefully make a note of the position you've taken up, and at sunrise take a few shots. Return to the same spot every hour, or if that's not possible, at least every two hours, and photograph the same scene. Keep returning to the location until sunset, at which point take your final shots.

Review

Download the photographs onto a computer and review them. The first thing you'll notice is the way in which the scene becomes increasingly well lit as the sun begins to rise. Depending on the scene, long shadows may form and, depending on the weather conditions, time of year and location, you'll see a gradual shift in colour temperature – from red to neutral – as the sun progresses across the sky.

By midday, shadows are more likely to have shortened, but they may well have strengthened, and any colour will appear more saturated. However, most noticeable will be the way in which objects are lit – whether it's side, front or back lighting. As the sun moves in the sky, surfaces will be lit in different ways and this will have the biggest impact on the image.

As noon passes and the sun begins its descent into the west, shadows will gradually start to grow longer, surfaces that were not previously lit may become illuminated, and colours will become more muted.

By late afternoon, the light will cast everything in a rosy glow (depending on time of year, location and weather conditions), while shadows will lengthen. As the sun sets, elements of the scene may be visible only in silhouette and any clouds will reflect the red glow of the setting sun.

Time of year

Try to repeat this exercise at various times of the year to see what impact the changing seasons have on your environment. Test whether you can tell the difference between the quality and temperature of the light on a sunny summer's day and a sunny winter one. When younger, those of us brought up in a mild temperate climate would often equate a blue sky with warm weather, but in fact it's impossible to tell the temperature from a blue sky alone.

▼ **BELOW** Each part of the day will bring its own unique quality of light and radically alter how a particular scene photographs.

Weather conditions

Deliberately photograph your selected location in a variety of weather conditions. Test out if the old adage that dull weather makes for dull photographs is true in the case of your chosen scene. If so, then what weather conditions are needed to bring a bit of sparkle to the shot? Does it require a sunny day or can subtleties of light, shade and tone be teased out under overcast conditions?

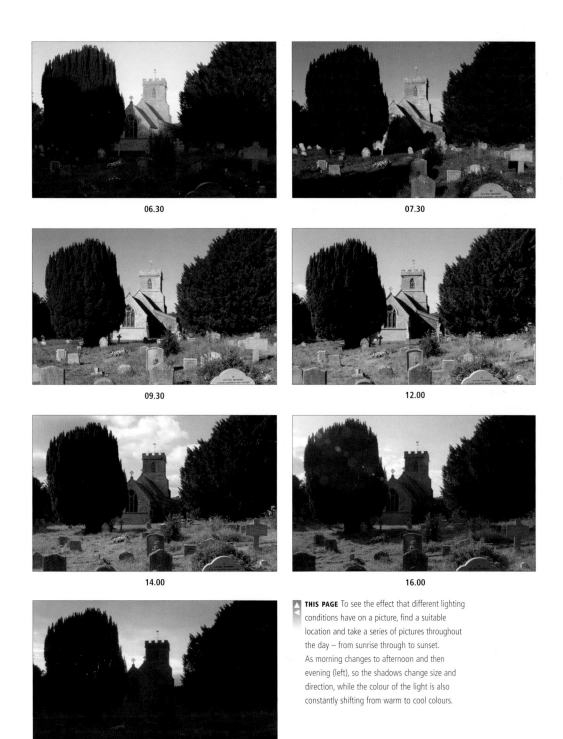

06.30

07.30

09.30

12.00

14.00

16.00

18.00

THIS PAGE To see the effect that different lighting conditions have on a picture, find a suitable location and take a series of pictures throughout the day – from sunrise through to sunset. As morning changes to afternoon and then evening (left), so the shadows change size and direction, while the colour of the light is also constantly shifting from warm to cool colours.

Focal Length

A lens's focal length is the distance between its optical centre (the point at which the light rays begin to converge), and the focal plane (the surface of the image sensor). Focal length is always measured in millimeters (mm). In the days when the majority of keen amateurs and professionals used 35mm film cameras, understanding focal length was relatively straightforward. However, digital cameras – or more accurately the varying sensor sizes used in digital cameras – have made the issue of focal length less easy to understand.

Whereas all lenses were once designed to project an image onto the standard 35mm (24 x 36mm) film frame, because of the numerous different sensor sizes available in today's dSLR cameras, a lens of a specific focal length will project a different view of a scene, often increasing the effective focal length.

Equivalent focal length

Let's try to explain this more clearly using numbers. A 35mm film frame, or a 'full-frame' digital sensor, has a diagonal measurement of 43mm.

Therefore, to provide an unmagnified, standard view, a lens would need a focal length of 43mm (historically this has been rounded up to 50mm).

A number of popular compact zoom cameras have much smaller sensors, with a diagonal measurement of 9.5mm (the measurement of a standard 1/1.7-in sensor). With a sensor measuring 9.5mm, the lens only needs a focal length of 9.5mm to achieve a x1 magnification.

So, while a theoretical 43mm lens provides a standard view on a full-frame sensor (x1 magnification – 43 divided by 43 = 1), on a smaller sensor measuring 9.5mm diagonally, the magnification would be 43 divided by 9.5 = 4.53, or the equivalent focal length (efl) 43 x 4.53 = 195mm, which is quite a powerful telephoto lens.

On many compact zoom cameras you may see the lens labelled along the lines of 9–70mm, which would make no sense in the 35mm format, but when converted to allow for the smaller sensor size this lens provides the equivalent focal lengths (efl) of 9 x 4.53 = 41mm, zooming to 70 x 4.53 = 317mm.

To make sense of these potentially confusing focal lengths, the equivalent focal length is often used in conjunction with real focal lengths in magazines, websites and sales material to give people a point of reference. This is why many hybrid camera lenses are advertised as 38–380mm (or 10x) instead of, or as well as, their true focal lengths.

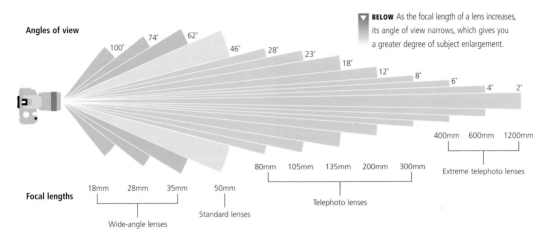

BELOW As the focal length of a lens increases, its angle of view narrows, which gives you a greater degree of subject enlargement.

Angles of view

100° 74° 62° 46° 28° 23° 18° 12° 8° 6° 4° 2°

Focal lengths

18mm 28mm 35mm — Wide-angle lenses

50mm — Standard lenses

80mm 105mm 135mm 200mm 300mm — Telephoto lenses

400mm 600mm 1200mm — Extreme telephoto lenses

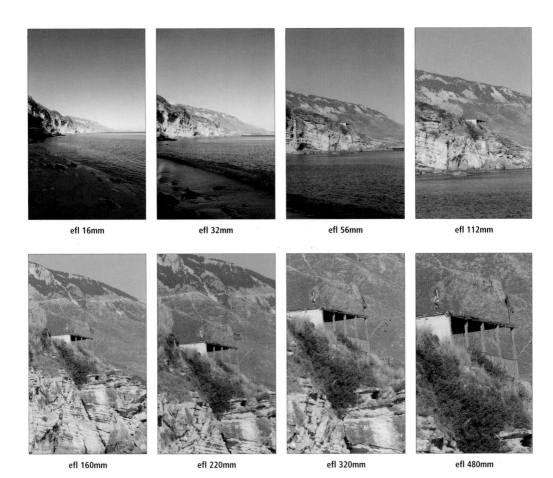

| efl 16mm | efl 32mm | efl 56mm | efl 112mm |

| efl 160mm | efl 220mm | efl 320mm | efl 480mm |

ABOVE Focal lengths are measured in millimetres (mm) and range from effective wide-angle focal lengths of around 16mm (or less) to equivalent telephoto lengths of 480mm (or more).

APS

The vast majority of dSLRs use APS-sized sensors. APS (Advanced Photo System) was originally a film format developed for point-and-shoot cameras. The system is now almost defunct, but the format has been taken up by the major camera manufacturers as a popular sensor size for dSLRs, because it is less expensive to manufacture, while still providing excellent images. To confuse matters slightly more, there are a number of APS sizes, but most are around 22 x 15mm.

CROP FACTOR

APS sensors are smaller than full-frame 35mm sensors, and therefore experience the same issue with focal length measurements. To standardize things, interchangeable lenses for dSLRs are labelled with their actual focal length. DSLR owners need to know the size of the sensor in their particular camera to find the equivalent focal length. The same calculation (dividing the diagonals) is carried out, and the result is often expressed as the 'crop factor'. For example, Canon's semi-professional dSLRs use a sensor with a diagonal of close to 27mm, which gives a crop factor of 1.6.

This means that to find the efl for a lens attached to the body, the photographer multiplies the real focal length by 1.6 – so a 60mm lens has an efl of 95mm. Nikon, Fuji and Sony use sensors with a crop factor of 1.5, so a 60mm lens on these models has an efl of 90mm.

1.6 crop factor

Short Focal Length

Lenses with an equivalent focal length of between 18mm and 35mm are described as having a short focal length. Offering an angle of view of between 100° (efl 18mm) and 62° (efl 35mm), they are also known as wide-angle lenses as they provide an angle of view greater than that seen by human vision (around 46°).

A wide-angle lens's ability to capture such a wide angle of view has a number of benefits and can be used to great compositional effect. One of the most common uses of a wide-angle lens is photographing interiors. With such a wide-angle of view, these lenses can photograph much more of a room than a standard (efl 35–50mm) lens.

This ability to capture such wide views is also often used in landscape photography to help emphasize wide-open spaces, and create a sense of emptiness. As well as having the ability to encompass more of a scene, wide-angle lenses also tend to differentiate more clearly between the various planes within a scene,

clearly separating the foreground, middle-distance and background objects from each other.

Depth of field

One of the most useful optical properties of wide-angle lenses is their great depth of field, as the shorter the focal length, the greater the depth of field at the same aperture setting (see pages 82–83). This allows the

photographer to ensure that very close foreground objects are in focus, as well as distant objects. This can bring an increased illusion of depth to an image, but the disadvantage is that it becomes harder to selectively blur specific elements within a scene.

A wide-angle lens's short focal length is particularly helpful with hand-held photography, as the risk of camera shake is reduced the shorter the focal

BELOW When you can't move too far back from your subject, use a wide-angle lens to squeeze in as much of the scene as possible.

ABOVE Wide-angle lenses let you get a lot of a scene in the frame, and the increased depth of field also lets you get everything sharp.

BELOW Short focal-length lenses can introduce a 'barrel distortion' effect, in which vertical lines, such as walls, seem to bulge outwards.

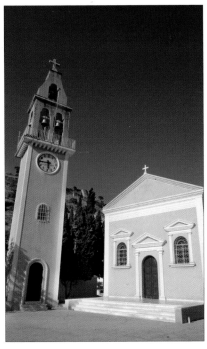

length of the lens. For example, shooting at $^1/_{30}$ sec with a standard lens setting of between 35–50mm would often result in camera blur, but with an effective focal length of 18mm camera shake is much less likely.

Distortion

Another key characteristic of wide-angle lenses is distortion – again, the shorter the focal length the greater the distortion. This effect becomes most apparent in photographs that include objects with straight lines, such as buildings. One form of distortion, which is known as

'barrel' distortion, makes vertical and horizontal lines bulge outward, most noticeably at the edges of the frame. Wide-angle and particularly super wide-angle lenses are not appropriate for portraits due to the effect of barrel distortion, unless you're aiming for a deliberate effect.

Another issue associated with wide-angle lenses is converging verticals – a form of distortion in which lines appear to move closer together the higher they rise. This is most noticeable in architectural shots and is a result of the wide angle of view from a wide-angle lens.

True wide angle

For those owners of dSLR cameras without full-frame sensors and who are considering buying a wide-angle lens, remember that it's important to take into account the crop factor of the sensor (see Crop Factor box, page 133). For example, the crop factor for most Nikon dSLRs is 1.5 – this means that in order to achieve an efl of 18mm, the lens needs to have a real focal length of 12mm (12 x 1.5 = 18mm).

COMPACT AND HYBRID WIDE ANGLE

You don't have to own a dSLR to get a really wide angle of view. As well as the main camera manufacturers, there are several third-party companies that make wide-angle converters, (such as the one pictured) to fit most compact or hybrid cameras, as long as the lens has a thread at the end. You'll need to know the size of the screw mount, and the angle of view the converter will provide will vary, but they typically range from x0.8 to x0.5. A x0.8 converter, for example, will change a 35mm focal length lens to 28mm.

Long Focal Length

Lenses with a focal length of between 80mm and 300mm are generally considered to have long focal lengths – although 400mm, 500mm and even 600mm focal length lenses are quite common. Such lenses are often referred to as telephoto lenses and cover an angle of view of between 28° (80mm) and 6° (400mm). It is a telephoto lens's narrow angle of view that creates the magnifying effect, for which there are numerous uses.

Sports and nature

Telephoto lenses are commonly used for sports and nature photography. The specific focal length needed depends on the type of nature or sports. It's often easier, for example, to get closer to the action when photographing tennis than it is with stadium sports such as football or track and field. Similarly,

photographing large mammals that are relatively accustomed to humans and to which the photographer can get close requires less telephoto power than photographing small birds.

There are a number of zoom compacts offering 10x magnification, (which is roughly the equivalent of efl 30–300mm), and this should provide most keen amateurs with the magnification that they need. For dSLR owners, with zoom lenses that are now capable of resolving and capturing almost as much detail as prime lenses, the best option is to opt for a 70–300mm lens, which will provide a useful telephoto range, particularly if the camera's crop factor is taken into account. A 300mm focal length with a 1.6 crop factor provides an efl of 480mm. Even professional sports and nature photographers rarely use lenses longer than 500mm

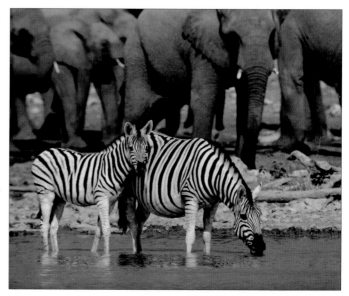

ABOVE Shooting sports often requires the use of a telephoto lens; however, many telephoto lens have a minimum aperture of f/5.6 or even f/8, for example, which means a relatively slow shutter speed will be needed to ensure an accurate exposure.

ABOVE The long telephoto lens is essential equipment for all wildlife photographers, allowing them to get 'close' to the action without disturbing the animals or risking their own safety.

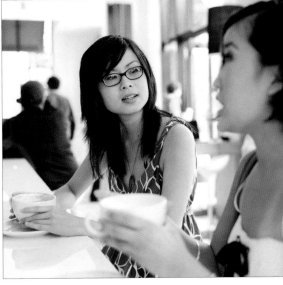

ABOVE Using a telephoto lens for portraits allows you to easily throw potentially distracting backgrounds out of focus.

ABOVE For candid street photography, a telephoto lens is the perfect choice as it allows you to keep your distance from your subject.

– their enormous size is down to the fact that they're extremely fast lenses that are often able to open up to apertures as wide as f/2.8.

Landscapes and candid shots

Surprisingly, a telephoto lens can also be a useful addition to the landscape photographer's kit. One of the key characteristics of long focal lengths is that scenes are foreshortened, so that distant, rolling hills take on a pleasing layered effect. In addition, landscape photographers can isolate and enlarge particularly attractive visual elements of a scene with a telephoto lens. Effectively, this is the case for all genres of photography. Telephotos are excellent at helping the photographer to fill the frame and the great benefit of using a zoom telephoto is that it's possible to frame shots in camera, rather than having to crop them at a later date on the computer.

Another use for a telephoto lens (in this case the more discreet the better), is in candid street photography. You'll have only a very short amount of time to frame and take the shot, but the results can be rewarding as the photographer will often capture an action or expression that becomes apparent only when reviewing the image on screen.

Portraits

Finally, short telephoto lenses of between efl 80mm and 130mm make excellent portrait lenses. In fact, in the early days of photography, such telephoto lenses were often referred to as 'portrait' lenses. They're good for the job because they not only help to distance the sitter from the photographer (so making the sitter feel less self-conscious), but the longer focal length also has the effect of flattening the subject's features very slightly. This results in a more flattering portrait and, when combined with a wide aperture, the narrow depth of field ensures that backgrounds are more easily thrown out of focus.

BELOW This 70–300mm 'super zoom' covers a wide range of telephoto focal lengths in a single lens. Vibration-reduction technology helps avoid camera shake.

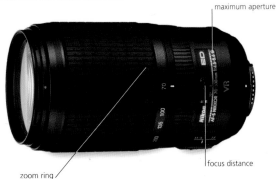

maximum aperture

focus distance

zoom ring

Focal Length and Backgrounds

In the earlier section on depth of field we discussed how, together with the lens's aperture setting and the focusing distance, the third factor governing depth of field was focal length. Now that we've examined focal length in more detail, let's return to the relationship between depth of field and focal length and look more closely at how adjusting focal length can be used to alter backgrounds.

Focal length and depth of field

As we know, a short focal length lens of efl 28mm set at f/5.6, for example, will have a zone of sharpness almost twice as wide as an efl 50mm lens set at the same aperture. This is why it's often advantageous to use a telephoto lens for portraits, as it's easier to throw a potentially distracting background out of focus with a longer focal length lens. You just have to walk farther back from your subject, zoom in so that you achieve the same shot and retake the picture – the longer the focal length the more blurred the background. However, it's not just depth of field that alters with focal length; you can also use varying focal lengths to alter the actual view of the background.

Altering viewpoint

A popular camera trick in the movies – one that's often used to promote a sense of unease or panic – is to show the subject standing still, but the background viewpoint changing from narrow to wide or vice versa. The technique is known as a dolly zoom, and was made famous by Alfred Hitchcock in his movie *Vertigo*. To achieve the shot, the camera tracks back or forward on rails while at the same time zooming in or out. This way, the size and view of the subject remains unchanged, but because the

ABOVE By using a wide-angle lens with a narrow aperture, everyone from the girl in the foreground to the man in the background is sharply in focus, creating a feeling of unity.

BELOW Using a long focal length lens or setting makes it easier to throw the foreground and background out of focus, so concentrating the viewer's attention on the subject.

focal length and, therefore, angle of view are changing as the camera zooms in and out, the background viewpoint and perspective also change. This trick can also be used by stills photographers to great effect.

The effect works on the basis that in a photograph, objects closer to the camera appear disproportionately larger than those positioned farther away. So with a short focal length lens and the subject positioned close

to the camera, the subject will appear exaggerated in size and the background far in the distance – this can often be used to create a sense of isolation. Moving back, using a long focal length and filling the same amount of frame with the subject, the background will appear much closer to the subject and relatively larger in size – in this shot the subject would appear much more part of his or her surroundings. This is partly due to the foreshortening effect of long focal length lenses.

Selecting background

Knowing that focal length alters view-point helps you to exclude or include background elements in a shot while the subject remains the same size. Also, since the angle of view affected is vertical as well as horizontal, a steeper perspective is also provided by a close camera view, which can be used to help isolate detail (see pages 140–141).

ABOVE AND ABOVE RIGHT By adjusting his viewpoint and zooming in slightly, the photographer has successfully isolated the tower so that it stands out more from the background.

BELOW By getting low to the ground and using a short focal length setting or wide-angle lens pointing upward, these pigeons are clearly silhouetted against the sky, creating a dramatic shot.

Focal Length – Try it Yourself

These exercises are designed to explore how varying focal length will affect images. The first exercise shows how focal length affects depth of field, while the second will show how focal length can be used to effectively change background viewpoints.

It's helpful if you have the camera on a tripod, as that way it's easier to set up the shots and compare the results, and you don't have to worry about slow shutter speeds if you're shooting in dim lighting conditions.

Depth of field

On a small area of land, set up two objects about 10 ft (3m) apart. Place the camera around 13 ft (4m) in front of the first object. The distances don't really matter – all that's important is that, with focal lengths ranging from 35mm (efl) and 170mm (efl), you can see both objects clearly. Now, with the

▼ **BELOW** For these three pictures, the lens was zoomed out as the photographer moved closer to the subject to match the framing. Notice how the longer focal length compresses the foreground and background areas.

zoom set to around 170mm, frame the front object so that it fills around half the height of the viewfinder and focus on it (making sure the rear object is still clearly visible). With the camera set to Aperture priority, choose the widest aperture and take a shot. Without moving the camera, zoom out to around 80–100mm and take another shot. Finally, zoom out to around 28–35mm and fire the shutter once more.

To see the shots at their best, you ideally need to download them onto a computer and crop the second and third shots so that they show more or less the same scene as the first – that is, the front object filling half height of the viewfinder. You'll be cropping right into the third shot, but don't worry about the image quality – all you're assessing is depth of field.

With all three images showing approximately the same scene, the rear object should be entirely out of focus in the 170mm focal length shot, in the 80–100mm picture the rear object should be more sharply defined, while the final shot – taken at 28–35mm – should show both objects in focus.

38mm

Changing viewpoint

For the second exercise you'll need a slightly larger area to work in, and the greater the difference between the shortest and longest focal length lens, the more apparent the results. The images shown were shot with a 35–170mm (efl) zoom and show the effect well. Use a tripod if you have one so the camera doesn't move between shots.

Begin by picking an object between 3 and 7ft (1m and 2m) tall – a family member or friend is ideal. Position

170mm

80mm

80mm

170mm

◄ **LEFT** Taken using 38mm, 80mm and 170mm focal lengths these three images were then cropped to the same size. Notice how by increasing the focal length it reduces the depth of field, making the books that are farther away out of focus.

▼ **BELOW RIGHT** Increasing the focal length can often be a more practical alternative to getting physically closer to the subject, particularly when taking shots of wild animals. Here a 500mm telephoto lens was used to get close to the doe and her calf.

your subject so there is variety and recognizable depth to the background, such as a tree at one distance, a hedge at another and a fence at a third. As long as you can see the relative distances between the objects it doesn't matter what they are.

Set the zoom to the longest focal length and position yourself so that the object fills the bottom half of the frame before taking a shot. Then, zoom out to half the original focal length, but also walk closer to the subject (trying to stay in line with the background), so that it still fills roughly the bottom half of the viewfinder and take another shot. Finally, repeat the exercise, but zoom out to the shortest focal length (widest angle) that your lens offers. Walk toward the subject, fill half the frame once again, and take a final shot.

Download the images onto a computer and review them carefully. It ought to be apparent how, in the longest focal length shot, the background appears to be compressed and the angle of view narrow. With the second and third shots, although the size of the subject should have remained more or less the same, you will see that the background appears to stretch out away from the subject, and the space between the various background objects should be increasingly well delineated. Notice also, however, how the angle of view is both wider and taller as you zoom out with your lens.

38mm

Close-up and Macro

With the great improvement in lens technology – which is apparent on both fixed-lens compact and hybrid cameras, as well as lenses for dSLRs – an increasing number of people have become fascinated with taking photographs of small, sometimes tiny, objects using the macro feature on the camera or lens.

True macro

Before looking at some of the equipment and techniques that will help you capture great close ups, it's important to differentiate between macro and close-up photography. Strictly speaking, macro photography involves being able to project an image onto the sensor the same size as the subject itself, in other words at a scale of 1:1. Over time, however, this definition has been relaxed somewhat, so that today lenses capable of projecting an image half the size of the original object (1:2) are widely considered macro. Many camera and lens manufacturers have gone even further, and have started to label lenses with only 1:4 magnification as 'macro', although these lenses aren't

LEFT A 'true' macro photograph allows you to image the subject at a ratio of 1:1 on your sensor, but some lenses allow even greater enlargement.

strictly macro, they simply have the ability to focus 'close up', enabling the photographer to capture the object in close detail.

At the other end of the scale, there are some macro lenses that are almost scientific instruments, having the ability to capture images at 5:1, or five times larger than the size of the original object.

Equipment

If you're a dSLR owner, for the best results and in terms of ease of use, a dedicated macro lens is the best option. Such a lens will retain all the usual functions, such as autofocus, auto metering and complete depth of

field control, as well as providing excellent results. Macro lenses are available in focal lengths ranging from around 50mm to 180mm. The longer the focal length, the farther you can be from the subject while still being able to capture true 1:1 macro shots. This has its benefits when shooting insects, for example, which may fly away at the sight of an approaching camera lens. Remember to take into account the camera's crop factor before deciding on a specific lens – a 60mm focal length on most

BELOW The narrow depth of field common to many macro shots is often apparent in advertising images.

Macro tools

For the highest quality results, a dedicated macro lens for your dSLR is the best, but most expensive, option. Alternatives include extension, rings that fit between your normal lens and the camera to enable close focusing, or a reversing ring that allows you to attach the lens 'back to front'. Although cheaper, both options can mean you have to focus manually and may also mean you have to set the aperture manually as well.

Macro Lens

Extension Tube

dSLRs will have an efl of around 90mm, for example. While designed specifically for macro shots, the majority of macro lenses also make excellent portrait lenses. The efl of 90–100mm (the most common macro focal length) is long enough to create flattering portraits and usually such lenses are quite 'fast', with a maximum aperture of around f/2.8.

Reversing rings
A much less expensive option to a dedicated macro lens is a reversing ring. As its name suggests, this device allows you to attach the front of the lens to the camera body, which has the effect of greatly magnifying the subject. Although good results can be achieved with reversing rings, you may find that you'll have to focus manually and that the aperture closes down as you adjust it, resulting in a dark viewfinder. This makes it much harder both to frame and focus potential shots.

Extension tubes
More expensive than a reversing ring, but again much less expensive than a dedicated macro lens, are extension tubes. These non-optical devices increase the distance between the sensor and the lens, thus allowing the lens to focus closer to the subject.

Extension tubes work with a variety of focal length lenses and can provide good results.

Hybrids and compacts
Some excellent close-up photography can be taken with hybrid and compact cameras. This is because the small image sensor only requires lenses with a very short focal length, which in turn means you can get very close to the subject and keep it in focus.

Manual focus
No matter what type of camera you're using, it may be much easier to turn off the camera's autofocus setting and focus manually on the subject. Rather than using the focus ring or focus buttons, set the focus close to the point you want to be sharpest, and move your entire upper torso nearer to or farther away from the subject, until you achieve the focus you want.

Tripod support
A common problem with macro photography is the extremely narrow depth of field you get. This can be used to the photographer's advantage by adding impact to an image, but

RIGHT Even with modern autofocus systems, macro focusing can still be quite tricky, so try using manual focus.

ABOVE LEFT In macro photography, the depth of field becomes very shallow, allowing you to pick out the tiniest part of your subject.

ABOVE Manually setting the focus point close to the area you want sharp and then moving forward and back until you achieve focus works well.

it does mean carefully considering the subject before deciding which elements should be sharp.

One way of increasing depth of field is to use a small aperture and long exposure. For this you will require a tripod, and the object being photographed has to remain perfectly still during the entire exposure.

Filters

In recent times, with ever more sophisticated image-editing software on the market, an ever-increasing number of photographers are turning to the digital darkroom to replicate the effects of lens filters. So does this spell the end for lens filters?

Lens filters are made of glass or plastic. They either screw onto the end of the lens, or are part of a kit that features a filter holder and an adapter ring that screws onto the end of the lens, to which the filter holder then clips. The former tend to be circular, while the latter can be square and simply slide into a slot in the filter holder.

All dSLR lenses and many hybrid camera lenses can accept lens filters – look for a screw thread on the end of the lens. Screw-in filters come in various diameters, ranging from around 45mm up to 95mm, and filter holder kits usually come in similar sizes. There should be a label on the front of the lens indicating that lens's specific filter size. Some compact cameras may also feature a lens with a screw thread.

Colour filters

Traditionally, when used with film cameras, colour filters were used either to correct a colour cast caused by artificial light or to add an overall colour to an image – neither of which could be easily carried out in the dark-room after the image had been shot.

The use of colour filters to correct colour casts when shooting digitally is certainly still possible, but if you're shooting in RAW, you're likely to achieve a more accurate colour-corrected image by editing it on computer. Similarly, using a colour filter to 'warm up' (make slightly more red) or 'cool' down (make slightly more blue) an image is possible, and

many photographers – even when shooting digitally – will still use this method. However, equally good results are again possible on the computer, and this also provides a much greater level of control in terms of both the specific colour and its strength.

Yet while much can be done in post-production to replicate the effect of certain filters, there are a number of filters that you may still want to consider purchasing.

Ultraviolet (UV) filters

Fitting a UV filter to a lens is worth considering, not so much for its inherent optical properties, but for the protection it affords the lens. The aim of a UV filter is to reduce the amount of ultraviolet light entering the lens, which can cause haziness in certain situations. Because such filters are usually clear they can be left on the lens and won't have any impact on the colour or tone of the image. Many photographers fit such filters to protect the front element of the lens, as it's much cheaper to

ABOVE These two shots show the effect of a polarizing filter. Without such a filter (top) reflections, which render the glass milky white, are clearly apparent in the glass table top. With a polarizing filter attached to the lens (bottom) the reflections disappear and the glass becomes more transparent.

LEFT Polarizing filters should be considered as almost essential for landscape photography. Not only will they cut reflections, but they can also make skies appear bluer.

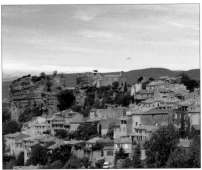

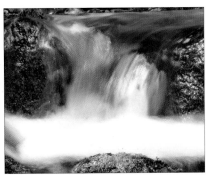

LEFT Like a polarizing filter, a graduated neutral density filter is ideal for landscape photography, allowing you to balance bright skies with darker foreground areas.

replace a filter than to have a scratch removed from an expensive lens. In addition, frequently wiping a filter is preferable to constantly cleaning the lens, which may damage the lens coating over time.

Polarizing filters

A polarizing filter is one example where the effect of the filter cannot be replicated easily on a computer. Such filters behave in exactly the same way as the polarizing lenses in a pair of sunglasses, in that they cut down on reflected light and reduce glare and haze. While these optical properties are often exploited in photography, polarizing filters can also be used to add contrast to blue, cloudy skies (making the sky bluer and the clouds whiter) and can boost the general colour saturation in an image as well.

Due to the overall darkening effect of polarizing filters, it's important to be aware that exposure can be reduced by one or two stops. In other words, a landscape that needs an exposure of

f/16 at $^1/_{125}$ sec, may need an exposure of f/16 at $^1/_{60}$ sec or $^1/_{30}$ sec, or f/11 or f/8 at $^1/_{125}$ sec when it's taken using a polarizer filter – or you could increase the ISO setting one or two steps.

If you're seriously considering adding a polarizer filter to your kit, ensure that you buy a circular polarizer. There are linear polarizers on the market, but the way in which they filter the light can sometimes stop a camera's metering and autofocusing systems from functioning properly.

Graduated neutral density filters

Another group of filters that all professional landscape photographers carry with them are graduated neutral density filters. These are a neutral grey at the top, graduating to clear at the bottom. Their purpose is to overcome the common issue of exposing for both bright sky and darker land. With such a large dynamic range, often either the sky is overexposed and the land correctly exposed, or the sky correctly exposed

and the land underexposed. By using a graduated neutral density filter, you can expose for the land, while the grey element (the 'neutral density') at the top half of the filter prevents the sky from being overexposed.

Graduated neutral density filters come in a variety of 'strengths', with darker or lighter grey being used depending on the brightness levels of the sky. As well as graduated grey filters, they are also available in a range of colours such as red, blue and yellow.

Plain neutral density filters

You can also get plain neutral density (ND) filters, which are uniformly grey. By reducing the amount of light reaching the sensor (without affecting colour), such filters allow for a longer exposure or narrower depth of field, both of which can be used creatively in certain circumstances. Like the graduated filters, ND filters are available in a variety of 'strengths' – ND2, ND4 and ND8 – that reduce exposure by one, two and three stops.

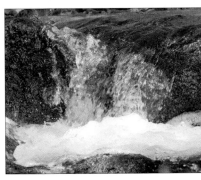

RIGHT Neutral density filters reduce the amount of light coming through the lens and reaching the sensor, giving slower shutter speeds that can be used creatively.

Photojournalism – It's Not Just Art

Up until now, we've concentrated on learning as much as we can about the intricacies of how a digital camera works; how to get the best possible results from it using manual and semi-manual modes and how to improve photographs through the application of some basic tips and hints on composition. This will help you to take photographs that are optimally exposed and have aesthetic merit in terms of their composition.

However, as well as the beautifully composed shot, always look out for images that will hold the viewer's attention in other ways. This may be through humour or poignancy, or through a specific issue the image raises. Frequently, you may only have a fraction of a second to capture the image – in which case the best policy may be to select Auto and fire away. You may not end up with the most creative exposure, but if you don't have time to consider the scene carefully, Auto should at least provide a reasonably accurate exposure and well-focused shot. And, once you've got a usable image, you can always switch to manual or semi-manual and try to improve on depth of field or exposure, if time allows.

Consider compact

Many professional photographers eschew their pro dSLR kit when they are out and about, in favour of a small compact camera. For grabbing quick, candid street shots while on the move, such a camera can certainly come into its own. Recent camera models start up and respond relatively quickly, and their size certainly makes them far less conspicuous than a dSLR with a long zoom lens, and this allows you to wander around more or less unnoticed. You might not have

ABOVE As well as technically competent photographs, always keep an eye out for unusual subjects, such as this 'giant' staring out from behind the doors.

BELOW These children are completely unaware of the camera in this image. Candid shots are much easier to obtain if you are using a compact than if you are wielding a bulky, professional-looking dSLR.

quite the same creative control as you do with a dSLR, but at least you'll be able record what's going on around you well enough.

It's worth getting into the habit of taking a camera with you wherever you go, even if you don't have a specific photographic opportunity in mind. It's likely that you'll find something worth photographing during the course of each day, and getting into the habit of looking for and assessing potential scenes will help you with just about every aspect of your photography.

Photographers' rights

What you can and cannot legally photograph varies enormously from country to country. If you're in any doubt, seek advice or permission from people who you trust – this may well be embassy or consulate staff if you're travelling abroad. If you plan to shoot a specific famous landmark, it pays to contact the owner or the people responsible for the property to ask for their permission first. If you're concerned about simply walking around a city or large town taking photographs, you may find some helpful advice at a tourist information centre.

Historically in the UK, USA and in most of Europe, photography would attract little attention. Photographers could happily walk around large cities taking pictures of major landmarks without fear of attracting the notice of either security staff or the police. Now, however, due to increased security awareness, photographers often find themselves being confronted by the authorities. While legally you're perfectly within your rights to photograph buildings and people in public places, you'll find that in larger cities you may be asked who you are and what you're doing. You may even find that attempts will be made to seize your equipment. Only a police officer is legally

entitled to seize property and then he or she has to be making an arrest; the police cannot seize property without a court order. If you're asked to hand over equipment to security staff, politely but firmly ask for their names and under what authority they're acting. If they refuse to tell you, but persist in demanding the equipment and won't let you simply leave, call the police.

▶ **RIGHT** Political rallies and marches can often provide strong graphic images. In these situations you may find a compact camera attracts less attention than a dSLR.

◀ **LEFT** Many modern compacts are capable of capturing an acceptable image even in the most difficult lighting circumstances, so it pays to have one with you all the time in case you come across unexpected events such this fire display.

▼ **BELOW** If you carry a camera with you at all times you'll be in the position to take a picture of anything that interests you, such as this shop window display.

Black and White

Although technological advances have been the catalyst for a transition from black and white to colour in both television and the movies, and similar technological advances have made it possible for us now to capture and print accurate colour photographs, black and white photography is still very much alive and kicking. There are numerous websites, magazines and books devoted to the art of black and white photography and, for many, the black and white image is the pinnacle of art photography.

Colour photography can, in many ways, be seen simply as a way of capturing and conveying an image of the world around us – as beautiful or as shocking as it may be – because most of us see the world in colour. A black and white image, however, is already one step removed from 'reality', and so it immediately becomes less a way of simply conveying a scene, and more about conveying the photographer's interpretation of the scene. The same applies for colour photography, of course, but even more so with black and white photography, which is why it is and will always remain such a popular genre.

TOP Removing colour often helps us to reveal nature's extraordinary forms and shapes more clearly.

ABOVE Black and white images can often convey a greater sense of gravitas or austerity than colour.

LEFT For many photographers, black and white is the only medium for street photography, immediately giving pictures a 'gritty' newspaper look.

Digital black and white

Traditionally, with film cameras, the photographer had to decide whether to shoot on black and white or colour film, and once the decision had been made, it was impossible to change. With digital imaging you are no longer forced to make that decision. If you want, you can shoot everything in colour and decide at a later stage which images are potential candidates for black and white conversion.

While there's nothing inherently wrong with this approach, it can make for a slightly hit or miss approach to black and white, and it's far better to know in advance what ingredients you need for a good black and white composition. There's no doubting that for most photographers used to working in colour, switching to black and white can come as something of a surprise. Until we start shooting black and white, we are unaware of how reliant we are on colour to make our images work, and that's a very good reason to spend at least some time 'thinking', and if at all possible shooting, specifically in black and white.

Shooting black and white

Most cameras have a black and white mode, and although this isn't the best way of capturing black and white images, using this setting when you're next out with your camera is an excellent exercise as it provides you

with an instant black and white preview. To obtain the best black and white results, shoot in RAW if you have the option, as this will retain much more tonal information than shooting JPEG.

However, if you print directly from your camera, you'll have to shoot black and white JPEGs. Although these will provide adequate black and white prints, you won't have the same level of control compared with converting the images on a computer.

Over the next few pages, we'll be looking at ways of learning how to best compose for black and white photography. Not only is this essential if you're to produce attention-grabbing black and white images, but it will also prove enormously helpful whenever you revert to colour photography.

Noise

When shooting in black and white, or for black and white conversion, it's even more important to set the lowest possible ISO than it is when shooting in colour. The reason for this is that noise is more evident in dark tones, such as dark greys and blacks, than in any other colour, particularly in low-light photography.

TOP This gorgeous shot is all about the soft tones in the image, which have been enhanced by a gentle blur and a slow shutter speed smoothing the water.

ABOVE Black and white portraits can often be far more powerful than their colour counterparts.

LEFT Shooting in black and white forces you to concentrate on tone and texture, avoiding the potential distraction of colour.

Black and White Composition

Without colour, it's inevitable that other elements of composition must come to the fore for a black and white image to be successful. This is the beauty and challenge of black and white photography, and the reason why so many people hold it in such high esteem. It forces us to be more aware and to look much more closely at potential subjects.

Tone, shape and texture

Without colour, it's crucial that the subtleties of tone are captured in as much detail as possible, and for this it's doubly important to be aware of the quality of light at different times of the day or year. Morning and late afternoon will usually provide light that best draws out the subtlety of the tones, but that's not to say that strong, midday light is inappropriate for black and white photography. With the sun high in the sky, shape is emphasized and – depending on the angle of light in relation to the subject – texture can also be clearer. Furthermore, with harsh light, you'll find that you can achieve a greater dynamic range; whites tend to be whiter and blacks darker. Given the right subject matter, the presence of strong blacks and strong whites – with little greyscale in between – can result in a powerful graphic image.

Over time, you'll appreciate how light impacts on black and white imagery in different ways to colour. For example, you'll quickly discover that dull light that may be unsuitable for colour photography because colours are rendered uninteresting and drab, is ideal for black and white as it allows the photographer to explore and emphasize the tones of a scene without fear of harsh, complicating shadows and blown highlights. Similarly, such light is often best for shooting portraits, as the tones are more flattering and the reduced contrast allows the intricate form of a face to be fully represented.

Pattern

One aspect of composition that does not rely too heavily on the prevailing lighting conditions is pattern. You can seek out appropriate patterns for potential black and white treatment whether the light is harsh or soft. For many photographers, the repetitious nature of pattern is made stronger without the distracting presence of colour, which in many scenes could be the only way that one element is differentiated from another.

▶ **RIGHT** The lack of colour in this shot of St Basil's Cathedral, Moscow, encourages the viewer to concentrate not only on the form and texture of the domes, but also on the spaces in between the domes.

▼ **BELOW** Strong lines are even more important in a black and white picture than a colour one as they help hold the viewer's attention.

△ **ABOVE** Without colour, the form, shape and tones of a subject take on a much greater significance if you want the viewer to be able to 'read', or interpret, an image successfully.

△ **ABOVE** With strong shadows, it's possible to create striking images in black and white pictures that might not have as much impact in colour.

Horizontals, verticals and curves

Without colour, another way of keeping the viewer's attention is to look for strong leading lines to guide the viewer around the image. Although leading lines are important in colour photography, they can be the key to a good black and white image and the stronger they are, the less the image is about representing a recognizable scene, and the more it becomes a visual statement.

Tonal contrast

Perhaps the hardest aspect of 'seeing' in black and white is forcing yourself to differentiate between tonal contrast and colour contrast. For example, reds and blues are on the opposite sides of the colour wheel and therefore contrast strongly, but when they are converted to black and white that contrast may well be diminished, or even lost altogether. When working in black and white, it's important to remember that it's not the hue of a colour that's important, but its brightness value.

While the rules of composition for colour and black and white photography are pretty much identical, you'll find at first that you have to work that little bit harder to get black and white images

that you're happy with. But, after a while, seeing potential black and white scenes should become second nature, while shooting them in colour and converting them on computer will give you the option of having two versions of the same scene. It will also give more control over the black and white conversion process.

▽ **BELOW** Although the subject of a silhouette is always black, silhouettes can often work better as black and white images as they have no distracting background colour.

Black and White – Try it Yourself

There are no short cuts to taking successful black and white images; it's a skill that develops over time and with experience. As we've seen, although more or less the same 'rules' of composition apply to black and white photography as well as colour, you really do have to plan a black and white composition more, and ask yourself exactly what it is that you're trying to achieve with the shot.

Comparative shots

The best way to start experimenting with black and white photography is to return to local places where in the past you have taken some successful colour shots. Replicate as closely as possible the shots that worked well and re-photograph them using the camera's black and white mode.

Download the images on to your computer and compare them on screen with prints that you have of the colour images. Alternatively, if you have image-editing software, try converting some of your favourite images into black and white.

Don't worry if the black and white images look nowhere near as good as the colour versions, the purpose of the exercise isn't to go out and take stunning black and white images, the purpose really is to compare the two sets to see how the compositional elements translate into black and white. Look to see how the colours have converted into different shades of grey. Examine the images to see if shape and form are emphasized in the black and white versions. Does the absence of colour change the overall atmosphere of the images?

▶ RIGHT The age and scale of this building in Prague lend themselves to a black and white image, taking us back to a bygone era.

Shoot black and white

Having carried out the comparative test, you should be a little more aware of what makes a good black and white composition. The next time you're out with your camera, make a deliberate point of shooting for black and white only. Aspects that should be at the forefront of your mind are:

• Texture and tone – look out for objects or scenes that have a good gradation of tone, from very dark greys to light whites. Try to shoot under varied lighting to see how it can affect the overall contrast of an image. Return to the same scene but under different lighting conditions to compare the effect of harsh, high-contrasting with soft, low-contrasting light. Look for objects and scenes that feature texture so apparent that you can almost 'feel' it just by sight.

• Pattern and shape – a lack of colour can emphasize rather than detract from pattern. There are numerous artificial as well as natural objects and scenes that reveal pattern often in quite unexpected ways. Also look out for objects with well-defined and interesting shapes – in a similar way to pattern, these can also benefit from being captured in black and white.

• If you're an avid landscape photographer, look out for blue skies with plenty of white clouds. Famous American photographer Ansel Adams is perhaps most famous for his black and white landscapes, many of which featured dark, almost black, skies with broad sweeps of white cloud. Use a polarizing filter to enhance the contrast between the sky and clouds.

• Leading lines and curves are important in colour photography, but they are often even more essential in black and white photography; look out for scenes with strong diagonals, verticals, horizontals and curves. These visual guides can lead the viewer through an image and provide the image with graphic elements.

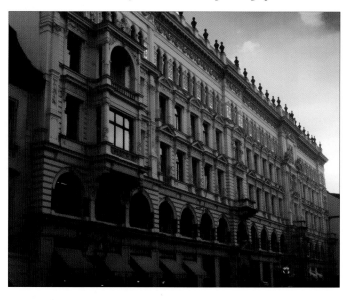

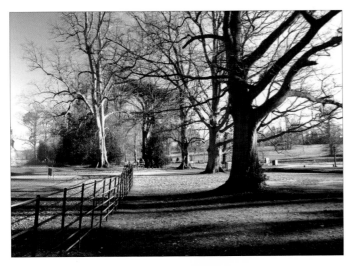

ABOVE AND ABOVE RIGHT Converting some of your images on computer is a good way to begin to learn what works well as a black and white shot. Here, the juxtaposition of the structures of the trees and the fence – one natural, one artificial – is more apparent in the monochrome shot; so, too, are the sweeping shadows.

RIGHT AND FAR RIGHT The purpose of these images is to compare the sense of texture between the colour image and the black and white, between both the stones and the clouds above.

LEFT AND BELOW In the black and white version the dappled light is still apparent and the image assumes a more abstract quality.

Shooting for Manipulation

Most amateur digital photographers (and all professionals) use computers and image-editing software as part of their photographic workflow today. Often this will be for the purpose of standard editing, such as sharpening, cropping or adjusting white balance or contrast, particularly if the images have been shot RAW, in which case no in-camera processing will have occurred and the images will need to undergo such basic editing processes before they can be printed.

There are a number of occasions when photographers will shoot images in the knowledge that they will be manipulated on a computer at a later date – during the process often referred to as post-production.

High-dynamic range

One of the most common occasions when photographers will deliberately shoot for post-production is when the dynamic range in the scene exceeds the camera sensor's ability to capture it. If, for example, due to a bright sky and dark land, the sensor is unable to record both highlights and shadow regions without either the former 'blowing out' or the latter 'filling in' and losing all shadow detail, then often the best course of action is to take two shots – one exposed for the sky and one exposed for the land – and compose them on computer as one image that successfully renders the entire tonal range of the scene.

RAW

Shooting in RAW allows you to adjust the exposure on a computer later and thus create two images (one each for the sky and land) that can be merged as one file. In many ways it increases the dynamic range of the sensor, but the difference between the highlights and shadows is often so great that the extra exposure compensation added in post-production is such that you run the risk of introducing noise into the darkest areas of the image – those most prone to noise.

Panoramas

Photographers will often deliberately shoot for post-production when they want to create panoramas. In such instances, the photographer will take two, three or even more slightly overlapping shots of a panoramic scene, often with the aid of a tripod to ensure the images are aligned accurately. Later the images can then be downloaded and 'stitched' together to form one long panorama.

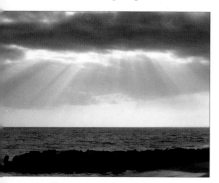

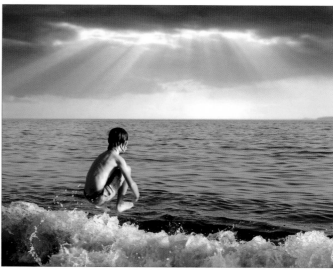

◀▼ **LEFT AND BELOW** A very good reason to keep a small library of different types of sky – stormy, cloudy or sunny – is that you never know when you'll want to superimpose a more interesting sky over a good shot with a dull sky; but be aware of the ethical compromise.

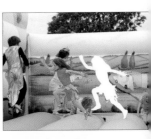

RIGHT Digital photography combined with a computer and some basic image-editing software makes photomontage quick and easy. A quick trawl through your catalogue of images will throw up endless possibilities.

Most examples of image-editing software feature commands that partially automate the process of merging the images together by looking for repeated 'patterns' of a scene from each shot and laying them on top of the other.

Photomontage

The third common reason for shooting for post-production is to create photomontages. This fairly old technique has been around more or less since the advent of photography and involves merging two or more, often incongruent, images together to make one image. In conventional film photography, this was usually only achieved by carefully cutting out the various components with a craft knife and assembling them on the main background image – with mixed results. With today's powerful image-editing software, featuring sophisticated cut-out tools, Layers and Blending Modes, it's now much easier to merge images together seamlessly to create all too credible scenes.

Image libraries

Now that photographers are able to potentially merge two images together seamlessly, many have 'libraries' of image elements, such as sunsets, blue cloudy skies, deserted beaches and so on, which they add when they have the option of photographing a potentially useful element. In this way, they can replace, for example, a slightly dull-looking sky in a particular shot with a much more photogenic one, to give the whole image a makeover.

Ethics

Inevitably, there are certain ethical issues affecting image manipulation. One professional photographer was struck off a well-known news service for slightly increasing the density of palls of smoke following an explosion to give the image an added sense of drama. A similar effect could have been achieved using traditional techniques in a darkroom, but the fear of digital image manipulation in professional circles is so great that draconian punishments are often meted out. Naturally, for amateur photographers who are displaying their photographs for family and friends, there's not an issue, but it may become one if images are entered into competitions and the rules strictly state that only minor enhancements to images are allowed.

RIGHT Combining one shot exposed for the foreground with a second exposed for the sky can be an effective way of obtaining an image with a high dynamic range – useful if you don't have a grey graduated filter to hand. But you will need a tripod or something sturdy on which to rest the camera.

Basic Image Editing

For those of us shooting digitally, most holiday snaps and family photographs can be printed directly from the memory card or camera. But for images you've really worked on, and shot in RAW to maximize quality, you may want control over the image's brightness levels, sharpness and so on. This chapter looks at the basic image-editing tasks that help to enhance your digital images. The projects are based either on Photoshop CS (the industry-standard editing application) or Photoshop Elements (the best-selling image-editing software). If you are a film user, you can still take advantage of image-editing by simply scanning your transparencies or prints.

Computers and Monitors

With computers now being such a principal component of the modern digital photographer's workflow, it's worth spending a little time looking at the specifications and peripheral devices you'll find either necessary or useful for image editing and storing your digital photographs.

Processing specifications

Computer technology, along with digital camera technology, has come an extremely long way in recent years, and will continue to do so. It is safe to say that just about any modern computer is likely to have sufficient processing power to run most of the image-editing software available, but here are some specific details:

• If you work on a PC running Windows®7, the minimum processing power you need is a 1GHz processor, 1GB RAM (32-bit) or 2GB RAM (64-bit), and 16GB available hard disk space (32-bit) or 20GB (64-bit). To run Windows®8 you need the same specification as above, but additionally a Microsoft DirectX 9 or higher graphics system.

• If you work on a Mac running the more recent OS operating system (OS X 10 and after), you will need at least 2GB of RAM, and 8GB of hard disk. Remember that for either operation system these are the minimum requirements – the higher the specification of your computer, the faster your software will run.

ABOVE Choosing the right computer is important for image editing, as the software you need to run will place huge demands on its processor, memory, monitor and operating system.

For either operating system, the monitor should have a resolution of at least 1,024 x 768 pixels, with a 24-bit colour video card.

Your system should also have a CD/DVD reader/writer so that you can load software and burn discs as a way of storing, sharing and backing up your images. You will also need a good internet connection – the faster, the better – as much of today's software is updated remotely. Additionally, you'll be able to download software on trial.

Finally, ensure that your computer system has appropriate connection ports; either USB, USB 2.0 or FireWire. These will enable you to download images directly from your camera or via a card reader, as well as provide connectivity for other peripherals, such as printers, scanners or external CD/DVD readers/writers and backup hard drives.

With the computer specification detailed above, you should be able to run most image-editing software, but remember that these are the minimum specifications and if you can afford to buy a computer with a higher spec, then do so.

Upgrading

If you find that your computer runs slowly, or that you can't use all the programs you'd like to use at one time, it may not be necessary to buy an entirely new system. There are numerous companies that produce memory upgrades that will be compatible with your computer and are relatively straightforward to install. A quick search on the internet will usually provide a whole host of companies.

If you think your computer is running unreasonably slowly, you should check to ensure that you don't have any viruses, as these will affect your computer's performance and may cause more extensive damage. There are many examples of virus software available that can identify and remove most common viruses.

External hard drives

No matter how long you think the hard disk space on your new computer will last, sooner or later it will be filled with your digital pictures. Before you get to that stage, you may want to consider purchasing an external hard drive for extra space. External hard drives can also act as a backup for your images if, in the worst-case scenario, you experience a complete hard-drive failure.

Monitors

Your computer monitor is very important, as you'll be making adjustments to your images based on how accurately and consistently it displays tone and colour. Most modern monitors are more than adequate for image editing. All are capable of displaying the maximum 16.7 million colours, which is about the same number of colours distinguishable by the human eye. In addition, they also have a resolution of at least 1,024 x 768 pixels, which is perfectly adequate for just about all image-editing needs.

In terms of size, buy the biggest monitor you can afford, as the larger the screen, the easier it is to display images at a good size, along with the various image-editing dialog and tool boxes. Aim for at least a 22- to 24-inch monitor, but again, bigger is definitely better. The drawback to a large monitor is the amount of room it takes up. But at least today's flat LCD screens take up less space than the old CRT monitors.

▲ **ABOVE** When you start loading up your computer with digital photographs, the space on your hard drive will quickly fill up, irrespective of its size. An external hard drive that connects to your computer using FireWire or USB is the perfect answer.

▼ **BELOW** FireWire and USB are the two most common ways of connecting peripheral devices to your computer. Some are very useful, such as printers and scanners, while others, such as a USB fan or torch, can be a bit more fun.

Image-editing Software

With digital photography now the principal method that most people use to capture and share their images, it's hardly surprising that there is a wide range of image-editing software available. The sophistication of image-editing software varies enormously, and this is reflected in the prices of the various packages – the most powerful, Photoshop, costs as much as a semi-profesional dSLR. At the other end of the scale, there is software that you can download for free. Here's a quick rundown of the most popular examples.

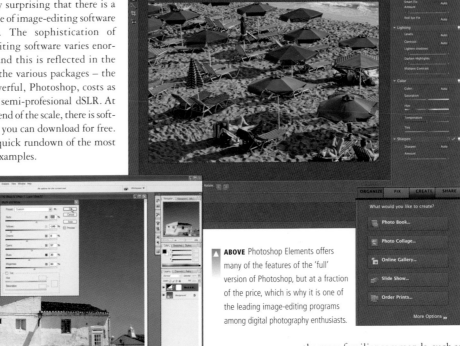

ABOVE Photoshop Elements offers many of the features of the 'full' version of Photoshop, but at a fraction of the price, which is why it is one of the leading image-editing programs among digital photography enthusiasts.

ABOVE The latest version of Adobe's powerful image-editing software, Photoshop, has a staggering array of editing commands and tools. One of the latest additions is the easy-to-use black and white conversion command.

Adobe Photoshop

Photoshop has been the industry-leading image-editing software for many years, and looks set to remain so. Adobe offer all their software on a monthly subscription basis. This not only makes the software more affordable for non-professionals but also ensures that updates are available instantly via an internet connection.

The full version of Photoshop provides photographers with a phenomenally powerful editing tool, capable of performing every conceivable image-editing task. It does, however, require a long learning curve, and for most amateur photographers the software is likely to offer more than they really need.

Adobe Photoshop Elements

Despite costing a fraction of the price of Photoshop, Photoshop Elements draws on its bigger brother for many of its features, including Layers and Blending Modes, as well as many of the more familiar commands, such as Levels, Sharpening, Hue/Saturation and so on. Few photographers would actually miss the features available in Photoshop that don't appear in Elements. In fact, in many ways Elements is more geared to the photographer than Photoshop, and features Quick Fix editing tools specifically for photographs. Despite offering very powerful editing, viewing and sharing tools, Elements is an intuitive program and relatively easy to learn thanks to the layout, the program's structure and the various 'wizard', or help, functions.

Elements has also evolved to become an extremely capable image organizer. Images are automatically downloaded

from the camera or card reader, then organized by date, and can then be renamed by batch. Digital 'albums' can be created and filled by dragging and dropping images, after which you can add key words, making images easier to find later on.

Corel Paint Shop Pro
Similarly priced to Elements, Paint Shop Pro offers a high degree of image-editing sophistication, with some features on a par with the full version of Photoshop. Early versions of Paint Shop Pro were difficult to navigate and the program was quite cumbersome, but thanks to a newly designed user interface and the inclusion of a number intructional videos and tutorials, the later versions of the software are much more user-friendly. Perhaps the one signficant drawback to Paint Shop Pro is that it is only availabe on the Windows platform.

Adobe Photoshop Lightroom
Lightroom is an example of what is often described as a RAW-processing program. It is designed for editing and organizing large numbers of RAW images. Unlike older, more conventional image-editing software, which works by altering the colours and tones of the individual pixels that make up an image, RAW processors make adjustments through a series of instructions (known as parameters), which overlay the original image data. As the original data are left untouched, this form of editing is known as 'non-destructive'. While non-destructive editing does not allow levels of editing down to pixel level, it is sophisicated enough to perform the vast majority of editing tasks that most photographers require, such as colour and tonal adustments, spot removal, sharpening and noise reduction. And because you're editing the uncompressed RAW data, the level of control is excellent.

Although it's possible to edit RAW images using Photoshop and Elements via the Adobe Camera Raw (ACR) plug-in, with Lightroom the opreation is seamless. The program provides an intuitive user interface, is easy to master, and excels at organizing and sharing images. If you shoot RAW for optimum image quality, Lightoom has a great deal to offer.

Picasa and iPhoto
Available as a free download for Windows and Mac OS, Picasa is a very easy-to-use, basic photo editor. Although you don't get the sophisticated tool set and commands found in the editors discussed earlier, it may provide you with everything you need to brighten up and crop your holiday shots.

Similarly, iPhoto, bundled free on every new iOS device, is a basic, no-frills photo editor that performs all the basic editing tasks. Again, it may not offer the level of control of dedicated image editors, but it does have all the tools you need for simple image enhancement.

Free trials
Most software is available free for trial periods. Research online the software you like the look of and give it a go.

LEFT Lightroom is a powerful RAW processing tool that allows you to edit and organize large numbers of images effectively and with ease. Its sophisticated, non-destructive way of working means that you can make as many adjustments as you like without affecting the original RAW image data. So if you don't like what you've done, you can always go back – to the very start if necessary. As a RAW processor it works in 16-bit mode so that colour and tone are rendered smoothly.

Cropping and Rotating

As you take more photographs, framing your shots will become an instinctive part of the picture-taking process. As well as beginning to identify attractive compositions, you'll also find yourself starting to watch for vertical (or horizontal) edges to confirm that the camera is held level and that your images will turn out straight.

Sometimes, however, there just isn't time to worry about making sure everything's perfect, and it's all you can do to grab a shot at all before someone gets in the way. When a photograph comes out looking incorrectly aligned on your computer screen, the answer is to 'reframe' using image-editing software.

RE-FRAMING A PHOTO

This shot has a number of problems that could be tackled, but the key issues are cropping and rotation.

1 In Photoshop Elements, it's easy to straighten a shot using the Straighten tool, which you can find halfway down the main toolbox.

If you're using the full version of Photoshop this tool isn't provided, so skip to step 4 which will explain how you can rotate the image manually.

In the Options bar at the top, ensure the Canvas Options drop-down menu is set to 'Grow' or 'Shrink Canvas to Fit'. This means that your image will be left intact after it's straightened. To straighten the picture, click and drag along any line in the image that should be horizontal, such as the tops of the light grey front panels in the example shown here.

2 This seems to produce the correct result. If you want to check, go to View > Grid. Compare both the horizontal as well as the vertical features against the nearest gridlines. Unless the subject is shot

straight-on, you may not be able to get everything perfectly straight, in which case it may be easier if you rotate the image manually, as explained in Step 4.

3 Once straightened, it is likely that you'll need to crop the photograph. You can crop any image that isn't composed as tightly as you'd like by selecting the Crop tool.

In the Options bar at the top, set Aspect Ratio to 'No Restriction', to crop freely.

Click at one corner of the area you want to retain and drag diagonally to the other. The area outside is dimmed to indicate what will be cropped out of the picture. Drag any side or corner handle of the crop box to adjust it, then either click the green check symbol or press Enter to apply the crop.

This photograph has been cropped square to eliminate the blurred figures on the right. The midpoint of the altarpiece is aligned with the centre of the crop.

4 You can also use the Crop tool to rotate an image manually. First, display the grid (as in Step 2) before you activate and configure the Crop tool as in Step 3.

Drag around the rough area you want to crop to, then move the cursor just off any side or corner handle to show the rotation symbol. Click and drag to rotate the cropped area. Unfortunately, there's no option to display a grid that follows the rotated area, so you'll have to judge by eye.

5

5 Alternatively, you can select the entire image by choosing Select > All, from the menu then Edit > Transform to reveal the Transform commands.

When you rotate the bounding box, the image rotates in real time, allowing you to check it against a grid.

However, the canvas isn't enlarged to accommodate the rotated image, so you may want to create some extra space. Use Image > Resize > Canvas Size and enter values that you think will be enough to encompass the rotated image. Unless you're rotating by a multiple of 90°,

rotating is a fairly destructive process, so if you're at all unhappy with your first try, go to Edit > Undo to retrace

your steps before rotating again. That way you'll retain as much of the image information as possible.

CROPPING TO A SPECIFIC SIZE

You can also crop an image by inputting the dimensions and resolution value in the Tool Options bar.

1 Here, we want to crop the image to 4in (10cm) square with a resolution of 300ppi.

2 Now you simply drag the Crop tool over the image. You can reposition the selection, if necessary, to ensure the best possible crop and click OK. The image will now automatically be 4in (10cm) square at 300ppi.

2

1

| | Width: 10cm | | Height: 10cm | | Resolution: 300 | pixels/inch |

Brightness

Getting the exposure right every time isn't easy, no matter whether it's the photographer setting the controls or the camera's automatic function. Sometimes it just comes out wrong, and at other times there's a good excuse in the form of tricky lighting. The classic example is the situation where you have bright sunlight in the scene, but not on what you're shooting. Almost inevitably, while the shot's overall brightness may or may not be correct, your subject will look dull. When starting out with image-editing software, you may be tempted to reach for the Brightness command. Don't! It's rarely effective, and invariably destructive, discarding tonal information that can't be retrieved with further edits. Instead, turn to Levels, (here using Photoshop Elements) as explained in this project.

ADJUSTING BRIGHTNESS WITH LEVELS

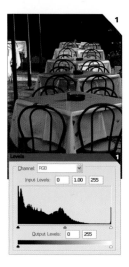

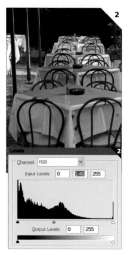

3 Now, to stretch the tonal range up into the lighter values, grab the white triangle at the right of the histogram and drag it to the left. Although it looks as if you're compressing the scale, you're actually expanding it. All those pixels represented by the black column above your marker become white, while the rest spread out across the scale, preserving the same relationships. The result is a brighter picture with more obvious light tones.

Bear in mind that any values to the right of your white marker will be 'burned out', which means they'll end up completely white, with highlight detail getting totally lost. Go too far and the image quality will suffer.

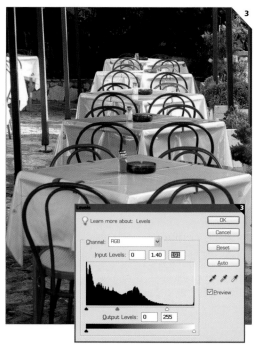

In this example, the image is slightly too dark.

1 Bring up the Levels dialog box by going to Image > Adjustment > Levels, where a histogram will show dark values at the chart's left, and light values at the right.

Here, pixel values are bunched at the dark end (left side) of the scale, with almost nothing brighter than a midtone except for a spike at the white end (right side), which represents the very few highlights in the image.

2 Two factors can make an image look dark; an absence of lighter values and the gamma (or grey) value. This is the location of the mid-point between white and black. To increase the gamma, click on the grey triangle below the histogram and drag it to the left.

If Preview is checked in the dialog box, the image will lighten. If pushed too far, increased gamma can make an image appear washed out so, in most instances, stop at about 1.4.

4 To see the effect you've had on the histogram, click OK when you're happy with how the picture now appears, then open the Levels dialog again via Image > Adjustment > Levels. The histogram shows a 'comb' pattern. Where tonal values are forced to spread out across the scale, gaps are left between them. This isn't a problem, but it represents a lack of tonal variation in the image and illustrates why an image that's shot right to start with will generally look richer than one you've had to correct using image-editing software.

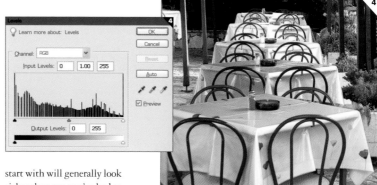

5 There is another way to correct brightness by using the Levels dialog box. Making the assumption that your image is slightly too dark, click the white Eyedropper icon, situated at the right of the Levels dialog box. This gives you an Eyedropper cursor.

Move it onto the image and click on a point that's bright, but not the very brightest value in the image. The effect is similar to dragging the white marker on the histogram back to this value, with pixels of this brightness becoming white. Setting the white point also affects colour balance, so by clicking on a point that should be neutral or white you can correct a colour cast at the same time.

If a shot is too light, you can correct it by reversing the advice here – that is, by selecting the black Eyedropper icon and this time clicking on an almost black element of the image.

DARKENING AN IMAGE

In this example, the image is slightly overexposed.

1 By moving the gamma point in the Levels dialog slightly to the right, you can darken the image.

Adjusting Contrast

There will be occasions when you've got the exposure right, but the picture still looks a little dull, and nine times out of ten the reason for this is a lack of contrast. While a lack of contrast can be a symptom of narrow tonal range, there's no hard-and-fast rule about how 'contrasty' a picture should be. It's really a matter of taste and what's appropriate for the specific image. For example, many classic monochrome landscape pictures have low contrast and rely on a subtle gradation of tone to maintain the viewer's attention. Most often though, you'll be looking to increase contrast to add impact to your pictures. Here's how to do it using Photoshop Elements.

INCREASING CONTRAST FOR IMPACT

Shot in hazy conditions, which hasn't been helped by the use of a telephoto lens, this image of cliffs has low-to-medium contrast.

1 To boost this contrast, go to Brightness/Contrast, which is found under Enhance > Adjust Lighting (in Photoshop Elements), or Image > Adjustments (in Photoshop). Increasing the Contrast setting to +40 gives a promising boost.

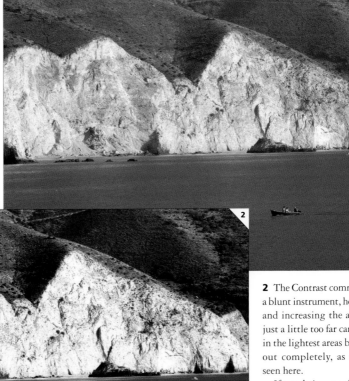

2 The Contrast command is a blunt instrument, however, and increasing the amount just a little too far can result in the lightest areas burning out completely, as can be seen here.

If you bring up the Info palette and move the mouse pointer over these areas, you'll see values of R=255, G=255, B=255 throughout, meaning that all the highlight detail is lost. This can happen even with modest adjustments.

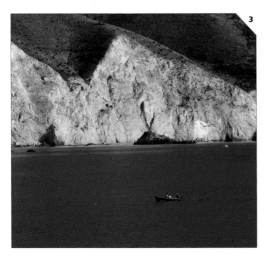

3 A far better option is to turn to the more powerful Levels command found under Image > Adjustments. In a low-contrast image, you will probably find that the histogram will show a lack of tonal values at the right and left ends of the scale – that is, the lightest and darkest values. Values cluster around the middle, falling off rapidly.

To correct this, grab the black and white markers in turn and drag them from the ends of the scale toward the middle. Leave each one at the point on the scale where the values start to rise. This gives a more subtle correction that leaves detail intact, allowing you then to control the result more precisely.

With some photographs, the histogram may appear to be all right, but the impression is still of low contrast. Moving the black and white points inward will still be effective, but make sure you watch out for lost detail in the shadows and the highlights.

4 Don't forget the gamma setting, represented by the grey marker in the middle of the histogram. Moving this to the left will emphasize the darker tones more, giving a bolder image. Moving it to the right will make the scene more pale and washed out.

Adjusting this setting along with the black and white points allows you to control the image's contrast and both the lightness and darkness independently. For example, here we've left the white marker alone, but have moved the black marker

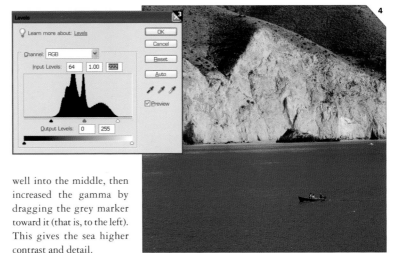

well into the middle, then increased the gamma by dragging the grey marker toward it (that is, to the left). This gives the sea higher contrast and detail.

USING AUTO-CONTRAST

Here is another alternative to adjusting the black and white points manually in the Levels command.

1 Try Auto Contrast (found under Image > Adjustments > Auto Contrast). The effect is similar to performing Step 3 manually but this method has the added advantage of not affecting the colour balance as you can see here.

Correcting Colour Cast

Most digital cameras come with good Auto white balance (AWB) correction built in. This element of the camera's internal processing software analyses the scene you are shooting and attempts to correct any colour cast caused by strongly tinted light, such as that created by tungsten or fluorescent lighting. You can usually override the AWB correction and select the specific white balance mode that you want to use.

For example, if you are taking pictures indoors with incandescent lights or fluorescent striplights, you can select either of these options from the white balance menu and your camera will adjust the tone to be more natural, despite the ambient lighting conditions. However, these settings are seldom perfect and the camera can be tricked into making the wrong correction, which will result in a colour cast across the entire image.

USING LEVELS TO CORRECT COLOUR CAST

In the example shown here, the camera's Auto white balance was set to tungsten by accident, which has caused all sorts of colour issues.

1 A cold blue colour cast has affected the entire image, most obvious in the stone door frame, which should be brilliant white.

2 There are many methods you can use to correct colour cast problems in image-editing software, but by far the most powerful is the Levels command. Let's first try Auto Levels (Image > Adjustments > Auto Levels). When you are using Auto Levels, Elements finds the lightest and darkest pixels in each of the three colour channels (red, green and blue) and changes them to white and black respectively.

In this specific example, Elements hasn't done a very good job, and the resulting image has become too yellow and looks a little washed out. Use the Undo function (Edit > Undo) to revert to the previous image.

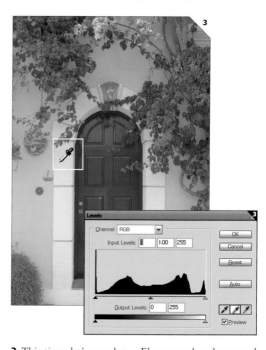

3 This time, let's see what happens when you take more control over the adjustment. Bring up the Levels dialog window, then click on the grey Eyedropper tool, which is the middle icon of the three found at the bottom right of the Levels dialog. Click on any grey part of the image with the tool, to tell Elements what the neutral tones are. Elements will rebalance the colours so that the area you clicked on becomes a neutral grey.

Don't be tempted to click on an area that is too bright or too white (such as the stone door frame), as this will give an entirely incorrect result, as shown in this example.

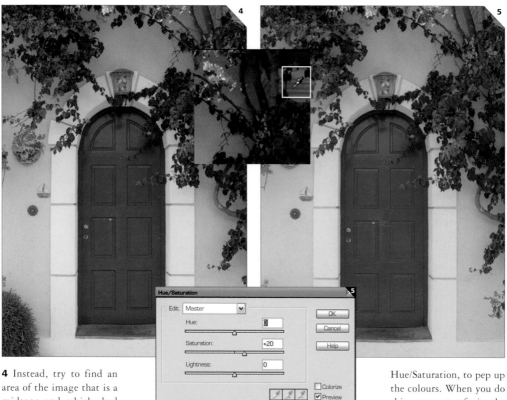

4 Instead, try to find an area of the image that is a midtone and which, had the image been correctly balanced to begin with, would have been close to a neutral grey. Here, a piece of stone cornice at the top right of the image has been selected. Clicking on the shaded areas in the grooves provides a much more accurate result.

5 Now the colour cast has been removed, it's often a good idea to increase the saturation using Enhance > Hue/Saturation, to pep up the colours. When you do this, you are safe in the knowledge that you won't be making the colour cast worse. Here, the saturation level has been increased by +20 to add more intensity to the colour.

USING AUTO COLOUR

Alternatively, you can try an automatic command to correct the orangey-yellow colour cast that is evident in this example.

1 The Auto Color command (which is found under Image > Adjustments > Auto Color) can sometimes be a bit hit and miss, but here it has successfully removed the colour cast of the street lamps in this outdoor café.

Curves

The Curves function is one of the tonal adjustments that is most often used by professional retouchers. The progression from dark to light in the image is depicted as a diagonal line, which you can reshape into a curve – or whatever shape you wish – to render the picture's tone exactly as you want it. Curves is a long-standing key feature of Photoshop, enhanced in recent versions to offer more information and control over individual colour channels. It has also been recently introduced into Photoshop Elements.

ADJUSTING TONE WITH THE CURVES TOOL

1 An extremely powerful and versatile tool, Curves can be used to adjust the tone of any photograph, but it's also a useful alternative to Levels for boosting a shot that looks a little flat and dull, such as this one.

Start by going to Image > Adjustments > Curves to open the Curves dialog box. As with Levels, you're shown a histogram in which each vertical bar represents the number of pixels of a certain value, from dark at the left of the scale to light on the far right. Overlaid on this histogram is a diagonal line that shows the relationship between the original image (or 'input') on the horizontal axis, and the result of the Curves function (or the 'output') on the vertical axis.

2 With this particular image, the grey histogram in the background (new to Photoshop CS3) fades off at both ends of the scale, indicating there is a lack of shadows and highlights.

As with Levels, you can shift the black and white points to fix this by dragging the markers at the left and right of the horizontal axis toward the middle. Move them to where the values start to climb and you'll see the end points of the diagonal line will then move along with them.

3 In the Levels dialog, you could then adjust the overall tone by moving the central grey or gamma slider to the left or right. Curves gives you greater control of the progression from dark to light. Click on the middle of the diagonal line and drag downward. The picture will look darker overall as shadows become deeper, but it still retains the brightness and detail of the highlights.

5 Curves can be used creatively in addition to correctively. The curve shown here produces a high-key image with false-colour shadows for a psychedelic effect. On monochrome images, a curve that has several peaks and troughs will give a metallic look. Experiment for yourself to see what effects are possible.

In general, when you're not aiming for special effects, your curve should remain smooth and, from left to right, each point should be higher than the last. Otherwise you'll create areas of flat, featureless colour within the image.

Unless you need to bring in the white and black points, make the curve continue smoothly to each

4 To brighten things up, click near the top right of the curve to add a second point. Drag this point upward and the curve will change shape. You now have what is commonly known as an 'S-curve'. Darkening the shadows and lightening the highlights in this way will create a bold, high-contrast image.

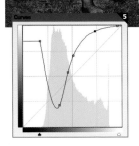

end of the scale, without flattening out. This avoids the problem of clipping shadows or highlights.

Preserving colours

Notice how colour, as well as lightness, is affected as you adjust the curve. As the image gains contrast, colours also become more saturated. If you want to adjust contrast while preserving colours, switch your image from RGB to Lab mode (Image > Mode > Lab color) before using the Curves command. You can then adjust the curve for the Lightness channel only, which affects contrast and not colour.

Dodging and Burning

The slightly strange-sounding terms of 'dodging' and 'burning' hark back to the days of the traditional darkroom. Both terms refer to localized print-exposure control as the photosensitive photographic paper is exposed to the light from the film enlarger.

For example, a common use of burning is to ensure a bright sky is sufficiently exposed to bring out detail in the clouds. The photographer will make a rough mask of the foreground, and, after a set time, use the mask to cover the foreground so that the sky receives a few more seconds of exposure to the light, therefore making it darker. Dodging works in the opposite way. If parts of the image are in deep shadow, the photographer will make a mask to cover those areas part way through the print-exposure time. By doing this, he or she reduces the light striking the shadow areas, making them lighter than the rest of the image so that they hold fine shadow detail.

The digital versions of dodging and burning tools are intended to replicate these effects. In other words, they allow specific parts of an image to be made either lighter or darker, primarily to bring out detail in those regions that might otherwise be lost.

ADJUSTING LIGHT AND SHADOW

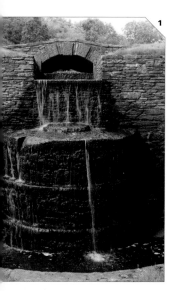

1 This photograph of a water feature was taken on an overcast day. Detail has filled in the darkest (under-exposed) regions of the photograph, while the top of the feature and the trees beyond are overexposed and have taken on a faded look. With careful dodging and burning, we should be able to balance the two regions.

2 To extract the detail from the darkest shadows, select the Dodge tool from the Toolbox. Make sure that the Exposure is set to between 5% and 10% in the Tool Options bar, and then set the Dodge tool to Shadows, using the drop-down menu in the Tool Options bar. Now adjust the tool to an appropriate size and then 'paint' over the worst offending areas.

You might discover that the results are sometimes a bit slow to appear, and rather than lightening the area, the Dodge tool can sometimes make the area appear a little cloudy.

3 To darken any over-exposed areas, select the Burn tool (it's in the same location as the Dodge tool), but this time use an Exposure setting of around 50% and select Midtones from the Tool Options bar. Brush the Burn tool over any overexposed areas. The Burn tool does a better job of darkening highlights than the Dodge tool does of lightening shadows, but control is still quite tricky.

4 Because the Dodge and Burn tools are tricky to control, the most effective way to dodge and burn areas of an image does not involve using these tools.

Instead, begin by creating a new blank layer by clicking on the 'Create a new layer' icon at the top of the Layers palette. In the Blending Modes menu at the top of the Layers palette, change the Blending Mode to Overlay.

5 Select the Brush tool in the Toolbox, and click on the default Background/ Foreground icon at the bottom of the Toolbar to ensure that the Foreground and Background colours are black and white.

Next, click on the small right-angle arrow icon next to the default colour icon to exchange them, so that white is now the foreground colour. Use the square bracket keys to set an appropriate brush size, and in the Tool Options bar set the Opacity to a value between 30% and 50%. As before, paint over the shadow areas. You should notice that the adjustment is much quicker than before and that the lightening effect is much more successful than using the Dodge tool.

You can also increase or decrease the Opacity if you want to increase or decrease the dodging effect. Another option is to increase or decrease the layer's Opacity in the Layers palette.

6 To replicate the Burn tool, you simply select black as the foreground colour. As previously, paint over the overexposed highlights to darken them and add some colour. Notice how the trees and foreground grass now look much more vibrant. Again, you can use the Opacity slider in the Tool Options bar if you want to adjust the strength of the burning effect.

7 When you're happy with the overall adjustment, try clicking on the Dodge and Burn layer's visibility eye to turn it off and on.

This shows an instant 'before and after' of the effect that the layer is having.

If you wish, you can go back and paint black on any over-dodged areas and vice versa. Alternatively, you have the option of reducing the overall Opacity of the Dodge and Burn layer as well, to reduce the intensity.

Sharpening

Sharpening is one of the most important functions of image-editing software. Although used primarily when images have been shot using the RAW files format, (which therefore require some post-production editing), sharpening can also help when you find a shot isn't perfectly focused, just as long as the problem isn't too severe. Even on pictures that already look crisp, an additional amount of sharpening can ensure detail really pops out, especially if you are going to make a print. Sharpening also has an important technical function in countering the softening caused by scaling an image to make it larger or smaller.

APPLYING UNSHARP MASK

1 Before you think about sharpening any image, it is best to view it at 100% magnification first – that is, with one pixel on the screen representing one pixel in the image. For corrections such as tone and colour adjustments, you'd want to zoom out so that you can see the whole image, but sharpening can only be judged at 100%.

2 The best command to use for almost all sharpening purposes is Unsharp Mask. The name reflects the fact that this filter works by subtracting a blurred copy of the image. It's a digital version of a technique which is used in traditional image processing. In all versions of Photoshop, the command is found in Filter > Sharpen. However, in Photoshop Elements 5, it was moved to the Enhance menu.

Choosing Unsharp Mask brings up a dialog box that contains three sliders and a small preview window. Tick the Preview box to see the result on the main image, or untick it to compare the preview against the original. Your task is to find the right slider settings for your picture. Start by trying Amount: 100%, Radius: 2, Threshold: 0. With low-resolution images, use a Radius of 1 for greater sharpening.

3 See what effect this has on the image. Most images will have limited depth of field, so concentrate on the areas that are meant to be in focus. It's these that you're aiming to sharpen.

The bee in this high-resolution picture needs to be sharp, to draw the eye and create contrast with the softer petals, giving us an

impression of the world at the insect's scale. To do this, increase the Radius setting until the detail becomes noticeably harder-edged. Here, 3.5 pixels is enough.

4 You can also increase the Amount if you need to create a stronger effect. It's important not to increase these settings too far though, so watch out for 'halos' around edges and a loss of subtle detail.

In this case, slightly over-zealous sharpening has created a marked glow around the bee's antenna, whereas the highlight detail has filled in.

5 Having set the first two sliders for the best result on key areas of detail, use the third, the Threshold slider, to mitigate any unwanted side effects.

Here, the low-contrast background areas, such as the distant foliage behind the petals, originally looked smooth, but the Unsharp Mask brings out noise (digital grain) in smooth areas of the image.

Sharpening down

When you print an image using a four-colour process (which is the method used to produce this book), the pixels are converted into dots of ink using half-toning. This has a softening effect, so to keep the picture looking crisp, you should sharpen a little more than normal. The dithering, or stochastic screening, method used in modern inkjet printing has less effect on sharpness.

It's often said that a digital image cannot be enlarged beyond its proper size without loss of quality, but it can safely be reduced. That's not strictly true, because when an image is reduced in size, it won't appear nearly as sharp. Before printing a high-resolution photograph at a small size, resample it using Image > Resize > Image Size. At the bottom of the dialog box, tick Resample Image and set the resampling method to Bicubic Sharper. Then enter the required physical dimensions under Document Size and click OK.

For even better results, especially with very small printed images, try resampling in stages, reducing by no more than 70% each time, using Bicubic Sharper. Apply Unsharp Mask at 100% with a 0.5 pixel Radius to the final, reduced image.

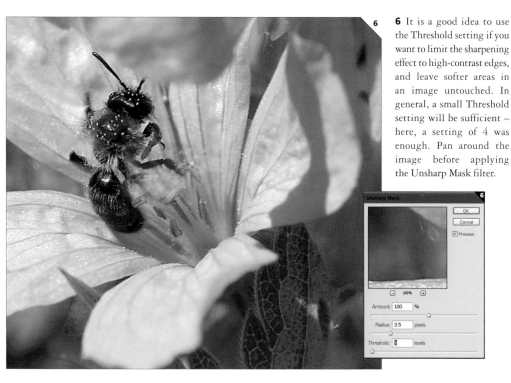

6 It is a good idea to use the Threshold setting if you want to limit the sharpening effect to high-contrast edges, and leave softer areas in an image untouched. In general, a small Threshold setting will be sufficient – here, a setting of 4 was enough. Pan around the image before applying the Unsharp Mask filter.

Advanced Sharpening

Some photographs present a challenge because they're substantially out of focus. This may be due to slightly inaccurate manual focusing, a subject being in motion at the time the picture was taken, the camera's autofocus picking out the wrong part of the scene or autofocus being compromised by low light.

Software sharpening can never completely correct poor focus, but it can help to restore a reasonable impression of sharpness. However, it is very difficult to achieve this without serious unwanted effects. Limiting unwanted effects requires more advanced techniques than simply applying the Unsharp Mask, as shown here.

MANUALLY IMPROVING FOCUS WITH UNSHARP MASK

1 This photo looks like it's in focus at first glance, partly because the red and gold decoration in the background is unfocused, which makes the foreground subject look sharp by comparison.

At 100%, however, you can see that the face is very soft, with the eyes in particular lacking the hard detail that would give the shot real impact.

On your own photograph, identify an area such as this where you feel you need to concentrate your efforts.

2 It may be helpful to zoom to 200% in order to get a really clear view, then go to Filter > Sharpen > Unsharp Mask and set the sliders to a base level, as discussed earlier. On such a soft image, there'll be little or no visible improvement, so increase the Radius until you start to get an actual result. In the image shown here, there's a noticeable boost at 4.5 pixels.

3 Such strong sharpening produces side-effects you don't really want, such as distinct halos around edges and an increase in noise. Part of the reason for this is that you're working on a colour image, and increasing the contrast at the edges also has an impact on the appearance of the colours. To avoid this, you just need to separate the light and dark tone information from the colour information. This can be easily done by simply switching your image from the normal RGB colour mode, where three channels store the red, green and blue values for each pixel, to Lab Colour.

To change to Lab Colour, cancel the Unsharp Mask dialog box and select Image > Mode > Lab Color.

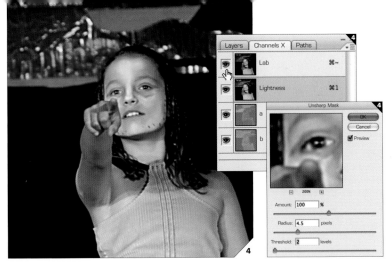

4 If you look at the Channels palette, you will see the image is stored as 'a' and 'b' channels (which contain colour information), plus Lightness.

Click the Lightness channel and the image then appears in monochrome, showing only the lightness of each pixel, rather than its colour. Click the box to the left of the composite Lab channel at the top to re-display the 'Eye' icon. Although you're viewing the full colour image, you will only be working on the Lightness channel when you apply the sharpening.

Open the Unsharp Mask filter and you'll see the preview within the dialog box reflects the monochrome Lightness channel. You should now find it easier to set a Radius that gives a clear improvement, but without excessive halos.

Watch for excessive noise in the low-contrast areas, but a small Threshold, such as 2 pixels, should be more than sufficient to fix this in most cases.

Smart sharpen

Adobe offers another sharpening command that has the option of using a method similar to Lab conversion to minimize unwanted effects, while keeping your image in RGB. If in Photoshop, go to Filter > Sharpen > Smart Sharpen. If you're using Photoshop Elements 5, then go to Enhance > Adjust Sharpness.

The Remove drop-down menu provides a selection of methods. It's possible to minimize halos by selecting Lens Blur, but you'll probably discover that you need stronger settings to get a visible improvement. There's no Threshold control here, so you don't have direct control over any resulting noise.

In Photoshop, you can click Advanced for extra controls that limit the sharpening effect to shadow or highlight areas. This can be a very useful feature if the sharpening settings that give the best result in the area of interest cause excessive halos or noise in other areas.

5 Using higher settings isn't the only way in which you can increase the effect of sharpening. It can be more effective to sharpen twice, so go back to Unsharp Mask and try a smaller Radius, and, if necessary, use a higher Threshold to avoid noise.

One way to think of it is that the first Unsharp Mask brings out edges from the background, and the second Unsharp Mask sharpens those edges. When you've got the best result, convert the image back to RGB using Image > Mode > RGB Color.

Cloning Tools

Cloning tools are an important feature of most image-editing programs. They are powerful editing tools that in simple terms copy, or 'clone', the pixels from one area of an image and place them over another part of the image. This is usually done in order to remove unwanted marks, blemishes or even entire objects. Because there is a number of different types of elements that you might occasionally want to remove, most image-editing software packages offer a range of cloning tools. These make it easier to ensure any corrections that you make are all but invisible to see, and they speed up the image-editing process. Here we'll look at the main Cloning tools offered by Photoshop, but other applications offer a range of very similar tools.

REMOVING UNWANTED MARKS AND OBJECTS

Spot Healing Brush

1 Before cameras had built-in dust removal systems, dSLR users would suffer from dust entering the camera body and attaching itself to the image sensor.

Even with these new dust removal systems, dust can still find its way onto the sensor. It manifests itself as dark spots that are most noticeable in uniformly coloured areas of an image, such as a very clear blue sky. They also become far more obvious when a small aperture is used.

The spots will continue to appear in the same place, frame after frame, until the sensor is cleaned.

2 Both Photoshop and Photoshop Elements have the perfect tool for deleting dust spots from images; the Spot Healing Brush.

Simply select the tool from the Toolbox and adjust the brush size using the '[' and ']' keys until the brush cursor fits neatly over the offending spot. Then all you need to do is click the mouse button.

3 The same tool works equally well on any skin blemishes, such as spots, freckles and moles.

The Spot Healing Brush has two options available in the Tool Options bar. Proximity Match samples pixels from around the edge of the selection to replace the blemish, while Create Texture samples all the pixels in the selection.

Healing Brush

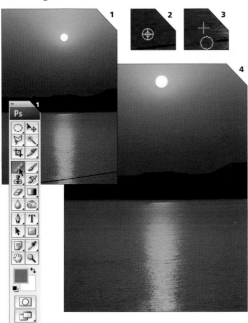

1 The Healing Brush tool is twinned with the Spot Healing Brush and works in a similar way. The sunset image shown here suffers from having a telegraph cable running along the bottom edge, which was unavoidable.

2 Select the Healing Brush from the Toolbox and use the '[' and ']' keys to adjust the brush size. The tool works more effectively if you use a soft brush.

To begin sampling, hold down the Alt key as close as you can to the start of the area that you want to replace. The Round Brush icon will then turn into a target to indicate that the tool is now

in 'sample' mode. This signals that you can now begin to fix the problem area, in this case, the telegraph cable.

3 Sample the area and then paint over the offending cable. You'll notice a cross near to the brush symbol, which moves along as you paint. This indicates the area that the tool is sampling. Here, for example, the tool is automatically sampling from the golden coloured water as it moves along the cable.

4 Removing the cable from this photograph took a matter of seconds using the Healing tool.

Clone Stamp

1 If the area that you want to replace is comparatively large and the region from which you are sampling is not a uniform pattern, the best tool to use is the Clone Stamp tool. In this image, for example, it would look better if the large sign on the rocks could be removed.

2 As with the Healing Brush, start by selecting an appropriately sized soft brush and then hold down the Alt key to sample the part of the rock that you want to copy.

3 When you've done this, release the Alt key and then click with the brush on the area that you want to replace. You may find that clicking the brush more than once helps to delete the area.

4 Continue to sample from different regions to avoid creating regular patterns of tell-tale signs of cloning. You may find that you need to go over parts of the image that have already been sampled. By adjusting the brush size and sampling from various parts of the image, you should soon be able to create a realistic-looking replacement area of rock face.

Advanced Cloning

The Clone tool is an indispensable item in Photoshop's and Photoshop Elements' tool chests. If you have unwanted objects or artefacts in your image that spoil an otherwise perfect shot, the Clone tool is probably the first tool to reach for. By allowing you to sample and paint using nearby pixels, you can use this tool to effectively eradicate, extend or duplicate elements in your scene – usually with a few strokes of the mouse.

DISCARDING UNWANTED ELEMENTS

1 In this photograph, modernity is encroaching on an otherwise picturesque, rooftop townscape. You could probably get away with leaving in the aerials, but the satellite dishes have to go. Here, the Clone tool comes to the rescue.

2 Start with the removal of the satellite dish on the right. First, begin by sampling an area of stone wall from anywhere around the dish by holding Alt and clicking on the image. Don't click too close, but not too far either, from the area you want to remove from the picture.

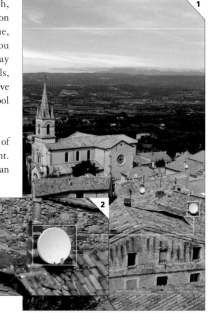

4 To replicate the top edge of the roof tiles, place the Clone tool over an existing edge section, and clone out the appropriate part of the dish. You may find using a harder brush provides a cleaner, more distinct line.

3 Set the Clone tool's brush to a smallish size, sample the wall and, using single clicks, cut out the part of the dish that's in front of the wall.

5 For areas that contain straight lines and in which there is a great deal of contrast between one region and the neighbouring one, such as the edge of the chimney stack 'overlapping' the stone wall in the background, the best method is to draw a selection around the existing side and copy it. Now we'll paste the copied selection over the remaining part of the satellite dish.

6 After roughly positioning the copied selection, use the transform commands to flip the section and rotate it into the right position. Flatten the layers and tidy up the new section using the Clone tool as before.

7 You can do the same with the remaining smaller dishes, cloning them out carefully, but always paying close attention to what patterns of pixels are immediately around them. If you choose your sample areas carefully, the final result should be a seamless image free from any unsightly satellite dishes.

When undertaking detailed cloning work such as that shown here, it pays to zoom right in when doing the cloning and then zoom out to normal size to see the correction in context.

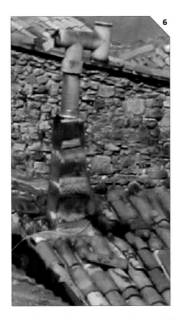

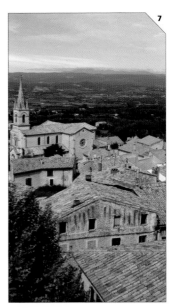

REMOVING AN IMAGE WITH THE PATCH TOOL

Photoshop also has a powerful, quick and easy tool for removing just about any item, from small facial blemishes to entire objects. It's called the Patch tool.

3 Once you have made the selection, click and drag it to an area on the image that most closely resembles the background of the object that you are trying to remove, and then release the mouse.

1 In this example, we are going to use the Patch tool to remove the last and smallest of these three red shoes in the image.

2 With the Patch tool selected, draw around the object you want to remove. Once you've done this, the selection will change to the familiar dotted line, or 'marching ants'.

4 Photoshop will sample the new area onto which you dragged the selection and use it to replace the initial area.

How effective the result is depends on the complexity of both the selected area and the sample area. Here, the random pattern of the road has resulted in a pretty convincing fix.

Advanced Image Editing

Image-editing applications have much to offer in terms of image enhancement. Here we're going to concentrate on pixel-based software, such as Photoshop, Elements and Paint Shop Pro. This type of software works on a layer-based system, allowing you to make localized or wholesale adjustments to an image without affecting the original. Using layers and controlling how they interact with each other by applying a variety of blending options, along with a vast array of editing tools and creative filters, opens up endless possibilities for your images. We'll also take a brief look at how Lightroom, a popular RAW processor, allows you to edit images.

Introducing Layers

Layers were first introduced with the third version of Photoshop, Photoshop 3. Their introduction turned image-editing software on its head. Layers make editing images much easier than if you have to work on a traditional single-layered canvas. They allow you to do things that would be impossible with a traditional 'one-layer' canvas.

The concept often employed to explain how layers work is that of a stack of transparent sheets, such as those you use on an overhead projector. Although you begin with a single layer (often called the Background layer) you can create a new, empty, transparent layer above it, as if slipping a new transparency on top of the original stack on the projector. This enables you to draw on the new layer, on top of the background layer, without actually altering the background itself. You can slide the sheet around to move the new elements relative to whatever is on the background, which will remain unaltered. You can keep adding new layers whenever you want. Most image-editing software now supports layers; here, Photoshop was used to illustrate the concept.

BASIC LAYER CONSTRUCTION

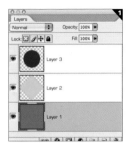

1 Here is a very basic three-layered visual construction of a circle, a diamond and a square. Each of the three elements was drawn on its own unique layer by selecting Layer>New. Each newly created layer will sit 'on top of', or 'in front of', the previous layer.

The corresponding Layers palette to the left of the illustration shows how one layer actually 'sits' on top of (or in front of) another. The Layers palette shows that the red 'background' square sits below a yellow diamond on which is placed a blue circle.

Note: visibility eye disappears

2 By clicking the 'Visibility eye' next to the Layer thumbnail in the Layers palette, it is possible to turn specific layers 'on' and 'off', making them visible or invisible. Here, clicking the Visibility eye next to the yellow diamond Layer thumbnail has rendered that layer invisible, leaving only the red square and the blue circle. Being able to turn layers 'on' and 'off' can help you to appraise images before and after an adjustment has been made.

3 Here, the blue circle layer (Layer 3) has been turned off by again clicking on the Visibility eye, leaving only the red square and the yellow diamond visible. Not only do layers behave independently of one another, allowing you to apply adjustments to individual layers as opposed to the entire image, but you can also change their order simply by clicking and dragging the layers around in the Layers palette. This is shown in the next step, Step 4.

4 In the image above right, the blue circle layer has been dragged underneath (or behind) the yellow diamond layer. As you can see, the diamond totally covers up the blue circle. However, as an illustrative exercise, the three-dimensional image shows how the blue circle is actually hiding underneath the diamond.

Unlike transparent sheets on a projector, digital layers are genuinely transparent, so no matter how many layers you add, the layers beneath will always remain sharp and clear. Digital layers differ in other ways, too: for example, it is possible to adjust the transparency – or 'Opacity' – of the elements. This allows elements on a 'lower' layer to start to appear through the upper layer. How visible they become depends on how transparent you make the layer above.

5 Using the Opacity slider to reduce the transparency of the yellow diamond layer allows the blue circle to start showing through the layer. Notice, however, that in reducing the opacity of the diamond layer, the saturation has also been 'weakened', draining it of its yellow colour. Wherever it interacts with another

colour, such as the red and the blue, a fourth and fifth colour are created.

The way that the hue, saturation and brightness values of individual pixels on one layer react with the corresponding pixels on another layer is governed by Blending Modes, another powerful feature of many software-editing programs, and usually found in the Layers palette. For more information on Blending Modes and how they work, turn to pages 190–191.

LAYERS IN PRACTICE

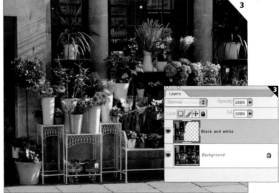

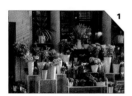

1 When you open an image in Photoshop, it's just like a normal photograph or artist's canvas. There's a single layer (called the Background layer), onto which you can draw or paint directly, or otherwise alter, using any of the editing tools. The heart of layers in most image-editing software is the Layers palette, which shows you all the layers that you have in your document.

2 Duplicate the background layer by creating a copy. You can do this in several ways, but the easiest is to drag the Background layer onto the 'Create a new layer' icon, which is at top of the Layers palette.

Alternatively, go to Layer > Duplicate Layer. You can now safely edit a copy of the image, while keeping the original background layer

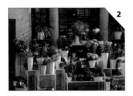

intact. In this example, desaturate the duplicate layer by going to Image > Adjustments > Desaturate.

It's good to get into the habit of giving your layers names, as this will help you track your editing. Simply right-click/double-click in order to highlight the relevant layer text in the Layers palette and type in the new name.

3 A simple way to exploit layers is to remove parts of upper layers to allow layers below to show through. Select the Eraser tool and delete around half of the black and white layer to let the original colour layer show through. When happy with the result, go to Layer > Flatten Image. All the layers will be combined onto one layer to keep file sizes down.

Using Layers

Having learned the basic concept of layers, and seen how by duplicating and altering the background layer you can create some interesting effects, let's see what happens when you combine two or more images to create one composite image. This could be the familiar photomontage type of composite, where images blend into one another to create a surreal piece of art, or when two or more images are combined to create an entirely believable scene. Here, using Photoshop Elements (but again other software will work in much the same way), we're going to replace the sky in one image with that from another, resulting in the creation of a new atmospheric shot. Replacing an uninteresting sky from a picture taken during an overcast day with a clear blue sky from another image is a common advertising trick.

COMBINING IMAGES USING LAYERS

4 Use the Magic Wand tool to select the blue sky above the church. If it doesn't select all of the sky, hold down the Shift key and click on those regions that were missed. This will add them to the selection. Now, once you've selected the sky, go to Select > Feather and enter a value of 1 to soften the edges of the church so that they will blend more realistically with the sky. Press the Backspace key to delete the blue sky.

1 Here are the two source images – one of a Greek Orthodox church under a clear blue sky, and the other of a late afternoon sun. The images are very different in mood, colour and camera angle, but combining them using layers is a relatively quick and easy exercise. The more uniform the sky you want to replace is in tone and colour, the easier it is to cut out of the image using the Magic Wand tool. You should bear this in mind when selecting potential images for sky replacement.

2 Start by combining the two images into a single document. In the Layers palette, click and drag the background thumbnail image of one photograph and drop it into the canvas of the other image. A border appears around the image to indicate you can drop it, and holding down the Shift key will ensure the image is centred. Here, the sunset has been dragged onto the church image, covering it entirely. However, the Layers palette indicates there are two images.

3 Right-clicking/double-clicking on the Background layer of the church file allows you to convert it into a normal floating layer so that you can change the layer order. Unless you do this, you won't be able to move the Background layer, as it is locked.

Photoshop Elements will ask you if you want to give the new layer a name. Call it 'Church'. Drag the church layer above the sky so that it is now the uppermost layer in the Layers palette and covers the sky image.

5 Now you need to move the sun a little to the left, so it's in line with the shadows on the church. To do this, you have to make the New sky layer a bit bigger, or there won't be enough sky on the right-hand side. Go to the Layers palette and select the New sky layer. In the Tool Options bar at the top of the screen, ensure Show Transform Controls is checked. This puts a box around the layer with eight rescale boxes – four at each corner, and four in the middle of each side. You'll have to zoom out to see these more clearly, which you can do by going to View > Zoom Out. Repeat the command until you can view the entire area, then resize the viewing window. Making sure 'Constrain Proportions' is checked in the Tool Options bar, grab one of the corners and rescale the sunset sky so that it is large enough to move to the left. Use the Move tool to reposition it.

6 You need to make the building and sky blend more closely in terms of tone and coloration. With the church layer selected, go to Image > Adjustments > Levels to open the Levels dialog window. Move the centre gamma (or grey) point to the right to darken the image of the church.

7 To adjust the colour of the church so that it matches the sunset sky, go to Image >

Adjustments > Variations and click on Increase Red to warm the image.

8 Here, you can see the successful final result. Simply by slightly repositioning the sun to the left, and getting the church to match the colour and brightness of the sky, it has been possible to create a believable and atmospheric image, using only two layers.

Adjustment Layers

Image-editing adjustments can enhance dull pictures and give you the creative control to overcome problems with lighting, colour casts or even exposure. Unfortunately, there is a catch. Once you've applied such adjustments, they can be difficult or even impossible to reverse, and if you apply several adjustments one after another, you may degrade image quality. However, many editing applications offer a way of applying adjustments that, while affecting how the image looks, actually reside on a separate layer. Using these 'adjustment' layers allows you to apply the entire range of editing tools and commands without affecting the background image. In this way, you can work on an image, applying brightness, colour and tonal corrections, which you can later go back and adjust or delete entirely, if you like. Here, we're using Photoshop Elements to show how versatile adjustment layers are.

CONTROLLING THE IMAGE ENVIRONMENT

1 Open the image you want to edit. Here, we're going to turn this daytime shot into a brightly lit night shot. Go to Layer > New Adjustment Layer to see a submenu of layer adjustments that can be applied in this way. Choosing an adjustment brings up a dialog box that allows you to give your adjustment layer a name. If you're making a lot of changes to a photograph, or want to create a multi-layer composition, it pays to remind yourself of the purpose of each layer by giving it a name.

Like other layers, an adjustment layer has its own Blending Mode and Opacity. You can leave these at the default settings for now, as you can always go back and adjust them at a later stage.

2 Click OK. You now get a dialog box for the selected adjustment, in this case Levels, which you can use in the same way as normal. Tick Preview to see the result on the main image. Here both the left-hand (black) point and the central gamma (grey) point have been moved to the right to darken the image, turning day into night.

3 When you click OK, the adjustment is applied to your image, but it isn't applied directly. If you look in the Layers palette, you will see that you've created a separate layer containing the adjustment, with the name you applied in Step 1. Hide this by clicking on the Eye icon to the left of its name. The original image is then revealed, unaltered.

While the adjustment layer is selected, you can click the Opacity drop-down menu at the top of the Layers palette to reduce the strength of the adjustment. Do this by dragging the slider. If you change your mind about the adjustment made, double-click the thumbnail at the far left of the layer name, which depicts the adjustment. In this case, a histogram for Levels is shown. The Levels dialog is reopened, allowing you to fine-tune the settings. To remove the adjustment altogether, delete the layer.

Because the adjustment is applied to the image 'live', you can add as many adjustment layers as you like, and change them as often as necessary, without any cumulative degradation in image quality.

4 The thumbnail to the right of the Adjustment layer thumbnail represents a layer mask. By default this is white, which indicates that the adjustment applies to the whole image.

To apply an adjustment layer to a limited area of an image, first create a selection. Here, the sky has been isolated using the Magic Wand tool. If you've already added an adjustment layer,

remember to select the Background (or whichever layer contains your image) in the Layers palette before creating the selection, then switch back to the top layer so that your new adjustment will appear above this.

Now, go to Layer > New Adjustment Layer and select the required adjustment. A Hue/Saturation layer is used here to knock back the sky. The Hue is shifted to the left to make the blue of the sky colder, while the Saturation is reduced to make the blue less vivid, and Lightness is increased to match the tone with the snow in the lower part of the image, balancing the composition better.

5 Click OK to create your masked adjustment layer. In the Layers palette, the Mask thumbnail shows the area the adjustment is applied to in white, and the rest in black. For more information on how to use layer masks, go to pages 200–201.

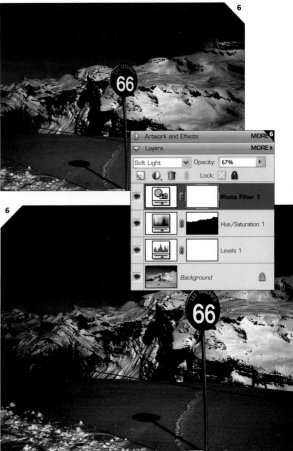

6 You can also use an adjustment layer's Blending Mode to alter its effect. Here, a blue tint has been added to the whole image using Layer > New Adjustment Layer > Photo Tint. The resulting artificial monochrome look isn't entirely satisfactory. In the Layers palette, changing the Photo Tint adjustment layer's Blending Mode from Normal to Soft Light helps to increase the contrast while preserving more of the underlying colour. Reducing the Opacity also helps to control the effect.

Blending Modes

In the last project we saw how altering the Blending Mode of an adjustment layer changes its effect on an image, but Blending Modes can be used for lots of other purposes, too. Every layer has a Blending Mode, which by default is Normal, meaning that anything in the layer covers up what's on the layer beneath. Again, most editing programs offer Blending Modes; here, we're going to use Photoshop to walk through some practical examples.

ADJUSTING TONAL AND COLOUR VALUES

1 To use Blending Modes, you'll need an image with more than one layer. In photography, a useful way to exploit Blending Modes is to copy a single image onto itself and adjust the uppermost image.

Open your photograph and go to the Layers palette. Right-click/double-click on the Background layer and choose Duplicate Layer from the menu. In the dialog box, rename the new layer, or just click OK.

2 The blending mode of the current layer is shown in the drop-down menu at the top left of the Layers palette. Try changing it from Normal to Overlay. This serves to intensify the image, making the shadows darker, highlights lighter, and colours more saturated. This also gives the image a 'contrasty' fashion-photography look.

3 For an even 'hotter' look, try choosing Color Dodge. This brightens the image by increasing contrast and giving it greater colour saturation. With portrait photographs, which typically contain red and yellow tones, the result is reminiscent of a shot taken under intense sunlight. You can also still use the Opacity slider to reduce the effect of the blending mode layer.

4 For a quick soft-focus effect, use Gaussian Blur (Filter > Blur > Gaussian Blur) with a large Radius – in the case of this high-resolution close-up shot, it is 24 pixels – which will soften the layer. With Blending Modes such as those mentioned above, underlying detail still shows through, while low-contrast areas, such as skin texture, are smoothed out.

5 Blending Modes can also be used to help you combine images. In this example, a thought bubble has been added to a new layer using the Custom Shape tool and its Opacity has been reduced to allow the image below to show through. We now want to add an image scanned from a child's drawing.

6 In the Normal blending mode, the white paper covers the image and the bubble. Switching to Multiply superimposes the drawing on the bubble, as intended.

Blending modes explained

Understanding Blending Modes will help you to choose the correct ones when it comes to editing your images. A standard colour image stores red, green and blue (RGB) numbers for each pixel, giving each one a value from 0 to 255. This set of numbers is the pixel's colour value. In a layer blend, the colour value of the pixel in the layer is the 'blend colour'. The value of the pixel in the image as it was before the layer was added is the 'base colour'. A mathematical operation is applied to these values, producing a 'result colour'.

Two of the basic blend modes are Multiply and Screen. Adding a layer in Multiply mode simulates placing two slides in front of a projector's lamp at the same time. Both block some light, so the combined image is darker. Multiply works by multiplying the base and blend colours, then dividing by the maximum value of 255. For example, if you're layering an image on itself, and the R (red) value of a pixel is 100, the result will be (100x100)/255 = 39.

Screen mode does the inverse of this, resulting in a lighter image. Overlay mode combines Multiply and Screen. Where the base colour is dark, Multiply is applied, and where the base is light, Screen is applied. The result is a marked increase in contrast.

Blending modes are grouped by those that lighten an image, those that darken an image and those that do both. These groupings also tell you the neutral colour for each mode. When darkening, any pure white in the layer will leave the underlying image unchanged. When lightening, the same is true of black. And with balanced modes, 50% grey is normally neutral.

Merge for High Dynamic Range (HDR)

For many people new to digital photography, the phrase 'Merge for HDR' may sound completely baffling, but in fact it's an easy concept to grasp.

Merge for HDR (High Dynamic Range) is simply a way of merging together a number of differently exposed images of the same scene in order to increase the dynamic range in a photograph. Digital cameras are only capable of capturing a set range of tones in a single frame, and any tones outside of that range became either pure black or pure white, with no detail visible. However, a number of editing applications now allow you to merge several images that have been taken using different exposures, to capture a much greater range of tones. These all work in more or less the same way, but here we're going to use Photomatix Pro. This works either as a stand-alone program or a plug-in.

CAPTURING A FULL RANGE OF TONES

1 In high-contrasting lighting conditions, such as occurs when photographing a bright sky and a relatively dark land area, it's unlikely that your camera will be able to capture the complete range of tones from bright highlights to dark shadows. The rule of thumb is to set your exposure to capture the highlights, letting the shadows underexpose to pure black. The rationale is that areas of black shadow are visually less offensive than areas of 'blown-out', pure white highlights. With digital photography, however, it's a relatively easy job to overcome the issue by taking a sufficient number of images that capture the full range of tones in the scene you're photographing. To help you do this, most cameras have a bracketing mode that will automatically adjust the exposure setting so that you can easily capture different exposures, as shown here in this scene of the famous gardens at Stourhead. Using auto exposure bracketing (AEB) and the camera set to continuous shooting mode, three images were taken in quick succession, one capturing the bright sky, another the midtones and the third the darker tones in the foreground. Now we can combine the three frames to make one HDR image.

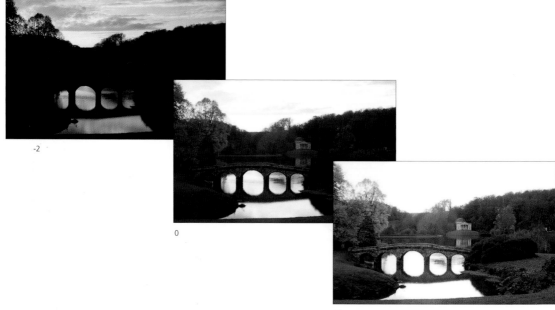

-2

0

+2

2 The next step is to open the images in the HDR software. There are a number of HDR programs available, and most offer a good level of control, along with some preset settings to choose from.

After selecting your source images, you will be presented with a dialog box that allows you to determine the settings that the software will apply to the images.

Ensure that you check the images will be aligned. Decide on the level of noise reduction you wish to apply and whether or not you want the software to fix chromatic aberrations. How good the software is at these tasks will vary. You may wish to use your standard software to correct such issues after the HDR program has combined the images.

3 Photomatix Pro's comprehensive control panel and powerful tone mapping algorithms let you determine the look of the merged photos – from naturalistic to hyper-realistic to surrealistic, and all stages in between. The choice is yours. The software also features a good number of presets which give you a good starting point from which to work.

4 Using low tone mapping settings and relying on the program's exposure fusion settings, the final image appears naturalistic. The complete tonal range as perceived by the human eye is rendered into one image.

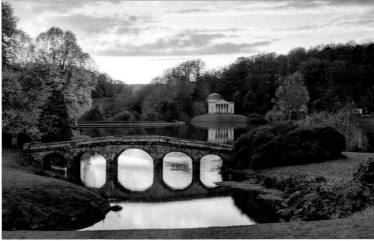

Using the Selection Tools

Selections are crucial to precise image editing, no matter what application you're using. There are literally scores of ways to make selections, and which one you choose to use will depend on the nature of the area you want to select and the specific software you're using; here, we're using Photoshop Elements. Although each of the tools can be used independently, the real power comes when you combine a number of Selection tools to isolate the area you want. For example, the Magic Wand is great for selecting ranges of similar colours, while the Marquee tools are very effective for selecting discrete islands of pixels, regardless of what colour they are. Using the Add or Subtract options, you can use the Marquee or Lasso tool to clean up a selection made using the Magic Wand, or vice versa.

SELECTING TO ALTER ELEMENTS OF AN IMAGE

1 If you want to make a selection in an image such as this, there are a number of options. Let's run through a few simple ways of adding to selections that will help speed up the process.

2 One of the pumpkins at the bottom left is a slightly different colour to the rest, so let's start by making this pumpkin even more off-colour. A simple option is to use the Elliptical Marquee tool – clicking and dragging from the middle of the pumpkin while holding down the Shift key to drag out from the centre will automatically create a perfectly round selection. You can move the selection by dragging inside it, and using Shift (to add) and Alt (to subtract) to fine-tune the selection, dragging out additional areas to add to or cut away from the current selection.

3 With the outline shape of the pumpkin selected, holding down the Alt key while using the Lasso tool (a small '-' minus sign will appear next to the tool's cursor) allows you to draw around the woody, fibrous base of the pumpkin to deselect it.

Once the pumpkin has been accurately selected, we can use the Hue/Saturation command to radically alter the colour of the pumpkin.

 4a

 4b

 7

4 Next, let's turn to the Magic Wand tool to select a sunflower. Begin by moving the tool around and adding to the selection by holding down the Alt key. Note that if you inadvertently select a large unwanted area, switch to the Lasso tool and, with the Alt key held down, draw around the unwanted selection to deselect it.

5 Once the flower-head has been accurately selected, the Hue/Saturation command can again be used to change its colour.

7 Having made the initial selection with the Magic Brush tool, the Lasso and Magnetic Lasso tools can be used to add to (by holding down Shift) or take away from (by holding down Alt) the selection. With the selection completed, that region of the picture can be recoloured.

 8

 6

6 Next, try using the Magic Brush tool to make a rough selection around the courgettes (zucchini). If you don't have a version of the software that features the Magic Brush, then you can use one of the equivalent selection tools.

8 By using a variety of tools, and by adding to and subtracting from selections, it's surprisingly easy to make even the most difficult selections and arrive at a positively multicoloured collection of fruit and veg.

Making Cut-outs

One procedure that you may find you need to carry out from time to time – particularly if you're keen on creating photomontages, making composite images of family members or friends, or placing objects in front of different backgrounds – is to make accurate cut-outs. All editing software will have the necessary tools to create accurate, natural-looking cut-outs.

As always, there are a number of ways of performing cut-outs, some of which might involve the use of the Selection tools discussed on the previous pages. In this example, however, Photoshop Elements is used to create a 'mask' around the image to be cut out, as this offers the greatest control and allows the cut-out to be constantly revised until you're happy with it.

USING THE MASK TOOL FOR CUT-OUTS

| Size: 100 px | Mode: Mask | Hardness: 100% | Overlay: 50% |

2 To begin with, click on the Selection Brush in the Toolbox. Programs other than Photoshop Elements may not include exactly the same tool, but you can usually use the Brush tool as a selection tool in the majority of programs. Go to the Tool Options bar at the top of the screen and select Mask in the Mode drop-down menu.

Elements will use a red colour to represent the mask as a default colour, a feature dating back to the days of conventional printing, when masks used to be cut out of a red acetate material that was known as Rubylith. If you're editing a photograph that is primarily red, the default mask colour makes it more difficult to see what you're doing, so simply click in the colour square and select a different colour for the mask.

It's also possible to change the Opacity of the mask, but for most editing jobs, leave it set to 100%.

3 Set Hardness to 100% initially, to ensure that there is a crisp edge. Adjust the size of the brush using the '[' and ']' keys, and begin painting the mask over the area you want to cut out. For large areas, where there's little risk of painting over the background, use a large brush, as this will speed up the job.

1 This image of a little girl and a dog presents an interesting array of problems in terms of creating an accurate cut-out. First, you will have to cut out around the hair of both the girl and the dog, which is notoriously difficult to deal with, and, second, the background is far from being uniform in colour, which makes it impossible to select using the Magic Wand tool.

4 Although you're painting a mask, you are in effect making a selection at the same time.

To view the selection, go to the Tool Options bar and change the Mode from Mask to Selection. The familiar

marching ants selection will appear. For this exercise, the Backspace/Delete key has been pressed to show how the mask is progressing. Click Edit > Undo to go back a step and bring back the background.

7 Once you're happy with the mask, go to Filter > Gaussian Blur and blur the mask with a Radius of 0.5, just to soften the edges of it slightly.

Next, convert the mask back into a selection in the Tool Options bar. Here, the background has been deleted to leave the cut-out on a white layer.

5 When you get to the more detailed areas, such as around the dog's coat, reduce the size of the brush so that you can trace the edges far more accurately.

You can also reduce the brush's Hardness value in the Tool Options bar. This creates a softer-edged brush, which means you will be able to soften the edges of the selection.

8 Alternatively, you can copy the cut-out, and then paste it into a new document, where you can then create an entirely different background.

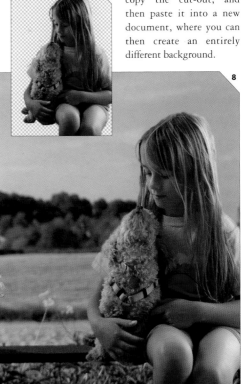

6 If you inadvertently paint over the background, simply hold down the Alt key and brush out the mask.

Zoom into the image as you go to refine the mask, using a very small brush to get into difficult areas.

Creating Montages

Having learned how to make selections and accurate cut-outs of individual elements within an image, it's time to put all these skills together to make a photomontage. Using image-editing software to create a photomontage is much quicker and easier than using old photographs and a pair of scissors and, because you can blend images, the results are much more satisfactory. Before you start to create your montage, it's a good idea to place all the images that you're considering using in one readily identifiable folder so that you can access them quickly and easily. All editing software is capable of creating photomontages; here, we're using Photoshop.

COLLATING PHOTOMONTAGE ELEMENTS

1 The first image you select for your photomontage is the most important, as it will form the central point of your image, and set the scene in terms of subject and tone. This particular image has been chosen because it has plenty of space around the main subject into which new images can be added.

2 Open the second image and make any editing adjustments you need. You may have to adjust the crop, the sharpness, or adjust the brightness levels to try and ensure that it matches the first image as closely as possible. This is best done with both images on screen at the same time so you can get the best possible match.

4 Ensuring that the 'Show Transform Controls' box is checked in the Tool Options bar, click on one of the corner boxes and, while holding down the Shift key to retain the image's proportions, rescale it to the size you want. When you're happy with the size and position of the second image, click OK.

3 Use the Move tool to drag the second image onto the first. In the Layers palette, you will see that the second image has been automatically created on a new layer. Give the layer an appropriate name so you can keep track of the various elements of the montage. In this example, we've labelled our layer 'Bikes'.

5 Go to the Toolbox and select the Eraser tool. In the Tool Options bar, set the Opacity to around 30% and use the '[' and ']' keys to select a suitable brush size. Carefully begin to rub out parts of the second image that you don't want to appear in the montage. Concentrate first on the edges, and remember that if you make a mistake you can always click Undo to undo the step.

6 Repeat the exercise with as many additional images as you like, remembering to give each new layer its own name in the Layers palette so you can keep track of the elements in your image.

7 When you have all your elements in place and you're happy with the composition, try experimenting with various Blending Modes and reducing the Opacity of some of the layers. This can add greater depth to the montage. Once you are satisfied with the way the piece is looking, go to Layers > Flatten Image before choosing Save to save the file on your hard drive.

8 Given the subject matter of this montage, however, before we flattened the image, we used a Hue/Saturation adjustment layer to desaturate the colours by moving the Saturation slider to the left for a faded, slightly nostalgic feel. It also helps to unify the montage visually.

Layer Masks

A number of the more advanced image-editing programs have a powerful editing tool at their disposal, known as 'layer masks'. Creating a 'mask' was described previously, and the project here is a continuation of that in some ways. As we know, the term 'mask' derives from conventional printing where, in order for part of an image to remain unaffected by additional processes, a mask cut out of acetate was made to protect it. Digital layer masks work in much the same way, but are far more flexible. Here, we look at how layer masks can be used in Photoshop, or Photoshop Elements, although similar principles apply to most editing software.

USING LAYER MASKS TO ALTER IMAGES

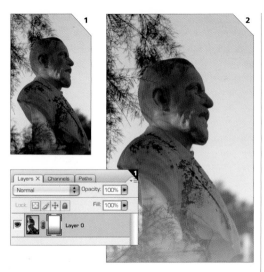

The aim here is to apply a simple mask to this image of a bust.

1 Go to the Layers palette and then begin by double-clicking the Background layer. It will ask if you'd like to rename the layer – click 'yes' to Layer 0. The reason why you have to do this is because a layer mask cannot be applied to the Background layer.

Click on 'Add layer mask' in the Layers palette. A white box will appear next to the image thumbnail.

2 Ensuring that the layer mask is active (it will have a double outline), return to the main image and draw a simple black gradient over the image. Part of the image will fade out. Looking at the Layers palette you'll see the part of the image that has faded out is represented by a fading black gradient in the Layer mask thumbnail.

Wherever black appears on the layer mask, the corresponding part of the image will be shown deleted (but it's still there until you flatten the image).

Let's apply this in a very simple 'real world' project. Here, the aim of the exercise is to mask the opening to this castle wall and replace the background.

1 Click on the 'Add layer mask' icon to create the mask. Return to the image and, with the Brush tool set to paint black, start to paint out the opening. Use a small, soft brush to paint the outline, and then fill the remainder with a larger brush, making sure Opacity is set to 100%. Looking at the Layer mask thumbnail in the Layers palette reflects where you've been painting.

2 Once the layer mask is complete, open the image for the replacement view and use the Move tool to drag it onto the main castle wall image.

In the Tool Options bar, ensure 'Show Transform Controls' is checked and then resize the new layer.

3 To get the new view to sit under the window, go to the Layers palette and move the new layer below Layer 0. You can independently edit the layers so they match in terms of tone and lighting. With the mask in place, it's easy to use any view you want.

CREATING COMPOSITE LAYERS

Layer masks are a great way to create composite images, as shown in this insect image.

1 Drag your new image onto the Background image, rescale it and then add a layer mask to each new layer. With the layer mask in place, paint with a black brush to reveal the layer underneath. Painting with a white brush reinstates any of the new layer that may have been removed.

ADJUSTMENT LAYERS AS LAYER MASKS

Photoshop Elements doesn't support layer masks in quite the same way. However, any new adjustment layer is automatically presented with its own layer mask, which can then be used in the way described previously.

1 In this example, we're going to use the layer mask that comes with a Hue/Saturation adjustment layer to create an image in which parts are coloured a sepia tone while other parts remain in full colour.

2 Having created a Hue/Saturation adjustment layer, clicked Colorize in the Hue/Saturation dialog window, and adjusted the sliders to create a sepia effect, the layer mask can now be selectively painted out using a white brush to reveal the colour underneath.

3 In a matter of moments, painting with white on the adjustment layer's layer mask has returned the foreground boat and distant figures to the original colour.

Meanwhile, the rest of the image has the sepia tone created by the Hue/Saturation adjustment layer.

Photoshop Filters

Photoshop and Photoshop Elements provide a huge variety of filters. These can alter an image in all manner of ways, from manipulating colours, adding textures, exaggerating or removing detail, picking out edges, simulating a painting or drawing, pinching or twisting the canvas, and more besides. You may not use them every day, but you can have endless fun exploring the creative possibilities.

One thing to remember with Filters is that the lower the resolution of the image, the greater the effect of the filter. The Filter Gallery provides a special user interface for many of the filters, with a large preview panel that you can enlarge further by expanding the window. The round button with two chevrons, to the left of the OK button, shows or hides the filters list, which also provides thumbnails to illustrate each effect. Using the Gallery is the best way to familiarize yourself with the filter names and their corresponding effects. Here is a small selection of available filters.

Posterize

The filters in the first group, Adjustments, are the simplest. Posterize, for example, simply reduces the number of colours in the image. Adjust the number of Levels for the desired effect, which is typically reminiscent of garish low-quality reproduction, as in Pop Art.

Cut-out

The Artistic filter set is slightly more sophisticated, with multiple sliders that give greater control over the results. The default settings often work well enough, however.

The Cut-out filter divides an image into areas of flat colour. Here settings of 5 Levels, Edge Simplicity 4 and Edge Fidelity 2 were used.

Film grain

Filters don't only (or always) do what they claim to do. Film Grain, for example, is at its most effective when used to simulate bad printing rather than grainy film.

Set the Intensity and Grain to high values, then increase the Highlight Area to restore image brightness at the expense of detail.

Posterize

Gallery page

Cut-out

Film grain

Rough pastels

Accented edges

Diffuse glow

Glass

Spherize

Polar coordinates

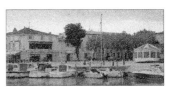

Pointillize

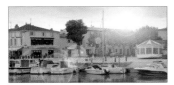

Lens flare

Glowing edges

Stained glass

Rough pastels

Look out for Size, Length or Scaling settings, as these will need to be adjusted according to the resolution of your image. Here, the filter has been used with Stroke Length 17 and Canvas Texture 166%.

Accented edges

Several filters emphasize edges. Accented Edges (under Brush Strokes) is one of the more versatile, and demands more slider fiddling. At its best, it will mimic a pen and watercolour sketch.

Diffuse glow

The Distort filters serve disparate purposes. Diffuse Glow is a distortion filter because it shifts pixels, but its purpose is to create a soft-focus effect. Increase Glow Amount for a stronger effect, and increase Clear Amount to restore detail.

Glass

At low settings, with the Frosted Texture selected, the Glass filter puts your image behind sandblasted glass.

Adjust the Scaling to suit the image size, or switch the texture to Tiny Lens and increase the settings.

Spherize

The distortion filters can be great fun to use. Apply the spherize filter with a positive value to create a fishbowl effect. The maximum 100% setting isn't all that strong, so try applying it more than once. A small negative setting can be useful for countering wide-angle lens distortion.

Polar coordinates

The most extreme of the distortion filters is proabably Polar Coordinates. A good tip is to rotate a landscape image 180% (that is, turn it upside down) before applying Rectangular to Polar. Try this on a panoramic landscape with a dark sky, then layer a picture of the Earth in the middle.

Pointillize

The Pixelate filters break images into colour cells. Pointillize mimics the 'pointillism' technique of the Impressionist painter Georges Seurat.

Lens flare

The Render filters are among the most sophisticated. Lens Flare simulates the rings that are produced by shooting toward the sun or a strong light source. Click to align the centre of the flare with the source, and choose a lens type to set the size and appearance of the flare.

Glowing edges

The Sketch filters are intended to work with hard-edged images, and often draw a blank with detailed images. More rewarding are the Stylize filters, which include Extrude, and are worth trying. Glowing Edges turns any image into neon, but keep the Smoothness setting high.

Stained glass

Texture is an intriguing set of filters. The Stained Glass option creates white leading instead of black. To fix this, invert your image, then go to Filter > Texture > Stained Glass, set the Light Intensity to 0, adjust the other sliders as you like, click OK, then invert again.

Dramatic Skies

One of the key elements of many successful landscape photographs is a sky that, without detracting from the remainder of the image, can grab and hold the viewer's attention and add to the overall atmosphere of the image – whether it comprises forbidding, stormy rain clouds or a clear, unadulterated, azure blue.

However, setting the correct exposure for both sky and land is sometimes impossible, especially if your camera cannot be fitted with a grey graduated filter, commonly known as a grey grad filter. These filters are tinted at the top and gradually fade to clear at the bottom, and are designed to prevent a sky being overexposed when the photographer has set the correct exposure for the land. However, it is mainly only dSLRs and some hybrid cameras that accept such filters, and not every dSLR owner carries them around at all times.

However, as long as you can manage to stop the sky from 'blowing out' altogether, and retain most of the detail, you can enhance the sky in your image-editing software and recreate the effect of a grey grad filter.

ENHANCE LIGHTING WITH GRAD FILTERS

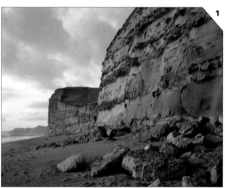

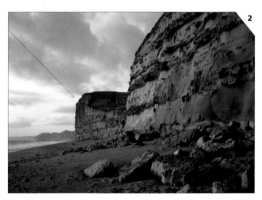

1 Although there isn't a dramatic difference in light levels between the sky and the land in this image, a grey grad filter would have brought out more depth in the clouds and given them a little more body.

2 To recreate the grey grad effect, begin by creating a new blank layer (Layer > New > Layer) and call it Gradient. Ensure the Foreground/ Background colours in the Toolbar are set to the default of black as the foreground colour and white as the background colour. Now, select the Gradient tool in the Toolbar and in the Tool Options bar select the 'Foreground to Transparent' gradient option.

Next, draw a line across the sky. You will see that the line runs diagonally from the top left of the image to the start of the cliffs.

3 After releasing the mouse, the area along the gradient line will darken. This is the result of creating a black-to-transparent gradient over the original image. Experiment with the length of the gradient line to see how it influences how much of the image is affected.

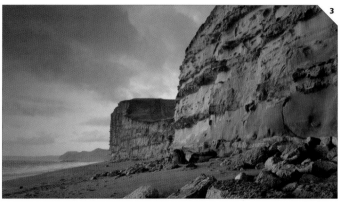

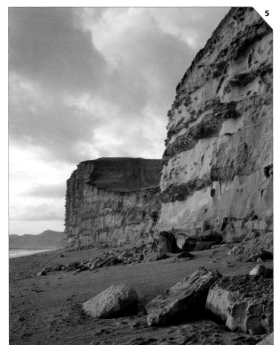

It is possible to use a similar technique to brighten areas of an image. In this example, the lower half of the image is very dark.

4 To complete the grey grad effect, go to the Layers palette. Ensure the Gradient layer is selected and change the Blending Mode to Overlay. The background clouds will now blend into the dark grey gradient and become darker.

1 As before, create a new blank layer, but this time choose white as the foreground colour instead of black before you draw the gradient rule. To do this, simply click on the right-angled arrow icon to switch between the two colours. If the foreground and background colours are anything but black and white, simply press the 'D' key (for 'default'). As before, change the gradient layer's Blending Mode to Overlay.

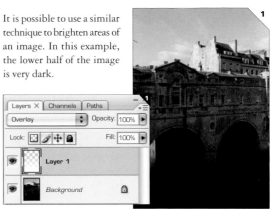

5 You can temper the effect of the gradient by reducing the Opacity of the Gradient layer. With this image, however, the sky could be enhanced further, so the Gradient layer has been duplicated, doubling the effect it has on the image.

2 With the white gradient layer set to Overlay, the water and lower part of the building are dramatically brightened.

Black and White Conversion

Creating good black and white images from your colour originals is not as easy as it sounds. You might think that all you have to do is remove the colour information in the digital image, and technically that is precisely what you do to get an essentially greyscale image.

Artistically, however, the results of such a simple process are rarely as good as you'd expect without some digital tweaking along the way. Part of the reason for this is that photographers have long used coloured filters to alter the image before it's captured on black and white film. Different coloured filters cause different objects or areas to be brighter or darker when photographed, depending on their colour.

This is important, because although certain objects, such as grass and sky, are different colours, their brightness may actually be very similar. This can result in a 'flat' black and white image, where similar areas merge together unless a filter is used on the lens. But rather than spend money on filters, you can replicate the effect in Photoshop.

REPLICATING FILTERS IN PHOTOSHOP

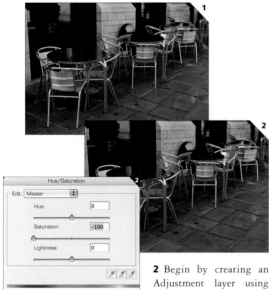

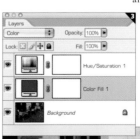

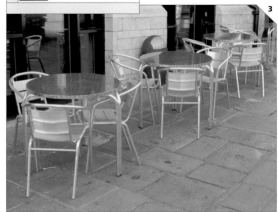

3 Just as a photographer uses coloured lens filters to adjust the brightness of the objects in the scene in relation to one another, you can prefilter the image before it is desaturated. To do this, simply create a new layer above the background layer and then fill it with a solid colour. With the background layer selected in the Layers palette go to Layer > New Fill Layer > Solid Color and click OK. In the subsequent Colour Picker box, choose an appropriate colour. Here, an electric blue has been selected. Set the Layer Blending mode of the Color Fill layer to Color. The image becomes washed out, but the pavement is now much lighter.

2 Begin by creating an Adjustment layer using Hue/Saturation to remove the colour information from the image. Set the Saturation slider to -100 to do this.

While the colour has gone, the image now looks dull and lacks contrast – this is often described as 'flat'. Now, the dark pavement dominates the picture, and the chairs and tables appear a little lost against it.

1 Here's the original colour image that we want to try and convert into a black and white photograph. There's not a lot of strong colour in the shot to start with, as the pavement, tables and doors are all neutral colours. This makes it more of a challenge to convert it successfully into a black and white image.

5 By adding a Brightness/ Contrast Adjustment layer above the Hue/Saturation layer, you can add some contrast to the image.

Move the Contrast slider to the right until you get the appearance that you want. The resulting image is a much snappier conversion and the tables really stand out from the pavement.

4 You can adjust different colours in the image by changing the Hue of the Color Fill layer. This is like changing the filter on a lens.

In the Layers palette, Right-click/Double-click the Layer thumbnail on the Color Fill layer.

Make sure that H is selected in the HSB section of the Color Picker and drag the slider to adjust the hue of the colour filter. This will change the relationship between the various tones.

Here, the Color Layer Opacity has been reduced to 50%, so the effect does not appear as strong.

6 The advantage of working with adjustment layers is that you can go back and edit each adjustment at a later stage. In fact, you can even save documents as Photoshop (.psd) or TIFF (.tif) files with the adjustment layers in place.

The only instance when you can't go back and alter an adjustment layer is once you've flattened an image. This is usually used as a way of keeping the file size down and is done by selecting Layer > Flatten Image.

In the two images shown here, the Hue/Saturation dialog window was activated by Right-clicking/Double-clicking the Hue/Saturation Adjustment layer in the Layers palette. Checking the Colorize button and also altering the Hue and Saturation sliders will adjust the colour as well as the intensity of the image.

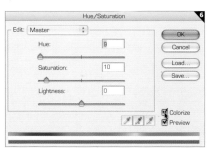

Converging Verticals

One of the most common problems with photographs of buildings – particularly extremely tall ones – is that in order to fit the entire building into the frame it's usually necessary to point the camera upward. When you do this, the side walls of the building appear to get closer together the higher up you look. The effect is similar to looking at a long, straight road, where the edges will appear to converge the farther you look down the road. With these long distances, the road often appears to meet at a 'vanishing point', and this is the same with buildings. To achieve really accurate shots of straight buildings, professional photographers use specialist equipment, but you can go some way to improving converging verticals using your image-editing software.

CORRECTING PERSPECTIVE ISSUES

Taken several years ago using a conventional 35mm film camera, this image was then scanned into the computer.

1 This well-exposed picture managed to capture the remarkable detail of the building, so it's worth spending a few minutes on it to adjust the problem of the converging verticals.

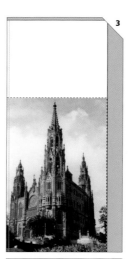

2 Begin by increasing the height of the canvas that you are working on, by going to Image > Canvas Size.

In the dialog window, you should then click the lower middle square next to the Anchor. This indicates that the canvas only needs to be extended upward from the 'ground'.

Click on the pull-down menu next to the height box and select 'percent'. Enter 150 into the height box to increase the height of the canvas by 50%.

3 Using the Rectangular Marquee tool, make a selection of the original image. Next, go to View > Rulers and drag a vertical line from the edge of the frame onto the image area to use as reference to ensure you get the walls vertical.

4 Go to Edit > Transform > Perspective and you will see that corner points appear at the corners as well as at the central points of the sides of the image.

Drag out one corner of the selection and you will notice that the corner point on the opposite side will begin to move out at the same time. Keep dragging until the side walls appear vertical. Compare it with the ruler guide you placed earlier. When it looks as if the vertical walls are

straight, make a note of how much wider the top part of the picture has become by checking the measurements in the Tool Options bar.

Here, the width has been increased by about 120%. Once you're happy with the adjustment, you should confirm by clicking the check box.

5 With the selection still active, go to Image > Transform > Distort. Grab the top middle handle with the cursor and stretch the building upward. The image will stretch in real time, which means you can see the effect of the adjustment as you go.

For guidance, you should keep on stretching the image until the height has reached 120% in order to counter the effect of the perspective adjustment.

6 To finish, deselect the selection (Select > Deselect) and use the Crop tool to crop out the unused canvas.

USING DISTORTION FILTERS

More recent versions of Photoshop and Photoshop Elements have a distortion filter that allows you to correct issues such as converging verticals, as shown here.

1 Go to the Filter menu. In Photoshop it is called Lens Distortion, while in Elements it's known as Correct Camera Distortion; both work in the same way.

2 By moving the Vertical Perspective slider to the right, the buildings can be set to align with the grid. With the correction made, click OK.

3 Now simply crop away the newly created transparent elements of the image at the bottom of the frame.

Soft-focus Effect: Landscape

In the days of traditional film cameras, photographers would experiment with numerous materials and techniques to achieve a soft-focus effect, ranging from smearing petroleum jelly on a clear filter fitted to the camera's lens to taking photographs through a pair of old stockings, or simply using a dedicated soft-focus filter.

All of these methods are perfectly valid today, but it's no surprise that it's possible to recreate a soft-focus effect during post-production in almost every image-editing program. Again, this has the benefit that the photographer has greater control over the effect and will also have a straight, unfiltered image.

SOFT FOCUS WITH LAYERS AND FILTERS

3 Most of the image-editing software packages have a soft-focus filter effect, and Photoshop Elements and the full version of Photoshop are no exception.

In these Adobe programs, the effect is known as Diffuse Glow, and the filter is found under Filter > Distort > Diffuse Glow. There are three sliders that control the overall effect of the filter, and it's well worth spending a little bit of time experimenting with these to see what effect they have on the image in the preview window.

If the image you have is too large for the preview window, you will find that there is a menu at the bottom left-hand corner of the dialog window allowing you to set 'Fit in View'.

1 This striking image of a field of spring bluebells in a wood is exactly the sort of photograph that might be successfully enhanced by incorporating filters and layers for a soft-focus effect.

2 Start by duplicating the Background layer (Layer > Duplicate layer), so you can delete any effects that you don't want, while retaining the original.

An alternative method of duplicating the layer is to go to the Layers palette and then drag the Background image thumbnail onto the 'Create a new layer' icon. It's helpful to rename the new layer 'Soft focus'.

4 Once you feel happy with the filter effect in the preview window, click OK, and the filter will then be applied to the copy of the original image. The Diffuse Glow filter in Photoshop has created a pleasing effect, but you may decide that you want to reintroduce some of the original colour of the bluebells by reducing the Opacity of the Soft-focus layer in the Layers palette.

5 If your software doesn't have a soft-focus filter, or if you're not pleased with the result the filter provides, the alternative is to use Gaussian blur instead.

On the Soft-focus layer apply a fairly liberal amount of Gaussian blur. Here, the Radius has been set to 30 to give an obvious soft-focus feel to the image.

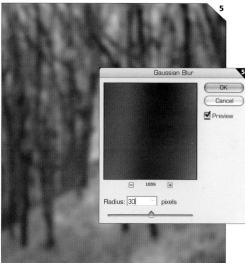

6 As well as blurring the duplicate layer, it's worth brightening it using Levels (Image > Adjustments > Levels). Here, the white and central gamma points have both been moved to the left.

7 Return to the Layers palette and reduce the Soft-focus layer's Opacity so that the original image begins to show through, as before.

At this point, you should try experimenting with the Opacity slider until you've reached the right amount of softening, then go to Layer > Flatten Image to combine the layers. It's worth remembering that once the layers have been flattened, you'll need to give the file a separate name or you'll overwrite the original. To do this, go to Save As and then key in an appropriate name.

Soft-focus Effect: Portrait

It's not just landscapes that can benefit from a soft-focus treatment. For many years, portrait photographers who shot on film also used soft-focus techniques and effects in their work. Often, soft-focus filters were used to flatter the sitter, as the softening effect hides blemishes and can make skin appear smoother. Alternatively, the effect could be used to provide a more dreamy, other-worldly result, which particularly suits portraits of children. The digital technique for a soft-focus portrait is quite similar to that of the soft-focus landscape, but it involves the use of Blending Modes, and introduces one or two further steps to fine-tune the result.

SOFT FOCUS USING BLENDING MODES

1 Here, we're going to apply a digital soft-focus effect to this portrait using Photoshop. Of course, the same technique can be used in other editing software. Although the girl is young enough to show no signs of ageing, the effect will give the shot additional charm.

2 Begin by duplicating the Background layer. You can do this either in the Layers palette by dragging the Background thumbnail onto the 'Create a new layer' icon or by going to Layer > Duplicate layer.

As before, it is a good idea to rename the new layer, in this case 'Darken', as this helps you to keep track of the various layers as you work through the project.

3 As with the soft-focus landscape effect, go to the Filter menu and select Blur > Gaussian Blur.

Set a large Radius of around 30 pixels. As you have seen with the landscape project, the image will become instantly indistinct and unrecognizable.

4 Duplicate the Darken layer using the same method as duplicating the Background layer described in Step 2. Rename this third layer 'Lighten'.

Click on the Darken layer and, using the drop-down menu at the top of the Layers palette, select the Darken blending mode. Next, reduce the Opacity to around 40% but note that this will have no visible effect on the image at this stage.

5 Next, click on the Lighten layer and set the Blending Mode to Lighten. Reduce the Opacity to around 60%.

At this stage, the soft-focus effect should have become apparent. However, by applying it to the entire portrait, the sparkle in the eyes, which is one of the most important elements of a portrait, has been lost.

6 To bring back some of the missing spark, we need to reduce the effect of the soft-focus 'filter'.

To do this, select the Darken layer and click on the 'Add Layer mask' icon at the bottom of the Layers palette. This will introduce a new blank Layer mask thumbnail next to the Darken layer thumbnail.

7 First, ensure that the Layer mask is active (it will be framed by a thin black border if it is) before going to the Toolbox to choose the Brush tool. With black as the foreground colour, start painting over the eyes.

Remember that you can easily adjust the size of the brush using the '[' and ']' keys. As you paint over the

portrait, the eyes should come back into focus and regain their sparkle. Notice how the Layer mask in the Layers palette will also indicate which areas you have been painting.

If you want to return to a more soft-focus effect, just press 'X' to change the foreground colour to white and paint the mask back in.

8 When you have finished, the final photograph ought to appear as a pleasing soft-focus portrait that has softened the main facial features and the skin, but

which still enables the eyes to show clearly through. Once you're fully satisfied with the final result, you need to go to Layer > Flatten Image and save.

Soft-focus alternative

The technique described here uses Layer masks, which are not available in some image-editing packages, such as Photoshop Elements.

However, a very similar effect can be achieved by simply duplicating the Background layer and applying the Gaussian Blur filter to the new layer. You need to reduce the Opacity of the blurred layer in the Layers palette and then use the Eraser tool to reveal the sharper background layer.

Recreating Depth of Field

Depth of field is one of the indispensable tools of the creative photographer. For stunning landscapes, setting a narrow aperture, compensated for by a long exposure, can help achieve pin-sharp focus on everything from the closest foreground detail to the horizon.

But when shooting portraits, sports, children or food, using a wide aperture to reduce the depth of field can add impact and drama. Because limiting the depth of field in this way demands a reasonably fast (and expensive) lens, it's also one of the factors that differentiates professional shots from the average holiday snap. If it proves impracticable to shoot with a wide aperture to get a shallow depth of field, or you just don't think of it until you're looking at the finished image, the effect can be recreated using software, with the careful application of selective blurring. The challenge is to make it look real.

APPLYING A SHALLOW DEPTH OF FIELD

1 First, decide where you want the point of focus of the image to be. Usually, your intention will be to bring out a particular object or figure. In this photograph, it's the boy standing on the groyne.

You'll need to make a selection to separate this from the rest of the scene, using one of the methods shown earlier. The selection doesn't need to be absolutely precise for this technique, so you can work quickly.

2 Creating a depth of field effect that's realistic isn't as simple as keeping your intended subject sharp and blurring the rest of the scene. Everything of equal distance from the lens should seem equally sharp, so you need to add anything that lies on the same focal plane as your initial subject.

In this picture, nothing is directly in line with the figure except the groyne, so the Rectangular Marquee tool can be used to select the strip of groyne around the boy.

3 Before going any further, you should save your selection by choosing Select > Save Selection. Remember to select 'New' at the top, give your selection a name, and then click OK so that it is saved for future reference.

What you actually want to select now is the area that you're going to blur, which means everything outside your subject. Choose Select >Inverse to invert the selection. You may also want to hide the 'marching ants' border temporarily by pressing Ctrl + H (on a PC) or Command + H (on a Mac). Then, once you have done this, go to Filter > Blur > Gaussian Blur. In the Gaussian Blur dialog box, the Radius setting governs the strength of the blurring. To create the impression of depth of field, you will require a Radius of several pixels.

If you attempt this in one go, you'll find that it will create an unnatural halo effect around the subject, which will even be visible in the preview.

Here, for instance, you can see that the colours within the subject appear to be 'leaking out' into the background.

4 To avoid this, start with just a 1 pixel blur Radius. Click OK, then go to Select > Modify > Contract.

In the dialog box, set a size of 3 pixels and click OK. This will make the selection shrink away from the subject. However, since the selection no longer follows the outline of an object, you'll need to feather it to avoid the problem of creating a hard edge, so go to Select > Feather. Set a Radius of 3 pixels and click OK. Having done this, reopen Gaussian Blur and this time set Radius to 1.5 pixels. Click OK.

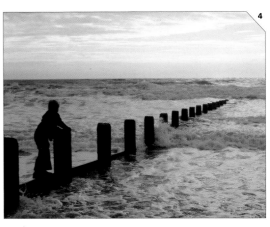

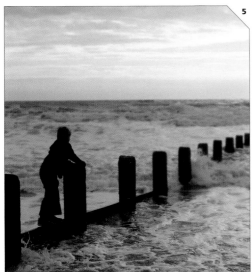

5 To complete the depth of field effect, you just need to repeat the same sequence of three filters with slightly larger sizes each time: for example, 10 pixels for Contract and Feather, and 10 pixels for Gaussian Blur, then going to 40 pixels and so on. In most scenes, these steps will give a realistic result without forcing you to

think about where the focus should fall off. Here the sea in the background ends up looking heavily blurred. It is also the area that would be most out of focus if you took the shot using a wide aperture.

The resulting image is a believable narrow depth of field shot, with the emphasis on the figure.

QUICK FIX USING LAYER MASK

Using layer masks, you can emulate depth of field.

1 Duplicating the background layer, click Add layer mask. Next, draw a Black to Transparent gradient over the image once the mask is active. The areas painted black will stay in focus.

2 On the duplicate layer, click on the thumbnail and apply Gaussian Blur. The gradually un-masked area will become blurred leaving the masked area sharp.

Creating Panoramas

The concept of taking a number of consecutive images along the length of the same scene in order to stitch them together to create one long panorama has been around for a long while now. Today, increasing numbers of digital camera manufacturers are going to great lengths to develop dedicated 'Panorama' settings for their cameras, which allow photographers to align the individual shots more accurately.

Image-editing software manufacturers have constantly refined their applications to improve the stitching capabilities of the programs. Adobe's latest version of Photoshop, for example, is now so sophisticated that it's no longer necessary to use a tripod and manual exposure to ensure an accurate end result – the software will deal with this for you. But if you don't have such advanced software, here's the best way to achieve great results.

STITCHING TOGETHER A SET OF IMAGES

1 These five images were taken using a tripod and, having determined an acceptable exposure for the entire scene, they were all shot in manual mode. The tripod helps you to align the various images accurately, while shooting in manual ensures there's no variation in the brightness values of the individual shots.

Once the shots have been taken, download them, and place them in a folder on your computer's hard drive for safety.

2 To start, bring up the Photomerge dialog box in Photoshop, and go to File > Automate > Photomerge.

Navigate to the files that you have decided to include in the panorama and then click OK.

3 In this specific case, you can see that even the mighty Photoshop CS2 hasn't done a particularly good job of aligning the images. So, you will need to make changes to the image manually.

4 By clicking on parts of the image, the pictures can be rearranged into the correct order. Photoshop will then automatically align the images by matching the pixels together.

5 With the shots now in the correct order, selecting Advanced Blending will greatly improve the 'joins' between the images, as shown in the Preview.

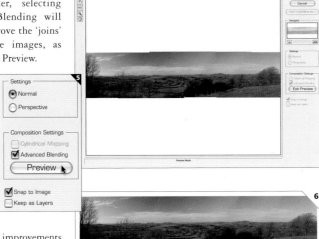

6 Before any improvements are made to this panorama, you need to cut away any of the landscape's unwanted background area using the Crop tool. This will also help to keep the file size to a minimum.

7 With the background cut away, perform any global changes you'd like to make to the panorama. Here, for example, the brightness has been increased using the Levels command.

Now zoom in to fix specific areas in the image that don't match exactly. With so much sky in this image, some of the tones aren't equal. Use the Clone Stamp tool to correct these, along with any areas where the join is visible.

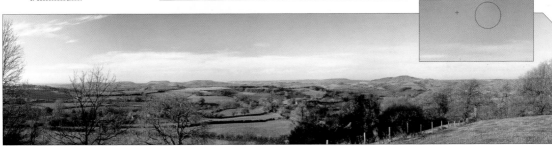

8 Both Photoshop CS3 and Elements 6 have a more powerful picture-stitching tool, which works in much the same way as in previous versions, but when you open Photomerge you have various options for stitching the images together. The 'Panorama' setting offers a true panorama representation, while the 'Cylindrical' setting will provide the view that we're more accustomed to, as does 'Reposition Only'.

It does pay to experiment with these various options. However, note how CS3 and Elements have both merged the images so successfully that, in fact, no remedial work (other than tone and colour) has been required to get to the finished image.

Hand-tinted Photographs

Before the advent of colour photography, the only way to add colour to a photograph was to use coloured oil paints and physically paint the image.

Although the results were never intended to be realistic in the way we view colour pictures today, hand-tinted photographs were immensely popular and they achieved a unique visual quality that couldn't be replicated with the arrival of colour film.

With image-editing software, it's now possible to recreate the effect of 'vintage' hand-tinted photographs, but without the mess – or irreversible nature – of paint. The exercise is easy and fun, and an ideal project for children. The colours can be as muted or as garish as you like, and can either emulate the look of old, Victorian, hand-tinted photographs or can create vibrant works that appear to be influenced by modern artists.

ADDING COLOUR TO A COLOUR IMAGE

In this first example, the starting point for adding colour is a colour image.

1 In the Layers palette, duplicate the Background layer by dragging the thumbnail onto the 'Create a new layer' icon, or by going to Layer > Duplicate Layer.

2 Select the duplicate layer, go to Image > Adjustments > Desaturate and create a black and white image.

3 All you need to do now is select the Eraser tool from the Toolbox and then set the Opacity in the Tool Options bar to between 30% and 40%.

Next, simply erase the black and white image to reveal the colour layer that is underneath.

4 An optional step is to blur the black and white layer by using the Gaussian Blur filter. Experiment with the amount of blur to achieve the effect you want.

5 As always, you can adjust the Opacity of the top layer to increase or reduce the intensity of the colour.

Here, the black and white image could have been scanned into the computer, shot in black and white mode on a digital camera, or converted to black and white.

1 Begin the exercise for this image by going to Image > Mode > RGB Color, so that you can add colour to the image.

2 Next, we need to duplicate the Background layer (Layer > Duplicate layer). In the Layers palette, change the duplicate layer's Blending Mode to Color using the drop-down menu. Then, make sure that you rename the layer 'Colour'.

3 The first tone you need to add is a flesh tone to all the exposed areas of skin. One option for doing this is to open a colour image that features a flesh tone (such as a portrait), and then use the Eyedropper tool to sample an appropriate area. Click on the skin to change the foreground colour to the chosen tone. This will be visible in the Foreground Color box at the bottom of the Toolbox.

Alternatively, you can click on the Foreground Color box to bring up the Color Picker. Navigate your way to an appropriate colour by using the slider and the cursor.

4 Choose a small, soft brush (adjustable with the '[' and ']' keys) and set an Opacity of around 30% in the Tool Options bar.

Start to paint over areas of skin on the Colour layer with the flesh tone you selected in Step 3.

5 Once you've coloured the skin, return to the Color Picker and choose colours for other areas of the image. Don't worry too much about painstakingly painting in the exact areas, as the intention is to create only the suggestion of colour for each major element of the image, rather than to create a full-colour photograph.

6 For this image, a total of six colours were used to colour the entire photograph. The Colour layer was then blurred slightly using the Gaussian Blur filter.

Restoring Old Photographs

The various cloning options and healing brushes covered earlier in this book are extremely powerful and versatile tools, and are ideal for fixing and restoring old or damaged photographs. These are a significant advance on the conventional restoration methods using inks and tiny paintbrushes that were all that was available several years ago. Nowadays, armed just with a desktop scanner, a computer and some fairly inexpensive image-editing software, it's possible to repair photographs to a much higher standard.

USING SOFTWARE TO RESTORE IMAGES

1 This delightful picture of two sisters feeding a Chinese goose was taken in 1938. The last 70 years haven't been kind to the original print and there are tears, creases and numerous dust and scratch marks.

2 After scanning the print, the first step is to check the tonal levels. Opening the Levels dialog (Image > Adjustments > Levels) shows that both the black and white points aren't at their optimum. Both points have been brought in a little so they sit under the ends of the histogram, giving the image a little more contrast.

3 The next step is to systematically fix and restore the numerous tears, creases and scratches. For large damaged areas, the best tool is likely to be the Clone Stamp tool. Clone a point that matches as closely as possible the area you're trying to repair, and remember to keep taking samples from other areas to avoid creating repeating patterns. Remember to use the '[' and ']' keys to choose a brush of the appropriate size. Use Edit > Undo to reverse any corrections that go slightly wrong.

4 For much smaller scratches, try using the Healing Brush tool. Sample as closely as you can to the area to be repaired and move slowly along the scratch.

5 All images will have slightly more complex areas to repair. For these, you should revert to the Clone Stamp tool and then sample those areas that share the same pattern as those you are attempting to repair. It's possible that you may find suitable sampling points in entirely different parts of the scene.

6 If you have the option of using a Patch tool, try using this on those areas where there is no obvious pattern, such as here, where the emulsion has become rather sticky, leaving a drying mark. Now draw around the offending area and drag it to an area that closely resembles the part that you are trying to correct.

7 This particular image was also suffering from a fair amount of dust damage.

To remedy this, apply the Dust & Scratches filter (Filter > Noise > Dust & Scratches), with a very small Radius. Too high a Radius will often soften an image to an unacceptable level.

8 Having made the repairs, the image should almost be as good as the original.

9 With the image stored in your computer, you can make any number of changes to it. Here, Hue/Saturation was used, clicking the Colorize option to apply a light sepia tone. With a Levels adjustment layer, the contrast was then increased to give the picture a vintage feel.

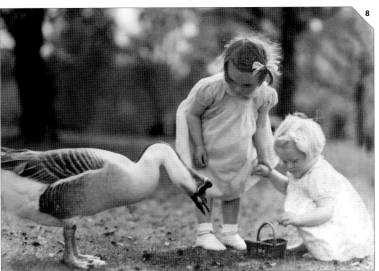

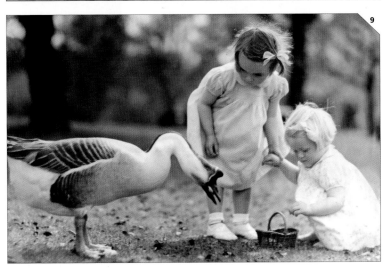

Retouching Portraits

The great thing about digital images is that they can be easily altered, right down to the pixel level if necessary. This means that it's not only really easy to fix old and damaged photographs once they've been scanned, but it is also easy to edit and fix less-than-perfect digital shots.

One of the most common retouching techniques is to remove skin blemishes and the subtle signs of age in portrait pictures. Practically every image you see in advertising (particularly in the fashion and beauty industry) has been 'fixed' digitally to make the models appear as perfect as possible.

However, it's quite straightforward to do similar work yourself using image-editing software. Without going to quite the extremes that the fashion industry does, impressive results can be achieved relatively quickly and easily using a few simple commands and common tools.

DIGITALLY RETOUCHING SKIN

1 The subject in this shot has a few wrinkles, crow's feet around the eyes, and the odd blemish here and there – a bit like most of us. Using almost any editing software, the age lines can be reduced and the skin generally cleaned up to make the subject appear younger.

3 The laughter lines around the subject's mouth can also be removed or at least smoothed out slightly, but for this adjustment it's far better to use a larger brush because the skin tone changes quite a bit.

The larger radius and soft edge of the brush will help even out the variation in tone and therefore ensure that the image retains a realistic appearance.

2 Close inspection shows the task at hand in more detail. The first step is to remove (or reduce) the crow's feet around the left eye.

First, make a duplicate copy of the Background layer before you start working. By doing this, you can easily rectify any mistakes, or reduce slightly over-zealous retouching. Preserving the original also makes it quick and easy to make before-and-after comparisons.

Using the Clone Stamp tool and a small, soft brush set to an Opacity of around 40% in the Tool Options bar, sample an area close to the uppermost line of the left eye's crow's feet and simply clone it out in one smooth stroke. As you work down you'll have more clean skin to sample.

4 Once all the major lines have been removed on both sides of the face and on the forehead, you can start fixing the blemishes on the nose. Sample areas of similarly coloured skin with the Clone Stamp tool and dab out the marks.

5 Finally, create a new layer by clicking on the 'Create a new layer' icon in the Layers palette.

Using the Eyedropper tool to take samples, paint over the duplicated original with the Brush tool, making sure you concentrate on areas where you want to even up the skin colour. Applied carefully, and with a low Opacity set in the Tool options bar, this will add the final gloss to the end result.

QUICK RETOUCHING WITH GAUSSIAN BLUR

For a very quick fix, you can use the same technique for soft-focus portrait effect, but to a lesser degree.

1 Duplicate the background image, then apply a small amount of Gaussian Blur (you can experiment with quantity).

2 Next, use the Eraser tool to erase the blurred layer around the eyes, mouth, hair and any other areas you would like to remain sharp.

Adding Type

Having the ability to create type for use on its own or to add to images allows the amateur photographer to turn into an amateur graphic designer, albeit for a short period of time. Adding type to images opens up a whole new world of possibilities, ranging from greeting cards and invitations, through to postcards and CD cover designs. The possibilities are literally endless.

Just about all image-editing applications have some form of type capability, but some are more sophisticated than others. Photoshop and Photoshop Elements have plenty to offer, and adding type to an image using either package is easy and intuitive. The range of type fonts, styles and effects is breathtaking – and it's possible to download even more fonts from the Internet.

INTRODUCING TEXT TO IMAGES

1 To begin adding text to an image, select the Text tool from the Toolbox. Photoshop, Elements and many other image-editing programs feature both Horizontal and Vertical Text tools. Here, the Horizontal type tool has been chosen.

With the Text tool now selected, place the cursor in the approximate position that you want the text to appear. Don't worry too much at this stage about getting it in exactly the right place, as you can move the text at any time until you flatten the image's layers.

2 Type the text you want to appear. The type will appear in the style of the last font that you used.

Once you've finished typing, click OK in the Tool Options bar. When you press OK, a new layer with your text is automatically created in the Layers palette.

3 Once you've placed the text on the image, you can then style it in any number of ways. Going to the Tool Options bar presents you with the opportunity to select or change the type font, size and colour. There are a huge number of fonts to choose from, and usually one that will serve your purpose.

4 Clicking on the 'Create warped text' icon brings up the Warp Text dialog. This features numerous weird and wacky custom shapes and patterns that allow you to shape your words. Clicking on a specific shape, such as 'Fisheye', brings up a further dialog box where you can control the specific size and shape of the effect.

5 Once you've selected the Warp Text style, go to the Layers palette and click on the 'Create layer style' icon. This will bring up a whole host of additional styles that can be applied to your type.

Here, 'Drop Shadow' has been selected. 'Outer Glow' was then selected in the Layer Style dialog box and some adjustments to the 'Drop Shadow' settings were made to achieve the effect shown here.

6 The black type looks a little dull, but clicking on the coloured box in the Tool Options bar brings up the Color Picker, where you can quickly and easily select a different colour.

Having chosen a colour and applied Layer styles to the text layer, return to the Layers palette and then you can see precisely which styles have been applied.

Clicking on any of the style icons will bring up the relevant dialog box where further adjustments can then be made.

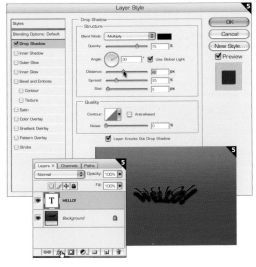

7 Finally, before 'fixing' the type, click on the Move tool and, with 'Show Bounding Box' checked in the Tool Options bar, you can now reposition, rotate and stretch your text.

8 Clicking on the Type tool to add additional text will keep on creating new layers that you can refine, style and re-edit until you eventually decide to go to Layer > Flatten Layers.

Adding Borders

Having created your own photographic masterpiece, why not try adding a border as a final creative touch? As with just about anything related to image-editing, there are countless ways of adding a border to an image, but the method described here allows you to experiment freely and easily with Adobe's extensive and powerful set of Filters, available in both Elements and Photoshop. Other programs have similar filter sets that can be applied in the same way, and if you don't like the one you initially select you can go back and try another until you find one you do like. Sooner or later you'll find a border effect that adds a touch of professionalism to your image.

USING A FILTER TO ADD A BORDER

1 Open the image to which you want to add a border, then select the Rectangular Marquee tool and draw a border around the inside edge of the image. You could just as easily use the Elliptical Marquee tool to create an oval border around the image, or you could even draw a freehand border with the Lasso tool.

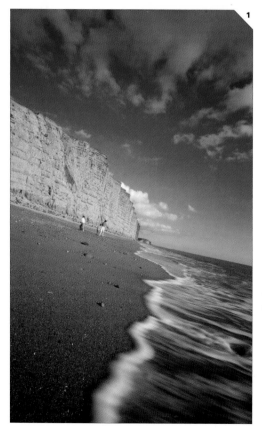

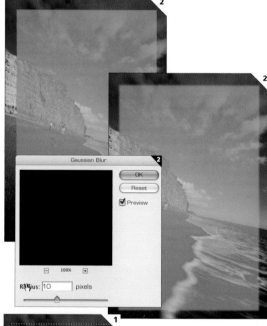

2 With the border in place, go to Select > Inverse and then click the 'Edit in quick mask mode' icon at the bottom of the Toolbox. Blur the mask slightly using Gaussian Blur (Filter > Blur > Gaussian Blur). The more blur you add at this stage, the more noticeable the blur will become when you get to the end.

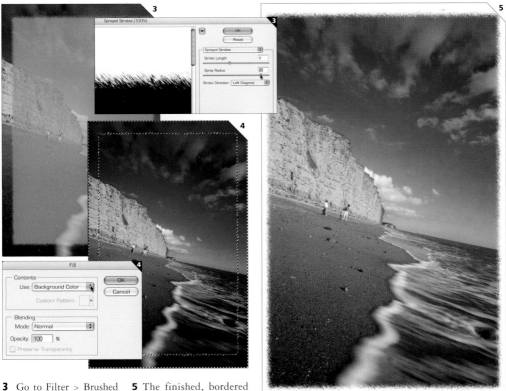

3 Go to Filter > Brushed Strokes > Sprayed Strokes, and experiment with the settings until you see a result you like in the preview window. You should remember that you are applying this filter to the mask, rather than the image itself, and bear in mind that the higher the resolution of the image, the less the effect of the filter. When you're happy with the settings, click OK.

4 To return to the main image, click the Quick Mask mode icon to turn the mask into a 'marching ants' selection. Then go to Edit > Fill and fill the border with a colour you feel is appropriate. In this example, white was chosen as the border colour.

5 The finished, bordered image is shown here.

ALTERNATIVE BORDERS

In the additional examples shown here, the same technique has been used to apply borders using the Extrude Edges, Glass (Tiny Lens), and Spatter filters. Experiment using any filter you like; some, however, are more appropriate for this task than others. You can use the History palette to go back each time to try another option – just delete the Filter Gallery line and start again with another filter. If you don't find a filter that works for your image, numerous websites allow you to view and download other border effects – some you have to pay for, but others are free.

Spatter

Glass (Tiny Lens)

Extrude Edges

Processing RAW Images

As digital camera technology has improved, combined with advances made in digital imaging software, an increasing number of enthusiast photographers are shooting and editing in the RAW format. As we discussed earlier, capturing images using your camera's native RAW format provides you with far more digital information compared with shooting using the JPEG format. The data are uncompressed and saved as a 12-bit or 14-bit file compared with JPEG's 8-bit information. The drawback to shooting in RAW is that images cannot be printed or shared until you have processed them.

The earliest popular RAW processor was a plug-in application available with both Photoshop and Photoshop Elements. Called Adobe Camera Raw (ACR), this plug-in allowed you to make basic corrections to uncompressed RAW files before opening them as 16-bit TIFF files in the host program. The image-quality benefits of being able to edit the RAW data before completing other editing tasks soon won favour across the photo community. This saw Adobe develop a dedicated RAW processor and image organizer in the shape of Adobe Photoshop Lightroom. Here we take a quick look at how Lightroom works.

RAW PROCESSING WITH LIGHTROOM

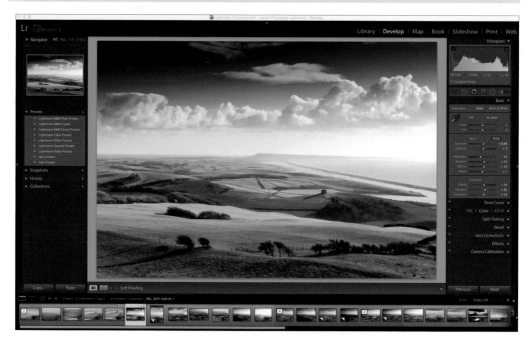

1 For such a powerful image-editing tool, Lightroom is a surprisingly easy program to learn. The user interface is attractively designed, and the entire workspace can be rescaled to fit the aspect ratio of your screen. Lightroom comprises seven discrete modules or workspaces accessible at the top right of the screen. These are: Library, Develop, Map, Book, Slideshow, Print and Web. These modules are intended to reflect a photographer's typical workflow. Images are imported from the camera into the Library. They are then optimized and edited in the Develop module before being shared in either Book form, as a Slideshow, Print or via the Web. The Map module allows you to pin where your images were taken on a detailed map and provides you with GPS coordinates. With a GPS-enabled camera, images can be plotted automatically – ideal for travel.

2 When importing images from the camera into Lightroom's Library module, you can create folders with unique names, and include key words to make searching for specific images easier at a later date. Lightroom will also automatically import all the EXIF data associated with the individual images. This includes the camera settings, image type, image size, and so on. This powerful feature set means you can easily keep track of your digital assets.

3 The Develop module is Lightroom's principal workspace used for editing images. Grouped together in logical palettes that can be expanded or collapsed by clicking the white arrows, the tools in the Develop module allow you to straighten and crop photos, adjust tone, colours, brighten or darken highlight and shadow regions, apply sharpening, lens corrections, such as chromatic aberration, convert images to black and white, and much more. The program is sophisticated enough to allow you to apply all these corrections to the image as a whole or to specific areas. Most corrections are made using sliders that work in real time, so that you can see the changes being made as you make them.

4 Another useful feature in Lightroom is that when in the Develop module you can set the main image to reveal how your image appears before and after your adjustments.

6

Viewing and Sharing

Whether it's simple family snaps or potential competition-winning art photographs, sooner or later you'll either want to make prints or create an electronic version that can be sent via e-mail, or create a slideshow on disk. Chapter 6 provides you with all the information you need to produce professional-looking prints, or to choose a series of images that you can then transform into a picture gallery or slideshow, complete with captions and background soundtrack. The chapter concludes with all the essential information you'll need to keep your invaluable images safe for many years to come.

Scanners and Scanning

While most amateur photographers and more and more professionals now shoot exclusively with digital cameras, many people still find a scanner a useful addition to their digital photography workflow. You may have a number of old prints, negatives or slides you would like to work on digitally, which can be edited and enhanced in some way, or you might still prefer shooting using high-resolution, medium-format film that then needs to be scanned before printing. There could be any number of reasons for wanting the ability to scan images into the computer.

ABOVE Most flatbed scanners have a built-in transparency hood, which means you can scan your slides and negatives, as well as prints.

Flatbed or film

There are two types of desktop scanner – flatbed and film. The former is the most common, featuring a hinged lid that closes down over a glass surface, or 'platen'. The size of the platen determines the size of the prints that can be scanned. Most flatbed scanners are A4 paper size, capable of scanning prints up to around 10 x 8in (25 x 20cm), which is more than enough for most needs. Most recent flatbed models also feature some form of film

ABOVE If you still shoot a lot of film or have a large library of film images, a film scanner will provide you with the necessary resolution to capture all the detail from the film.

or slide carrier in the lid, known as a transparency hood, making it possible to scan individual slides or strips of film. However, flatbed scanners are primarily designed to scan prints, and many do not offer the high resolution needed to make the most of film. For this reason, if most of the material you intend to scan is film, you'll get better results from a dedicated film scanner.

What to look for

Both film and flatbed scanners work in more or less the same way. An imaging sensor, such as a CCD, records the colour and tonal information from the print or film, which is converted and stored as digital data in much the same way as it is in a digital camera. The difference is that the sensor in a scanner scans the information a line at a time, hence the term 'scanner'.

Resolution

There are three factors to bear in mind when looking to buy a scanner: resolution, colour depth and dynamic range. Resolution figures for scanners are often given as two figures, such as 2,400 x 4,800ppi. The first figure represents the actual 'optical' scanning resolution of the sensor, while the second represents how

finely the scanner head moves. Rely on the first figure and ensure the figure you're quoted is the actual resolution and not an 'interpolated' one. If you want a flatbed scanner to scan images in order to make prints, a resolution of 2,400ppi will be perfectly adequate for most uses. For film scanners, a higher resolution is required, and around 4,800ppi would be sufficient.

Colour depth

The number of colours a device is capable of recognizing is also key. Even the most basic scanners offer 24-bit colour, meaning they are able to distinguish among 16.7 million colours. If you can afford to, buy a scanner that offers 36-, 42- or even 48-bit colour. The increased colour depth will provide you with greater scope when editing the colour in your images, as well as being able to better render detail in shadow areas.

Dynamic range

Another factor governing a scanner's ability to capture subtle detail in high-lights and shadows is its dynamic range. Dynamic range in scanners runs on a scale with a theoretical maximum of 4.8. In reality, professional drum scanners with a resolution of 11,000ppi achieve a figure of around 4. For flatbed scanners, you should look for a model with a dynamic range (DMax) of 3+ if you are scanning colour prints. For scanning film, look for a dynamic range of 3.8+.

Be wary of manufacturers' claims, as there is no standard means of measuring dynamic range, so two scanners with the same quoted DMax figure might not actually have the same dynamic range.

Scanning

All scanners come equipped with their own software that enables them to perform scans. Once this software is loaded onto the computer you can either start scanning by launching the newly loaded software, or you can usually access the software via your image-editing software.

1 If you're in Edit mode in Elements or using Photoshop, begin the scan by going to File > Import > [Your scanner]. In Elements' Organizer mode you can go to File > Get Photos > From Scanner. Other image-editing software will have a similar command. With the software launched, you usually have the option to create a preview of the scan.

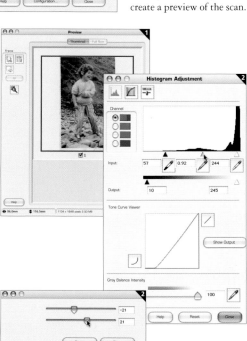

2 Having created a preview of the scan, you will usually have the option of adjusting the image before the final scan is made. In Epson's basic 'Home Mode', for example, you can adjust brightness and contrast levels, whereas if you are using the more sophisticated 'Professional Mode' you will have greater control over the scan.

3 Once you're happy with the preview view, click Scan to complete the scan. Depending on the resolution you've selected for your particular scan, the process will be complete within approximately 1–5 minutes.

What resolution?

Deciding at what resolution to scan prints, negatives and transparencies can be confusing, as much will depend on how large the final image is intended to be used. Here are some useful guidelines:

Original Source	Use/Size	Scanning resolution
Print	Web	72–100ppi
Print	Same size as original	200–300ppi
Print	Twice size as original	400–600ppi
Print	Four times original	800–1,200ppi
Pint	Half size of original	100–150ppi
35mm neg/slide	6 x 4in (15 x 10cm)	1,200ppi
35mm neg/slide	10 x 8in (25 x 20cm)	2,400ppi
35mm neg/slide	18 x 10in (46 x 25cm)	3,600ppi

Printers

Once you've captured your images, either via a camera or scanner, sooner or later you'll want to start printing your favourite images to show friends and relatives, or even to exhibit. Home printing, either direct from the camera or via a computer, is increasing in popularity and there is now a huge variety of printers available for the job.

Inkjet

The once-lowly inkjet printer was given a new lease of life with the advent of digital photography. At one point it seemed that the laser printer would supersede the inkjet, but it quickly transpired that inkjet technology lent itself perfectly to digital imaging and today, despite there being affordable colour laser and thermal (or dye sub) printers emerging onto the market, inkjet printers still provide the highest-quality images for the price.

Size

Inkjet printers are available in a wide variety of sizes. On the one hand, there are small 'portable' models that print standard 6 x 4in (15 x 10cm) prints, which are ideal for family holiday snaps, while at the other end of the scale, there are professional printers capable of producing poster-sized prints. If you're an enthusiastic amateur, it's certainly worth buying a printer capable of printing A4-size paper. It doesn't mean you can print only A4 – a tray will hold and feed smaller-sized paper for printing snaps – but it does give you the option of producing good-sized prints of your favourite images should you wish to display them framed and hung on a wall. You may even want to consider an A3 printer, bearing in mind that in the longer term the paper and inks will cost a lot more than the printer itself, which may not cost a great deal more than an A4 printer.

▲ **ABOVE** Inkjet printers, such as Epson's Picture Mate 500, can be small and relatively portable, so you can print images while on the move.

Dots per inch

A printer's ability to resolve fine detail, in other words its resolution, is measured in dots per inch (dpi), which should not to be confused with the image's own resolution, which is measured in pixels per inch (ppi). A dpi figure tells you how many droplets of ink the printer is capable of printing on an inch of paper, so the higher the number the greater the resolution. Most printers today have settings ranging from 360dpi, through to 720dpi, 1,440dpi and up to 2,880dpi. The lowest resolution should be used for basic print jobs such as letters, using standard plain paper, while the higher resolutions should be used in conjunction with higher grades of photographic-quality paper. The paper you buy should tell you what resolution can be used. Printing with a high-resolution setting on standard paper will simply result in too much ink being applied.

Numbers of colours

Another aspect to consider when assessing an inkjet is the number of different colours it uses. All inkjet printers use the basic secondary

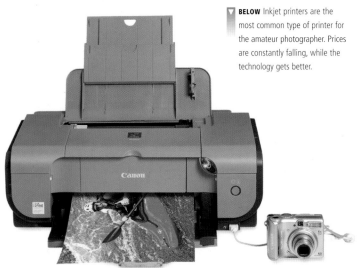

▼ **BELOW** Inkjet printers are the most common type of printer for the amateur photographer. Prices are constantly falling, while the technology gets better.

LEFT Dye-sublimation, or dye-sub printers, are mainly limited to 6 x 4in (15 x 10cm) print sizes, although some larger models are made. They tend to have a higher cost per print than inkjet printers.

colours – cyan, magenta and yellow (CMY) – to replicate the reds, greens and blues (RGB) of the digital image and, in addition, all printers also use a black ink (K) to add depth to darker regions of an image. While in theory, CMYK are the only colours you need to produce all the visible colours of the spectrum, some of the more sophisticated printers have additional colours, such as light cyan and light magenta, to improve subtle colour gradation. Some even include an additional light black or grey for improved neutral tones in black and white prints.

Direct to printer

You don't have to own a computer to enjoy the benefits of photographic-quality home printing. A number of manufacturers, such as Canon and Epson, produce printers that can print directly from a digital camera or a memory card. Such printers are capable of producing excellent results, but be certain to look into how much editing can be undertaken. Some, for example, will only allow simple cropping, while others may have the option of making brightness and tonal corrections and other more sophisticated adjustments. However

comprehensive the 'in-printer' editing capabilities, they will still pale into insignificance compared with what can be achieved using image-editing software.

Dye-sub printers

Although inkjets are the most popular photographic-quality printers for the home, there are alternatives. There is an increasing number of dye-sublimation printers available on the market. Most are small, portable printers producing 6 x 4in (15 x 10cm) prints, and many have been designed to print directly from a camera or memory card.

Dye-sub printers use cassette-like cartridges that are loaded with strips of cyan-, magenta- and yellow-coloured ribbon. An additional clear coating ribbon is used to add a protective coating to the prints. As the paper passes through the printer, the colour ribbon is heated and the dye in the ribbon transferred to the paper. The paper passes through the printer four times before

the final, protected image is complete. If you're considering a dye-sub printer, don't be thrown by the advertised resolutions of 300 – 400dpi. Because dye-subs work in a different way to inkjets, these comparatively low resolution figures actually equate to a very high print resolution. In fact, dye-sub prints probably resemble traditional colour prints much more closely than inkjet prints in terms of feel and texture.

When it comes to image quality, many claim dye-sub printers to be as good as inkjets, but print for print they tend to be a little more expensive, particularly the less common A4-sized (letter) printers. However, with more and more people buying these small but sturdy printers, it's possible that the consumables will come down in price.

Laser printers

While affordable laser colour printers are now available, these still tend to be used in offices for producing large numbers of colour reports or similar uses. Laser printers are not yet as close to photographic-quality prints as inkjet and dye-sub printers and are rarely thought of for home use.

RIGHT An Epson Aculaser C1100. There was a time when it seemed that colour laser printers would be a popular choice for photographers, but inkjet and dye-sub technology took over.

Paper and Ink

LEFT Inkflow systems like these mean you don't have to change your cartiridges as often. The cost per print tends to be cheaper with bulk systems, too.

No matter how much you pay for an inkjet printer, there are two further factors that will certainly govern the quality of the prints it produces – paper and ink. Using cheap, inferior consumables is likely to cost you far more in the long run.

Paper

To achieve the best-possible print quality from your printer, consider carefully the paper you're using. As a rule of thumb, the heavier the paper, the better it is likely to be. If you've ever tried printing a colour picture onto plain copy paper you'll know how dismal the results can be, as the inks spread and the colours appear dull and muted. Such paper weighs around 80gsm (grams per square metre). To achieve 'true' photographic-quality prints – be wary of the names manufacturers give to their various papers – you'll need to use a paper weighing between 210 to 250gsm. Unfortunately, compared with lighter papers, such heavyweight paper is quite expensive, particularly in A4 or A3 (letter or tabloid) sizes. With such paper costing a premium, you may want to use a lightweight paper for proofing, and smaller sizes for your holiday and family snaps.

Inks

As well as paper weight and quality, the inks you use will also affect how good your prints look, and how long they last. There are numerous third-party ink manufacturers that on the surface provide much better value for money than the branded inks produced by companies such as Epson and Canon. But, although such inks are less expensive, it may well be the case that they are a false economy. First, third-party inks may not provide you with the quality you want for your prints, and, second, it's likely that they will fade much quicker, particularly if exposed to daylight.

RIGHT The paper you use for your prints will play a big part in print quality. For your best photographs, make prints on the best quality paper.

Of course, these inks have a use for producing short-lived 'fun' projects, such as greetings cards, or proofs, but if you want the best-possible quality and longest-lasting prints, the best solution is to use inks produced by the same manufacturer as the printer.

Ink flow

One alternative that may offer some savings, particularly for medium-to-heavy print usage, is an inkflow system. Offered by companies such as Lyson (www.lyson.com) and Permajet (www.permajet.com), these systems feature large refillable ink containers that are connected to the printer via a series of narrow tubes, which in turn connect to the printer nozzles.

Although initial start-up costs can be quite expensive, when it comes to refilling, the inks are much cheaper to buy separately compared with buying an entire set of colour cartridges.

In addition, the various coloured inks are used and replaced individually, so you only need to replace those colours that have run empty.

With some colour cartridges, you have to replace the whole cartridge as soon as one colour runs out. As well as the financial incentive an inkflow system may offer, there's also an environmental advantage that all of us should consider.

Specialist inks

Lyson and Permajet also manufacture specialist inks that are designed specifically for photographers using inkjet printers. As well as coloured inks, which are designed specifically for use in certain makes of printer, these companies also produce a series of grey and black inks, which are used together to produce high-quality black and white prints. The use of grey inks in addition to black helps to highlight the subtle tones of the black and white image to their very best advantage.

Both these companies make strong claims for the longevity of their pigment-based inks, with some calculated to last over a hundred years before they begin to fade.

▲ **ABOVE** The more sophisticated inkjet printers use individual colour cartridges, which means you only need to replace one at a time.

Leave it to the professionals

Although it's possible to achieve great-looking prints relatively easily in the comfort of your own home, it can take time, and many people simply do not get around to it. If this sounds all too familiar, it's worth considering one of the many online printing companies. You'll need a computer and Internet connection for this – and the faster the connection the better. A quick search on the web will throw up a number of companies. It's then simply a case of registering and following the instructions. This will involve uploading the images of which you want prints, making payment, and waiting for them to arrive by post (usually within a day or two). Buying a large number of prints this way is not only very easy, it can work out cheaper than printing them at home, and the results are usually excellent. Most online printing services offer more than just photographs. Photobooks, T-shirts, poster prints, mugs and greetings cards are just some of the more popular ways in which you can get your images into print. Most online companies also double up as online galleries where you can store and share your images.

Printing

If you've only just bought a printer, you'll discover that it came with a CD. The disc will contain what's referred to as 'driver' software. This contains all the software needed for your computer to communicate with the printer. Without the driver software, the computer won't recognize the printer and you won't be able to print. To install the software, insert the disc into your computer's CD drive and follow the onscreen instructions. This should be very straightforward and take only a matter of minutes. If you've bought a used or refurbished printer and it doesn't have an accompanying CD, don't worry. Simply go online and search for the printer manufacturer. You'll find all the information you need on the website to download the driver software for your particular printer.

PRINTER OPTIONS AND FUNCTIONS

With the printer set up on your computer and running with good-quality inks and paper, photographic-quality prints are only a few clicks away. Printing is a straightforward process, but there are one or two things to look out for when you first start. Let's run through a typical print job using Photoshop Elements – other software will have very similar commands and dialog boxes.

1 Once you've completed editing an image in Edit mode and you're ready to print, go to File > Print. This will bring up the Print dialog window. Under the Printer's drop-down menu, select the name of your printer.

2 Make sure that your image is going to print in the correct format. In this example, a landscape-format image is incorrectly set up to print in portrait format. To correct this, click on the landscape/portrait format icons in the lower left-hand part of the dialog window.

Before you start printing, it's important to make sure that you have the correct paper size and type set up. Click on Page Setup in the lower right-hand corner of the dialog window.

3 In the Page Setup dialog box, choose the paper size from the Size drop-down menu. Here, we've chosen A4.

Click on the Printer tab to bring up the printer's Properties window. There are a number of controls here, but the most important is the Media Type drop-down menu. Click on the type of paper on to which you're going to print. The menu attempts to cover the most common terms used by paper manufacturers.

Once you're happy with the settings, click OK to return to the Page Setup window. Here, click OK again to return to Element's Print dialog window.

4 With the correct paper size and type selected, it's time to finalize how the image looks on the page before printing. Under the Print Size menu the image will default to Actual Size.

In a way this size is not important, and what's more relevant is checking to see what the Print Resolution figure is toward the bottom of the window, in the Scaled Print Size area. Here, the image is going to print at a healthy 300ppi, which is the optimum print setting. The outer edge of the white border in the preview window represents the size of the paper.

5 But note what happens to the Print Resolution figure if we scale the image down or up. Selecting a smaller print size (3$^{1}/_{2}$ x 5in / 8.9 x 12.7cm) from the Print Size drop-down menu has seen the Print Resolution increase to 546ppi, while selecting a larger print size (8 x 10in / 20.3 x 25.4cm) results in the resolution falling to 255ppi. With the 'Show Bounding Box' checked, you can rescale the image by dragging one of the corner boxes.

If, when you first go to print your image, only a small part of it appears in preview box, and it's entirely covering the preview paper area, check to see what the print resolution is. It may be that your camera saves files at 72ppi, which is not a problem, but it means you will have to rescale the image before printing. Check the Scale to Fit Media box and note the percentage reading. Uncheck the Scale to Fit Media box, input a smaller percentage than you noted, and you should then be able to see the corners of the Bounding Box to help you scale the image. Scale the image to the size you want it to appear on the page. Check the resolution is a satisfactory 200ppi or more, and then click Print.

6 To print more than one image on a page, click the Print Multiple Images box in the Print dialog window. This will bring up a Print Photos window. In the Select Type of Print menu, you have various print styles, from Contact Sheet to Picture Package.

7 In the Select Layout menu, you can select how you want your image to appear and whether or not to add a preset border style. The window to the left allows you to add and delete images from the selection.

E-mailing Photographs

With so many people now connected to the World Wide Web, more and more of us are staying in touch with friends and family via e-mail. With broadband Internet access becoming increasingly widespread, it is now viable to send images without fear of wasting the recipient's time as they download relatively large files. Even so, unless you know that images are specifically going to be required for printing, it still pays to reduce file sizes for onscreen viewing. The more sophisticated image-editing software packages make it very simple to e-mail images.

SHARING YOUR IMAGES

1 Using Elements to send images via e-mail only takes a few clicks of the mouse. Select Share in the main viewing window and click the E-mail Attachments button to bring up the E-mail dialog window, where you can choose your preferred e-mail application.

2 If the image you want to send is open in the Edit window, it will automatically be selected and placed in the E-mail Attachments window. In the same window, click the Convert Photos to JPEG box, as this is by far the most efficient format in which to e-mail images. Elements' default Maximum Photo Size settings are fairly standard, and images measuring 800 x 600 pixels will display well on most computers, including laptops. If you have

specific needs, then you can select smaller or bigger files. The Quality slider determines how much compression is applied to the image, and the lower the number, the greater the amount of compression that is applied. This will also lower the quality. The higher the number, the less compression is applied and the higher the quality.

Once you've chosen the image size and compression setting, Elements will tell you how large the file is and how long it estimates it will take to download via a slow, dial-up speed connection.

If you think the file is going to take too long to download, simply reduce the file size or increase the compression.

3 If you want to add any images, click the '+' symbol at the top of the E-mail Attachments window to bring up the Add Photos dialog window. From here you can navigate to your image collections and add whichever images you choose. When you've chosen, click Done to return to the E-mail Attachments window. If you're happy with your selection, click Next.

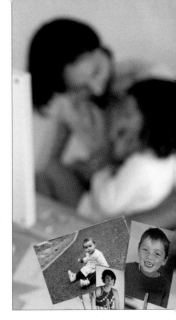

4 In the next screen you'll be given the option of typing your message and selecting the people to whom you want to send the images. After choosing the recipients, click Next and Elements will open up your preferred e-mail application with a pre-formatted new e-mail message to your list of recipients, containing your images and accompanying message. Now all you have to do is send.

▲ **ABOVE** Sharing images via email has never been so simple. Images can be sent aross the world in a matter of moments.

MANUAL RESIZING

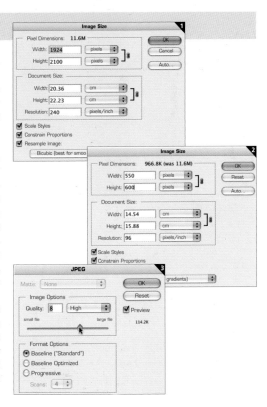

If you don't have Elements, and are unsure of how your software can automatically resize images, here's how to do it manually. All software can resize images in this way.

1 To resize an image for use on a website manually, go to Image > Resize > Image size. This brings up the Image Size dialog box. At nearly 12 MB the notional image is far too big to be used on the Internet.

2 Make sure the Resample Image box is ticked, and use Bicubic Sharper, as this is a specific algorithm for reducing image sizes. Change the image's resolution to 96ppi, which is the resolution for most Windows- based PC screens, and set the Height to

600 pixels, the optimum height for all screen images. This reduces the image's file size to 966K (just under 1MB), but this is still quite big for a web image.

3 Go to File > Save As and rename the file. Use a 'web' suffix so that you don't over-write the original, and select JPEG as the file format. Click OK, and the JPEG Options dialog window will appear. Here, a Quality compression setting of 8 has been chosen, which has reduced the file size to an acceptable 114 K.

You can also save the file as Progressive, which means that when it opens on screen, the image will appear quickly, but blurred, and gradually sharpen with the set number of scans selected.

Online Galleries

Photoshop Elements has a number of extremely useful automated tools to make editing images as easy as possible. One of the most useful is the Online Galleries command. Essentially, this allows you to select any number of your images; Elements will then resize them automatically, and place them in a pre-formatted gallery style. The gallery is then saved, ready for you to upload to the Internet, which is ideal for showing wedding or other special-event photographs to as many or as few people as you like, no matter where they live. If you have Photoshop, you can create similar galleries via the Browser window. Simply select the folder containing the images you want to use and then, still in the Browser window, go to Tools > Photoshop > Web Photo Gallery. There, you'll find a number of preset gallery styles to choose from. Once you've selected a gallery style, Photoshop will automatically resize the images and prepare the gallery for viewing in your web browser.

BUILDING AN ONLINE GALLERY

1 Before you start creating the Online Gallery, you may want to preselect the images you want to include in the Browser window. This will make the process quicker in the long run, but it's by no means essential. Nor do you need to resize any images manually to make them suitable for sending via e-mail – Elements will do this automatically.

To begin creating the gallery itself, click the Share tab to the top right of the Elements' window and then select Online Gallery.

2 Click on the '+' symbol at the top of the first Online Gallery screen to navigate to the collection you made earlier. Drag the folder over to the window, or browse for individual images and drag them across one at a time. You can rearrange the order in which the images appear by dragging and placing the image thumbnails in the small window. Once you've finalized your selection, click Next at the bottom of the window.

3 Elements will now present you with a variety of gallery templates to choose from. When you select a specific template, Elements provides a brief description of the template you've chosen at the bottom of the window, and also whether or not that template allows you to include captions. With such a diverse variety of gallery styles to choose from, you should easily find a style appropriate for your needs.

You can also choose how you want the images to be displayed in the gallery. 'Interactive' allows viewers to select specific thumbnails to view them at the larger size, while other options, such as 'Standard', will play the gallery from start to finish. Having chosen the gallery template, click Next.

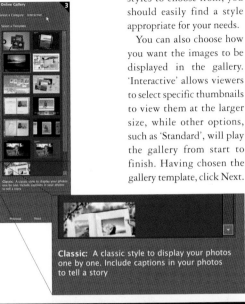

Classic: A classic style to display your photos one by one. Include captions in your photos to tell a story

4 Depending on the chosen template, Elements will present you with a screen where you can customize your gallery. Here you can enter the gallery name and other details about the gallery, such as your name and e-mail address, so that people can easily see who the gallery is from and how to contact you.

In addition, and depending on the type of gallery, you can choose the transition effect (experiment to see which one you like best from the options given, such as Fade, Cut and so on). You can also choose how large you want the images to be saved. There are two standard settings – Broadband and Dial-up, which are self-explanatory. If you know that most of your viewers have a fast Internet connection, then select the first; otherwise it is safer to select the dial-up option.

6 Finally, you have the option to upload and share your gallery using one of the options in the window. How you do this will depend on your Internet Service Provider (ISP). If you have any doubts on how do this, contact your ISP and they'll take you through the steps you need to take.

Elements also gives you the option of burning the gallery onto a CD should you wish to distribute it in this way.

5 After a few minutes, Elements will present you with the complete gallery, which you can run to check that you're happy with it. If you want to change the template style, go back to the Online Gallery window and select Previous, where you can then select another template. Alternatively, if you're happy with the gallery, you will be asked to give it a name and choose a location to save it to on your hard drive. Once you've entered this information, click Next.

Slide Shows

Another excellent way to show off your pictures to friends and family is to create a slide show of your selected photographs – whether they're of a recent family holiday, a wedding or your new home. Most image-editing software packages offer this option, and Photoshop Elements is no exception. In a relatively short space of time you can use Elements' Slide Show option to create a professional-looking slide show featuring all your favourite images, accompanied by music, voiceovers and text, should you wish.

Perhaps somewhat surprisingly, this attractive feature isn't available to Photoshop users, who will have to content themselves with using the Web Photo Gallery feature explained in the last project.

CREATING A SLIDE SHOW

1 Before you start creating the show, you may want to place all the images you intend using in one easily identifiable folder. This will save time, but, as with the Online Gallery, it's not essential. To start, select the Slide Show option in the Create window.

2 The first window provides you with the basic options for the slide show. Most of the options are fairly self-explanatory, such as Static Duration, Transition Duration and Background Color. The Transition box provides a drop-down menu of the various transition styles available to you.

Although you may be tempted to use some of the more exotic-sounding styles, this can sometimes be a distraction, particularly if the Transition Duration is quite lengthy. You're better off keeping the transitions short and simple.

The Pan and Zoom option gives the slide show a professional feel, but it can be a bit too much if applied to all the slides – again, a case of less is more. If you don't click this option in the Slide Show Preferences window, you'll still have the option of applying Pan and Zoom transitions manually to the slides that you think are most suitable for the treatment. Once you've finished selecting your basic preferences, click OK.

3 Elements will now bring up the Slide Show Editor screen. Here, you can select the images you want to include in the slide show by clicking the Add Media button at the top of the screen. This will bring up the familiar Add Photos window, where you can navigate to the images you want to include. Once you've located the images, click Done at the bottom of the screen to return to the Slide Show Editor window.

4 The Slide Show Editor is a powerful tool that enables you to customize all sorts of aspects of your show. The images you've selected will appear in a timeline at the bottom of the window. You can select individual images and apply a whole host of effects to them.

Many of the options are geared toward the fun side of slide shows, allowing you to add cartoon animals, different backgrounds, speech bubbles and costumes. If you're using the slide show to make a presentation, you can add text and narrative to make more serious points.

5 One of the most attractive aspects of Elements' slide shows is that it allows you to add sounds or music to your show. Selecting 'Click Here to Add Audio to Your Slide Show' near the bottom of the Editor window will bring up the 'Choose your Audio Files' dialog box.

From here, you can navigate to any music tracks that you might have stored on your computer, such as those you've downloaded for an MP3 player or those that were supplied when you purchased the software. Here, the Sample Music folder has been selected.

6 Once you have chosen your music, you'll see that the music appears as another line underneath your selection of images in the Editor window. You can edit the images to appear at specific points along the music timeline, which is useful if you've selected more than one piece of music. If you've only selected one track, the easiest option is to set the music to repeat and click the Fit Slides to Audio option.

Adding text is just as straightforward. Click the Add Text button and the Text Editor will appear. You can type in the text you want over any specific slide. You have the option of resizing and placing the text where you wish, and you can also change the font and colour of the text.

7 In the Properties window you can add a Pan and Zoom effect to individual slides. Click on Start and draw a green square around the area that you want to appear first when the image opens. Click on End and select the area that will complete the slide.

Here, for example, the slide will open with a close-up of the sun and pan out to reveal the entire image. To change the order of any of the images, simply click and drag. To preview the show, click Full Screen Preview at the top of the window.

8 When you're happy with the slide show, click Save Project in the top left corner of the Editor window and Elements will offer several ways to save the show – either as a file on your hard drive, on CD/DVD or straight to your television. Elements provides easy-to-follow instructions and advice to help you make the right choices for your show. A lot depends on how instantly you want to view the show and whether or not your prospective audience lives in the same home as you or on the other side of the world.

Organizing Your Photographs

One of digital photography's greatest benefits is that once you have a camera, a memory card or two, and a computer onto which you can download your images, it costs almost nothing to take photographs. The result is that in a very short space of time you'll discover you have a vast number of images on your computer.

If you're a keen photographer, you'll soon have thousands of images, and keeping tabs on them all will become harder and harder, especially as your computer's hard drive will need clearing out from time to time, in order for your applications to run properly. Once you find yourself adding additional desktop hard drives or burning images to CD or DVD, it's time to consider using some form of image catalogue or database software.

Digital asset management

The buzz term for cataloguing your images is 'digital asset management', which sounds more daunting than it is. As implied earlier, digital asset management is really just an efficient way of keeping track of all your images so that you can find any specific image efficiently. Today, there are numerous cataloguing programs to help you do this.

EXIF

The most effective cataloguing software works by recording all the EXIF data that is embedded by your digital camera every time you take a photograph. Simple examples of EXIF data include the date and time the photograph was taken, the make and model of the camera, and the exposure setting. Some professional cameras will also provide the exact geographical co-ordinates at which the image was shot. This information

TOP Photoshop Elements' Photo Organizer is an integral part of the image-editing software package. You can switch between browsing and editing and easily create searchable Albums and add Keyword Tags to groups of images or single photographs.

ABOVE Photoshop CS comes with its own sophisticated organizer, known as Bridge. Bridge retains image EXIF data, and will allow you to add and apply keywords to any number of images, making it easy to search for the images at a later date.

is stored along with the image itself and can be viewed by most image-viewing software. In this way, you can use EXIF data to search for specific groups of images.

Keywords

In addition to storing and retrieving searchable EXIF data, most image-cataloguing software can be 'programmed' so that keywords, such as an event, a location or other textual descriptions, can be input and then searched for.

Image-editing software

Many image-editing applications come with built-in cataloguing software, and you may find that this add-on is all you require. Photoshop Elements' Photo Organizer, for example, allows you to import and batch-name photographs, add keywords, rate photographs, rename, move and adjust the dates of your photographs, and perform extensive searches. Even for a relatively large number of images, this may be all you need, and other editing programs feature similar software.

The full version of Photoshop CS also has a sophisticated browser, referred to as Bridge. Bridge is accessed via Photoshop (or any of the

ABOVE Extensis' Portfolio is a dedicated digital asset manager that can hold thumbnails of thousands of images, retaining all the EXIF data and keywords associated with them. New catalogues are easily created and edited, all of which are quick to search.

ABOVE Apple's iPhoto is only available to Mac users as part of the iLife suite of applications. As well as managing photographs, iPhoto features basic editing controls and a link to Apple's electronic and paper-based viewing and sharing packages.

other CS suite of applications) and provides an easy-to-use interface between Photoshop and all the files on your hard disk, or any additional drives. Information on photograph files includes (among other things), the date the file was created, its dimensions, colour mode, EXIF data, and so on. It's simple to assign images a keyword that you can search for later, and once you've located the image you want, simply click on it to open the file in Photoshop.

Cataloguing software

As well as 'built-in' cataloguing software, there are numerous programs dedicated to the same job. Some, such as Extensis Portfolio are ideal for photographers who simply want to catalogue their work. Images can be batch processed with specific searchable data, keywords can be assigned, and folders and subfolders created, edited and moved about.

Just as some editing software provides an organizer to help you keep track of your images, some cataloguing software provides basic editing, viewing and printing tools. For Mac users, iPhoto can be used to enhance images as well as provide a powerful cataloguing application and a sharing and printing interface. Most software developers provide free trials for their products, so have a look at the ones that you think are most appropriate for your needs, and then download a trial version.

LEFT Adobe's Lightroom is an editing and cataloguing application that does a lot more than just allow you to manage your images. The user-friendly interface also provides access to a number of ways to print and share your images on the web [www.adobe.com].

Storing Your Photographs

Although at first it may feel that your computer's 250 gigabyte (GB) hard drive will last a lifetime, if you're a keen photographer you'll be amazed at how quickly it will begin to fill up with images. Digital bitmap image files are notoriously large when compared with other types of files, particularly when you use uncompressed formats such as TIFF and RAW. If you take a lot of pictures you'll soon be searching for other places to store your images.

However, this is no bad thing, as you should always avoid having all your images stored in one place. There are numerous stories of people losing their entire collection of images and you certainly don't want to be the next. Whether through theft, fire or a hard drive failure, losing an entire collection of unique images doesn't bear thinking about. So what is the best practice for storing images?

BELOW LEFT If you buy a new computer, you should expect a combination DVD and CD burner as standard. If you don't have one built-in, you can buy one to use as an external plug-in accessory.

BELOW MIDDLE There are various grades of CD and DVD. Some, such as these, claim to last for as long as 300 years.

BELOW RIGHT The price of external hard drives is dropping all the time, so by the time the disk on your computer is full, you will find a high-capacity external solution to suit your budget.

External hard drives

Increasingly, many photographers are turning to external hard drives as the preferred storage method. External hard drives are becoming less and less expensive and their capacities are getting ever larger. A 500GB external hard drive is now quite affordable, and getting more so by the week. By the time you've filled that one, you may find that a 750GB hard drive is affordable, and so on.

Whereas most people used to back their images up onto a CD or DVD, these days it may make more sense to store images on an external hard drive and buy a new hard drive every three to five of years or so. Most modern hard drives will work continuously for between 10 and 15 years, and many will last much longer. These periods compare favourably with the lowest-quality CDs and DVDs, which, if not stored in dry conditions, may degrade after only three to five years. However, it is worth noting that some of the more expensive 'gold' CDs and DVDs are claimed to last up to 300 years.

Before investing your money in either storage option, try to find out as much as you can about the life expectancy of the device or media – and remember, don't always rely on manufacturers' claims.

▶ **RIGHT** If you are archiving your images to CD or DVD, then dedicated disk-burning software such as Roxio Toast can be a good investment. Such software will often let you create a contact sheet to act as a sleeve for the disc.